The Universe History of
ART AND ARCHITECTURE

ROMANESQUE

George Zarnecki

Universe Books
New York

Published in the United States of America in 1989
by Universe Books
381 Park Avenue South, New York, N.Y. 10016

© 1971 by Universe Books

89 90 91 92 93 / 10 9 8 7 6 5 4 3 2 1

Printed in Hong Kong

Library of Congress Cataloging in Publication Data

Zarnecki, George.
[Romanesque art]
Romanesque / George Zarnecki.
p. cm. — (Universe history of art & architecture)
Bibliography: p.
Includes index.
ISBN 0-87663-759-4
1. Art, Romanesque. I. Title. II. Series:
Universe history of art & architecture.
N6280.Z36 1989
709'.02'1—dc19 88-31734
 CIP

CONTENTS

INTRODUCTION

For various reasons, the chronological limits of the Romanesque period cannot be clearly defined. First of all, they vary from country to country. Secondly, the Romanesque style is not easy to define and its beginnings, especially, are imperceptible, so that it is often impossible to state categorically that any given work is already Romanesque. Similarly, at the other end, the change from Romanesque into Gothic did not occur overnight, and the period of transition varied in duration from region to region. Generally speaking, however, bearing in mind the imperfections of any firm definitions, it can be said that, by the middle of the 11th century, the Romanesque style was already firmly established, after a preliminary period of about fifty years, during which the style had gradually evolved. The 12th century is usually considered the Golden Age of Romanesque art, but it must be remembered that it was before the middle of this century that Gothic architecture was initiated at St-Denis Abbey and that, while in most of Europe the Romanesque style continued unaffected or little affected by this artistic revolution, the royal domains of France and the adjoining regions were already moving fast toward this new style. A further complication is that even in the same artistic center, developments in the different media were not always in step. For instance, the first Gothic building in England, the choir of Canterbury Cathedral, was designed by a French architect, William of Sens, in 1174. But a psalter (now in Bibliothèque Nationale, Paris, MS Lat. 8846) illuminated at Canterbury as late as c. 1200 is not Gothic in style but belongs to that "classicizing" period which separates the Romanesque and the Gothic styles. In fact the truly Gothic style in painting and in sculpture did not evolve until the 13th century.

Although in some regions of Italy, Romanesque buildings continued to be built throughout the 13th century, and some survivals of Romanesque sculpture can be found as late as the 14th century in remote parts of Apulia or Portugal, the truly creative time of Romanesque art is encompassed by the hundred years 1050–1150, with half a century before as the period of preparation and half a century after as that of the gradual decline or transition to Gothic.

In order to understand the Romanesque style, its genesis, its development, the features that distinguish it from other styles, and above all its significance and meaning, it is necessary to bear in mind the political conditions of the times.

After the calamitous epoch that followed the disintegration of the Carolingian empire, the second half of the 10th century witnessed a gradual improvement in conditions and a rebirth of organized political and social life. Led by Germany under the Ottonian rulers, Western Europe regained confidence in its own destiny, and the forces of law and order slowly triumphed over anarchy, bloodshed, and plunder. The revival of the Holy Roman Empire under Otto the Great (962–73) again brought Germany and large parts of Italy into close contact and, although the long-term political consequences were disastrous, the immediate benefits for the revival of artistic life were enormous. The renewal of relations with Byzantium was an additional stimulus for the rebirth of the arts.

France and Spain, though slower than Germany to organize strong centralized power capable of ensuring a more stable life, both emerged during the 11th century as states in-

spired by new vigor and energy. During the 11th century, France was still a conglomeration of large and small feudal units, but by the 12th century, the central royal authority had been imposed over most of them and France emerged as a political entity of the first order. By then, Germany, weakened by the struggle with the papacy and internal divisions, gradually relinquished the position of supremacy it held during the 10th and 11th centuries.

The Spanish wars of the reconquest, which gained momentum during the 11th century and recovered large territories of the Peninsula held by the Arabs since 711, were only one aspect of the new confidence of Western Europe in its own strength. The Crusades and the resulting conquest of the Holy Land, the Norman settlements in southern Italy and their final victory over the Arabs in Sicily, were further proof of the new spirit of pious zeal and adventure but also of greed. The same Normans, as if driven by the atavistic Viking urge, conquered England and brought that country into far closer contact with continental Europe than ever before.

The Scandinavian North, by now Christianized, entered the life of the Western world as an active if marginal partner. To the east of the empire, new territories joined their destinies with Western Europe by accepting Christianity from Rome rather than Constantinople. Thus Poland, Hungary, and Bohemia, as well as the newly conquered German provinces, were opened to influences from the West. The Romanesque world comprised geographical regions from Scandinavia (and Iceland) to Sicily and from the Atlantic to the Vistula and Transylvania and, during part of the 12th century, to the Latin kingdoms in Asia Minor. Romanesque Europe was a conglomeration of feudal states, old and new, with differing traditions but all of which owed their allegiance to Rome. Latin, the language of the educated, was common to them all. In this way, in spite of considerable differences, they had much in common.

If the Roman church was the unifying factor, it should be added that it was, in every sense, the leading force as well. That Europe rose once again in the 10th century from the state of degradation and chaos into which it had fallen was overwhelmingly due to the church and more especially to its most active instrument, monasticism. Led by a few individuals, fired by deep religious convictions, and acting against the prevalent corruption and decay: the reform movement gathered momentum. The German, Flemish, and English reforms of the 10th century were all surpassed in importance and influence by the work of the monastery at Cluny. From modest beginnigs in the 10th century (it was founded in 910), Cluny became the head of a vast organization which included nearly two thousand monastic houses. Inspired by Cluny's example, or in some cases in opposition to its mode of life, numerous more strict new monastic orders were founded, giving expression to the new fervent religious zeal and piety. By the 12th century, the influence of Cluny was on the wane and its place was taken by the Cistercians (founded in 1098).

Monastic reform was closely linked with the reform of the papacy which led, inevitably, to conflict between the growing authority of the church and that of the secular rulers. The struggle over the investiture was only one, though the most serious, conflict resulting from the competition for leadership and from the claim of the papacy for supremacy, not only in spiritual but also in political matters. Three dates stand out in the history of this conflict;

1077, when Emperor Henry IV, standing barefoot in the snow before Gregory VII, submitted to all the demands of the reforming party; 1111, when Henry V was crowned emperor, having forced Pope Paschal II to an almost unconditional surrender; finally, 1122, when a compromise was reached at the Council of Worms. The church emerged from this struggle as a force with which all states had to contend and its influence was felt in all spheres of life. The struggle between the emperors and the popes was resumed again under Frederick Barbarossa and ended in the peace of Venice (1177), with the papal power further increased.

But in spite of this constant conflict, strife, and frequent warfare, Western Europe witnessed a revival in learning and literature. "The 12th-century renaissance" is all the more remarkable because it came after a long period of intellectual sterility. It was during this time that universities were founded. Some branches of learning—for instance, canon and civil law, for which Bologna was preeminent—had practical applications, but many were studied out of solely intellectual curiosity. The humanism of the 12th century was based on the study of the classics and found its most striking expression in the school of Chartres. Many Greek texts, hitherto unknown in the West, were now translated into Latin from the original or Arab versions. Classical authors and poets were widely read, studied, commented on, and in their turn inspired Latin writing in prose and verse. Writers on theological subjects were no longer content with commentaries on the scriptures but turned to intellectual speculation such as, for instance, developed between the Nominalists and Realists toward the end of the 11th century and continued in the 12th century, involving such brilliant men as Abelard. The 12th century also witnessed a revival of historical writing in the form of annals, chronicles, biographies, and the lives of saints. In this age, vernacular literature also emerged, including Icelandic sagas, the lyric poetry of the troubadours, the epic *chansons de geste*, the romances concerning King Arthur and his Knights of the Round Table, the adventures of Alexander, and the *Nibelungenlied*.

In this historical, religious, and intellectual climate, the visual arts developed and flourished. Little survives of the secular art of this period, but it can be taken for granted that in the castles and palaces of the rulers, the feudal aristocracy, and even the rich merchants, there was an accumulation of beautiful objects for worship, ceremonial, entertainment, and everyday life. Among the leading intellectual men of the age there was collecting, chiefly of books but, at times, even of antiques. The brother of King Stephen, Henry of Blois, bishop of Winchester, bought antique statues in Rome and shipped them to England.

By and large, however, Romanesque art was religious in purpose and predominantly religious in content. In the Carolingian period, the court and the small intellectual elite had been the chief patrons of the arts. The patronage of Ottonian times was mainly aristocratic, involving the imperial court and the princely bishops. Romanesque art was supported by a much wider range of patrons: the popes, the monasteries, the secular clergy, the emperors, the kings, and the feudal aristocracy, all of whom devoted enormous resources to the building and embellishment of churches. This activity was usually an expression of their genuine piety, the fulfillment of a vow, repentance for sins, or an act of thanksgiving. But other motives also played their part, such as vanity and ostentation. Lesser men and women contributed according to their means. For instance, the frescoes of S. Clemente in Rome were

paid for by a butcher's daughter, and there are numerous other examples of similar acts of pious generosity. The enthusiasm for church building is sometimes recorded as having taken the form of an almost touching personal involvement as, for instance, when the people of Monte Cassino carried on their shoulders, up the high and steep slope, the first of the antique columns brought from Rome by Abbot Desiderius. Similar manifestations of piety took place at Chartres, St-Denis, and elsewhere.

But more was required than material resources, religious zeal, and enthusiasm in order to build large churches, of which Cluny was the largest in Christendom until the rebuilding of St. Peter's in Rome in the 16th century. What was needed, above all, was the skill of a professional architect. Unfortunately, we lack information on contemporary architects and their methods, and only by the examination of the buildings themselves can certain deductions be made. What is certain, of course, is that before any large building could be erected, detailed drawings had first to be made. No such drawings from the Romanesque period survive. Made on a plaster floor, board, or parchment, they would be discarded when no longer needed. The skill needed in preparing the drawings presupposes some knowledge of geometry, for the plans and elevations often reveal a carefully planned system of proportions. These were based on a combination of standard units. The great church of Cluny, for instance, begun in 1088, was designed with the use of a unit equivalent to five Roman feet. The desire to build on a large scale, unknown in the West since classical times, sometimes led to disasters, especially in the construction of vaults and towers. (Part of the nave vaults of Cluny collapsed in 1125.) The "Leaning Tower of Pisa" and a few others survive in spite of weak foundations, but a great many crashed soon after they were built. Builders learned by experience, improving building methods and designs and perfecting tools. The progress of building techniques in the course of the 11th and 12th centuries was very great.

It has been said that the Crusades contributed considerably to this progress, by providing the opportunity for close contact with the building techniques practiced in Byzantium and the Muslim world. This can be demonstrated in the case of castles, and it is likely that the improvement in certain skills, such as, for instance, the building of domes, was due to contact with Byzantine and Arab architecture. The pointed arch, which was to become an essential feature of Gothic buildings, was already in use in the 11th century in such abbey churches as Monte Cassino and Cluny, and therefore before the First Crusade (1095), and could have been adopted from Islamic sources through trade contacts, which were particularly active in southern Italy.

Gunzo, the architect of Cluny, was a monk, but the majority of master-masons were undoubtedly laymen. In many cases, they would be members of families in which the craft would have been passed from father to son for many generations. The architect of a large church, who had to produce designs, to arrange for the delivery of materials, and to organize teams of masons, carpenters, smiths, and many other craftsmen, so that the work could progress smoothly, must have been a man of energy and intelligence and he must have been fairly well educated.

Other artists and craftsmen, such as sculptors, painters, and metalworkers, required less demanding organizing abilities, but their works show that, quite often, they were not only

literate but were also well read. Of course, it could be said that these artists were merely carrying out iconographical programs supplied by learned patrons, and this was undoubtedly the case in a few instances. From Abbot Suger's account of the work done at St-Denis during his rule, it is quite clear that he took an active interest in it. He probably composed the inscriptions and it is quite likely that he also had definite views on the question of subject matter, if not on the style of metal objects, stained-glass windows, and other works. But, in any case, he was an exceptional man in many respects. Not every artist of the Romanesque period was learned or even literate, but many were. For book illuminators, it was essential to be able to read the text being decorated. Sometimes the illuminators were monks but more often they were laymen. Not infrequently, the status of a painter can be deduced from his signature or even from his portrait. For instance, in the Dover Bible (Corpus Christi Library, Cambridge, MS 3-4), two secular artists are represented painting an initial, while in the Bohemian Missal (Kungliga Bibliotheket, Stockholm, Cod. A. 144), three people are shown in collaboration: a monk is writing the text; a lay artist, Hildebert (inscribed *pictor*), is painting; while his assistant Everwinus is holding two paint pots. The same painters appear in another manuscript (University Library, Prague, MS Kap. A. XXI), and this time a touch of humor is added by Hildebert's gesture of throwing a sponge at a mouse that is eating the food on a table. A comic caption in Latin explains his annoyance.

The fact that so many artists of the 11th and 12th centuries signed their works or added their self-portraits shows that they took pride in their work and wanted to be associated with it. That was surely the motive of the Burgundian sculptor Gislebertus when he put his name in a prominent place on the tympanum at Autun. The Italian sculptor Wiligelmo, who decorated the cathedral at Modena, was less modest, for he immortalized himself by the following inscription: *Inter scultores quanto sis dignus onores*
Claret sculptura nunc Wiligelme tua.
(Among sculptors, your work shines forth, Wiligelmo. How greatly you are worthy of honors.) In this attitude of pride in their work, and in their need for recognition and honors, one detects the influence of antiquity, transmitted by the texts of Vitruvius and Pliny.

From modest beginnings, through the study of ancient models and through trial and error, the artist of the developed Romanesque period was a highly professional expert in his branch of art. The artist's manual *De diversis artibus* (On Diverse Arts), written by Theophilus c. 1100, proves that, by this time, the skills in various arts had reached a high degree of technical excellence. But it is worth bearing in mind that, on the author's own admission, he had written his treatise to increase the honor and glory of God. This religious aspect of most of the activities connected with the arts was natural enough, since the great majority of works of art were intended for church use.

Yet, it would be a mistake to stress this point too strongly. A great deal of the art in Romanesque churches is not of a religious nature, and this applies especially to sculpture. Over the doorway of S. Nicola at Bari is carved not the story of the patron saint, whose relics were in the proud possession of that church, but an episode from the epic of King Arthur and his knights. The same legend is illustrated in sculpture at Modena, and on the pavement mosaic at Otranto where, in addition, there are other heroes of epic poems, Ro-

land and Oliver as well as Alexander. Roland and Oliver are also, in all probability, re-
presented on the doorway of the cathedral at Verona. Even more curious is the doorway of
S. Maria la Real at Sangüesa in Spain, on which are carved scenes from the Scandinavian
saga of Sigurd (Siegfried). Some of the heroes of these epics, for instance Roland, were the
embodiment of Christian knightly virtues and thus naturally found their way into church
iconography. But there was a host of other subjects, derived from classical mythology, from
oriental sources, or from the artist's imagination, for which there was no justification from
the religious point of view. However, they were amusing or horrifying and appealed to
the contemporary hunger for the exotic, strange, miraculous, and monstrous. Roman-
esque art is full of such subjects. Many scholars try to read into them a symbolic meaning,
for the use of such subjects offends their notion of Romanesque art as always deeply
spiritual. However, St. Bernard, the austere Cistercian, who lived when these subjects were
being painted or sculpted, knew nothing of their symbolic meaning, for he condemned
them wholesale as *deformis formositas ac formosa deformitas* (formless decoration and
decorative deformity).

This does not mean that all the nonreligious subjects of Romanesque art were merely
grotesques, whose only aim was decorative. Many subjects were no doubt selected for
their didactic or moral meaning. The illustrated bestiaries in which animals, real and imagi-
nary, are depicted and their symbolism explained provided a mine of motifs to be copied,
especially on Romanesque capitals. Fables, ancient and more recent, also found their way
into art. But the paintings covering the walls of churches and the large tympana over their
doorways were, as a rule, devoted to biblical or symbolic representations, and therefore
almost all the greatest works of Romanesque art are concerned with religious stories and
ideas. These can range from simple illustrations of events based on the scriptures to very
complex programs. It is not always easy to understand the meaning of such programs.

In the cathedral of St. Lazarus at Autun, for instance, numerous capitals are carved with
figural subjects. While most of the subjects are readily identifiable, it is not clear why they
are placed in the order and in the position in which we find them. Why, for instance, are the
two temptations of Christ in widely separated parts of the church? On the other hand, two
other subjects, the story of Cain and Abel and the Suicide of Judas, which are placed close
to each other, though at first sight quite unrelated, were undoubtedly selected with good
reason, for a nearby capital is decorated with the personifications of the sins of Cain (Anger)
and Judas (Greed), which are being trampled by the corresponding virtues, Patience and
Generosity. Thus, the two stories were selected for the moral lessons they both teach, and
this applies to many other capitals, some of which, as, for instance, the one showing the
punishment of Simon Magus, were particularly topical. Simon tried to bribe St. Peter and
thus gave the name to simony, the sin of the corrupt buying of church offices. Church re-
formers were particularly eager to eradicate this evil, and the frequent appearance of the
story of Simon Magus in Romanesque art must be regarded as one of the means of pro-
paganda used by the reforming party of the church.

The forms in which Romanesque art expressed itself vary considerably from region to
region and they underwent constant changes as time went on. The regional differences in

the style of Romanesque art depended, to a large degree, on the existence of available models. Thus in Germany, for instance, the Romanesque style—in architecture as well as in the figurative arts—developed from Ottonian art. In France, the sources of Romanesque art were far more complex and varied, with the result that regional differences were more pronounced than in Germany. Because of the Norman conquest of England and the introduction of the Norman form of Romanesque art, no regional differences existed at first in England. Out of this fairly uniform style, regional variants developed only gradually.

In the two previous important artistic revivals, the Carolingian and the Ottonian, the character of the revival was dictated, at least in part, by political motives. The Carolingian renaissance was an attempt to recreate the Christian empire as it had existed under Constantine the Great, and consequently its sources were chiefly Early Christian and Roman. The early Ottonian rulers aimed at reviving the Carolingian past and the close links that had existed between the empire of Charlemagne and Italy. Thus, Ottonian art was based, in its initial stages, on Carolingian models, with Byzantine and antique sources joining later on as important secondary influences. The Romanesque artistic revival had no similar, single-minded policy behind it. Linked with church reform, it was inspired by the ideal of the decent Christian life. The artistic revival did not specifically seek inspiration from one single source or period. It was willing to learn from any worthy model, whether Roman, barbarian, Byzantine, Carolingian, or Ottonian. Each country or region turned eagerly to local monuments, if there were any, to learn the techniques of and to draw inspiration from the art of the past. The Scandinavians, who had to learn the art of building stone churches from the English and the Germans, soon adopted the local techniques of timber construction to building churches and, in the process, also revived some of the decorative styles from their Viking past, applying them with great success to the enrichment of churches. The Italians, who had wonderful examples of buildings and other monuments from past ages all around them, frequently looted Roman ruins to extract from them columns and other architectural features, to be used in their buildings. But certain famous buildings were left standing for their associations or beauty, and guidebooks were even written to help visitors, as for instance the *Mirabilia Urbis Romae*, the guidebook describing the marvels of Rome, written shortly before 1143. No wonder that, in this atmosphere, the example of the glorious past was a constant source of inspiration, and the Italian Romanesque style, more than any other, is rooted in the art of classical Rome. But even in France and Spain, where Roman buildings were less numerous and, by the 11th and 12th centuries, largely sad ruins, the impact of these monuments, buildings, sarcophagi, and other objects was profound and one of the most influential sources in the revival of architecture and sculpture. Thus the classical element in the Romanesque style was not confined to Italy alone.

During the 11th century, the period of the formation of Romanesque art, and the 12th century, the time of its expansion and blossoming, two civilizations inspired envy and emulation, on the one hand that of Byzantium and on the other that of Islamic Spain and the East. Through trade and other contacts, objects of art of Islamic workmanship reached the West, and there was also some knowledge of Arab buildings, for their influence is present in Spain, France, and Italy. But it was the Greek East that was a constant source of inspira-

tion for Western artists. The Crusades gave an opportunity for a great number of people, including artists and future patrons, to visit Constantinople. The capture and sacking of that marvelous city by the Fourth Crusade in 1204 was a shameful way of repaying the debt the civilization of the West owed to that great center of art and learning. In its beginnings, Romanesque art developed independently, free of any Byzantine influences, but from the late 11th century onward, and coinciding with the First Crusade, wave after wave of Byzantine elements invaded the Romanesque style. Greek art of the 11th and 12th centuries was still ultimately based on the traditions of the late classical style, and the Byzantine influence on Romanesque art had the predominant effect of injecting it with classicizing forms and an understanding of the human body, its structure and movements. The drapery was not used as a camouflage but as a means of presenting the human figure in three-dimensional space. Basically, these tendencies were opposed to the essentially flat, abstract, decorative qualities of Romanesque art and much of the art of the 12th century mirrors the attempt to find a compromise between these two trends. It was the eventual victory of classicizing forms that led to the gradual disappearance of Romanesque art.

In spite of all the regional variations which undoubtedly exist in Romanesque architecture and the figurative arts, the Romanesque style has certain recognizable common features which justify the claim that it was an international art, in fact as international as the Roman church itself. One of the misconceptions about the conditions in 11th- and 12th-century Europe is that travel was too perilous and rarely undertaken, and that the life of most people was isolated. The truth is that in spite of all the perils (and some were certainly very real), contacts, even between distant countries, were frequent. "I have ten times passed the chain of the Alps," wrote John of Salisbury in 1159 and, being a scholar, he had less reason to travel than, for example, a merchant. Churchmen from all parts of Europe went on business to Rome and, being deeply concerned with church building and equipment, they would be particularly observant in artistic matters. The spread of Italian art forms throughout Europe was no doubt largely due to this incessant traffic of clergy going to Rome. Moreover, a journey to the papal curia was frequently combined with excursions to the famous shrines en route, and this had profound artistic consequences. In an age so deeply religious, so concerned with the salvation of souls, the indulgences given at various famous shrines to pious visitors was much valued. Going to Rome, it was worth making, for instance, a visit to Lucca to pray at the Volto Santo, the miraculous wooden crucifix, showing Christ in a long robe. Copies of this famous cult image were made in many countries; there is an 11th-century stone replica at Langford near Oxford, and another (perhaps of wood) is mentioned as having existed in Bury St. Edmunds. There is a large group of wooden copies in Catalonia and a 12th-century version, also in wood, in Brunswick Cathedral. Other famous Italian shrines were those of St. Nicholas at Bari and of St. Michael the Archangel on Monte Gargano.

Rome was, of course, the great attraction for such pious visits, on account of the shrines of Sts. Peter and Paul as well as the tombs of countless early martyrs in the catacombs. For pilgrimages, Rome was second in importance only to the holy places in Palestine and these, with the establishment of the Crusading Kingdom, became much easier so visit than in

previous centuries. The rewards for the pious pilgrim were manifold—not only the remission of sins, but the opportunity for obtaining relics, souvenirs, and other objects which, once brought home, could have important consequences in matters of style and iconography.

The pilgrimage which during the 11th and 12th centuries competed in importance with the pilgrimages to the Holy Land and Rome was to the shrine of St. James (Santiago) at Compostela and, from the point of view of artistic results, it was certainly as important as the other two. It was encouraged by the church and especially by the Templars and Cluny. Apart from the material benefits from pilgrim's offerings to the churches on the route to Santiago, many pilgrims would be potential recruits for the Christian armies, fighting the wars for the reconquest of Spain from Arab rule. Hospices and bridges were built by monasteries to help the pilgrims along the roads to Compostela. A celebrated pilgrims' guide, written in the first half of the 12th century, describes the four important routes through France, all of which joined south of the Pyrenees at Puente la Reina. The pilgrims were given details of the famous shrines worthy of a visit along these routes, as well as practical information about the character and customs of the inhabitants of the regions to be crossed. The Compostela pilgrimage was a long one, but it had many attractions. Not least among these were the *chansons de geste* sung by troubadors for the benefit of pilgrims and other travelers. Especially relevant to the Compostela pilgrims was the *Chanson de Roland*, with its account of the heroic fight of Christians against the followers of Islam. Many of the pilgrims would cross the Pyrenees through the valley of Roncevaux (Roncesvalles), the battlefield on which Roland, Oliver, and their knights perished. Many would have visited Blaye with its tomb of St. Roland and Bordeaux where his famous Olifant (horn) was kept as a relic, and Belin, where Oliver was buried. The legendary deeds would thus become alive. The Crusades and the Spanish war of reconquest were holy wars and the exploits of the heroes of the epic poems would inspire 12th-century people to follow their example.

The results of the Compostela pilgrimages were of great importance for the spread of artistic forms throughout Europe. Not only was there a particular type of "pilgrimage" church to be found along the route to Compostela, at Limoges, Conques, and Toulouse, not only did the sculpture of Toulouse and Compostela have a remarkable similarity, but the artists and craftsmen who were among the pilgrims retained memories of buildings and objects which had impressed them, and which could be at any point on the route, and on their return home they made use of them in their works. In one concrete case, it is, for instance, possible to demonstrate that, as a result of a documented pilgrimage from England to Compostela about 1135, a very original school of sculpture came into being in the west of England, on the border with Wales, in which motifs derived from Parthenay-le-Vieux, Aulnay-de-Saintonge, Bordeaux, and Santiago de Compostela itself are frequently used. The international character of Romanesque art was due to many causes — to the similar spiritual needs of all peoples, to the unifying influence of the church and the monastic orders, but also to the constant exchange of artistic ideas between distant centers, due to travel and especially to pilgrimages. Romanesque art knew no frontiers or national barriers; it was truly the art of the Christian West.

ARCHITECTURE

It is sometimes said that there is no such thing as a Romanesque style of architecture. And it is quite true that, for instance, the cathedral of Pisa *(Ill. 45)* and the Norman abbey of St-Étienne at Caen *(15, 17)*, which were founded within one year of each other (1063 and 1064), have, at first glance, nothing in common. The great differences that exist in the plans, in the internal and external elevations, in the spatial compositions, and in the decorative details of Romanesque buildings are undeniable. But in spite of their endless variety, Romanesque buildings can be recognized at once as such by their stylistic features.

The 11th and 12th centuries witnessed an almost feverish building activity throughout Western Europe. The period was a highly experimental one during which new building techniques and designs were tried. In their search for improvements, the builders turned to such structures as were likely to teach them something useful—to surviving churches and even to the monuments of antiquity, which had the prestige of the glorious Roman past as well as technical excellence. Their indebtedness to past styles varied enormously. The architect of Pisa Cathedral knew well Early Christian basilicas of which there were and still are numerous examples in Italy, while the builder of St-Étienne at Caen did not have the advantage of such models in his region. But he must have known northern Carolingian churches with their stress on the towered western complex. Yet certain general aims and features are common to most Romanesque buildings.

Generally speaking, the plans of Romanesque buildings were not new. They followed the tradition of three-aisled basilicas with or without a transept, with an eastern apse, and, in German lands, often with a western apse and transept as well. Centrally planned churches, though on the whole rare *(30)*, also had early prototypes in such buildings as the Pantheon, the Holy Sepulcher in Jerusalem, S. Vitale in Ravenna, or the Palatine Chapel at Aachen, to name only the most famous. What was new in Romanesque churches was the development of the eastern end, the choir. Whether through the grouping of staggered apses, or through an ambulatory with a cluster of radiating chapels, the eastern part of the church was given an emphasis unknown before. There were many reasons for this: the monastic, and especially Cluniac, reforms required large choirs for the enriched liturgy; the display of relics in shrines behind the high altar instead of the older custom of keeping them in crypts; the increasing popularity of pilgrimages and the necessity of providing suitable arrangements for the unimpeded circulation of crowds around the shrines with relics. Crypts, which in the past were small and dark, became like large underground churches *(31)*.

The complexity of the east end of the church also involved new solutions in designing transepts, from which project apses, often of differing depth. Occasionally, transepts repeat the form of the choir, producing the trefoil arrangement *(22, 23)*.

The interiors of Early Christian basilicas were characterized by a rhythmical succession of columns separating the nave from the aisles. In Romanesque churches, this method was not entirely abandoned, but new solutions were invented and widely followed. These involved alternating supports, such as columns and piers in repetitive groupings. Thus, the continuous space was divided into units. A pilaster or half-column attached to a pier was

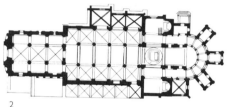

1

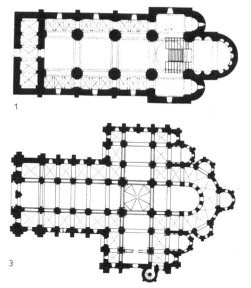

3

in 11th century on earlier crypt. Three-aisled nave, transept with two apses and two-storey narthex, chiefly early 11th century.

3 ABBEY OF STE-FOY, CONQUES. 11th and 12th centuries. Church of pilgrimage type. Wide nave, flanked by aisles continued around transept and choir. Similar plan: St-Martin, Tours; St-Martial, Limoges (both destroyed); St-Sernin, Toulouse; and Santiago de Compostela.

4 CATHEDRAL, SANTIAGO DE COMPOSTELA. Longitudinal section of church as existed in 12th century (after Conant). Main entrance through late 12th-century narthex, flanked by two towers and standing on western crypt. Vast nave has gallery and barrel vaulting. Transept with aisles surmounted by tower at crossing. Twin doorways lead to each transept, of which only southern survives (see *125*). Spacious choir has ambulatory and radiating chapels.

5 S. VICENTE, CARDONA. Exterior of main apse showing vertical pilasters, arches under eaves of roof, and "blind windows," all characteristic of First Romanesque.

1 S. VICENTE, CARDONA. 1020–40. Plan of collegiate church, example of "First Romanesque" architecture in Catalonia. Nave has barrel vault with transverse arches and aisles have groin vaults. Dome over crossing. Each transept arm has apse, and choir ends in large apse with tall internal niches. Clerestory windows give direct light to nave.

2 ABBEY OF ST. PHILIBERT, TOURNUS. Late-10th, 11th, and 12th centuries. Choir with ambulatory and five radiating chapels built

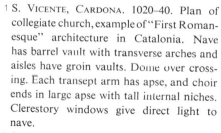

4

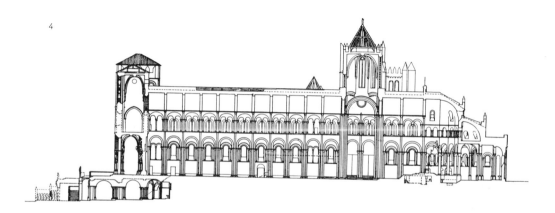

6 S. Vicente, Cardona. Interior showing dome and barrel-vaulted choir.

7 St-Philibert, Tournus. Interior of nave toward east. Highly developed First Romanesque church in Burgundy of early 11th century with some portions surviving from late 10th century and substantial 12th-century additions. Huge cylindrical pillars carry applied colonettes and diaphragm arches between which are barrel vaults, placed across axis of nave. Early 12th-century imitation of early 11th-century vault in the narthex. Other types of vault include groin vaults and half-barrel vaults. Two-towered façade and crossing tower found here became standard features of large Burgundian Romanesque buildings.

8 Ste-Foy, Conques. Interior toward east. As in other pilgrimage churches of this group, elevation includes large triforium galleries. No clerestory windows; light provided by windows of aisles and galleries. Barrel vaults reinforced by transverse arches supported by semi-columns, which also provide articulation of walls. Over crossing, dome on squinches, which contain figure sculpture.

9 St-Philibert, Tournus. Longitudinal section. Church, vaulted throughout, largely first half 11th century. Towers heightened in 12th century.

10 Cathedral, Santiago de Compostela. Interior of transept from south to north. Similar to Conques but built on much larger scale. Started c.1078, church was largely finished by c.1140. Transept completed by end of 11th century.

11 Ste-Foy, Conques. Exterior from northeast. Modest church built under Abbot Odolric (d.1065) enlarged and extended under Abbot Bego III (d.1107). Western towers 19th-century additions. Harmonious grouping of forms crowned by octagonal crossing tower.

12 Fontévrault Abbey. Nave toward east. Founded end 11th century as monastery for monks and nuns. East end with ambulatory and transept ready by 1119. Then, wide single nave of four bays erected, each bay surmounted by dome on pendentives (part-ly reconstructed in 1910). This feature introduced c.1100, probably from Cyprus. About eighty domed churches built during 12th century in western France. (See also 21 and 61.)

13 Abbey, St-Savin-sur-Gartempe. Nave toward east, c.1100. Very tall and heavy cylindrical columns support barrel vaults without transverse arches. Aisles of almost same height as nave.

14 Priory Church, Paray-le-Monial. Interior of nave toward west, c.1100. Built under auspices of Abbot St. Hugh of Cluny. Was modest imitation of Cluny, then under construction (so-called Cluny III; see 19 and 20). In common with Cluny, pointed arch used in nave arcade and vaulting. Classical-inspired fluted pilasters also found in both buildings.

15 St-Étienne Abbey (Abbaye aux Hommes), Caen. Interior of nave toward east. Founded in 1064 by Duke William, shortly afterward King William the Conqueror of England. Three-storey elevation (nave arcade, triforium gallery, clerestory with wall passage) normal in 11th-century Normandy. Sexpartite rib vaulting added c.1120 to replace original timber ceiling.

16 Priory Church, Paray-le-Monial. Choir and transept from northeast. Grouping of forms such as radiating chapels, ambulatory, apse, gable of choir, and crossing tower is direct imitation of Cluny III (see 19). Paray-le-Monial far more modest in size and design: three chapels while Cluny had five, one transept against Cluny's two, and nave short, of three bays only.

17 St-Étienne Abbey, Caen. West front, c.1070 and 12th century. Massive two-towered façade with heavy buttresses, monumental in effect and rational in design. Had profound influence on design of early Gothic façades.

18 Notre-Dame-la-Grande, Poitiers. West façade of collegiate church, second quarter of 12th century. One of most lavishly decorated screen façades of Poitou. Every available surface covered with reliefs and even masonry consists of blocks of stone cut in ornamental way.

5 ▷

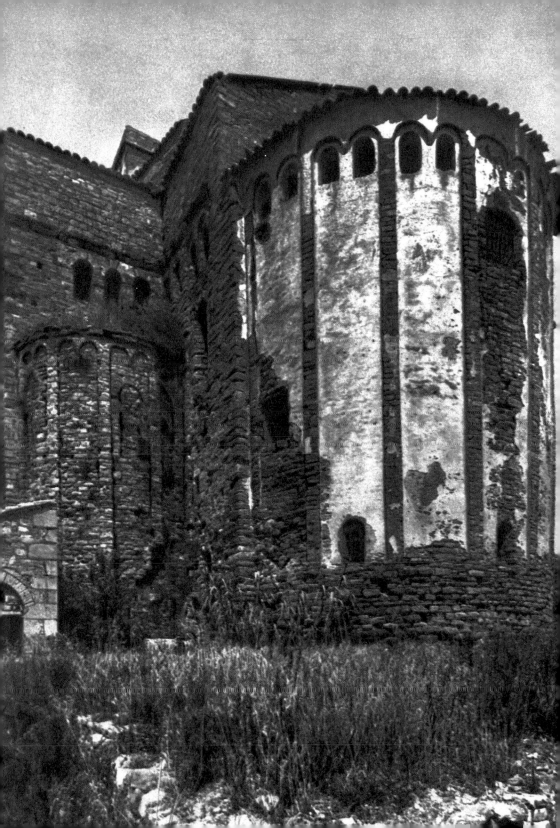

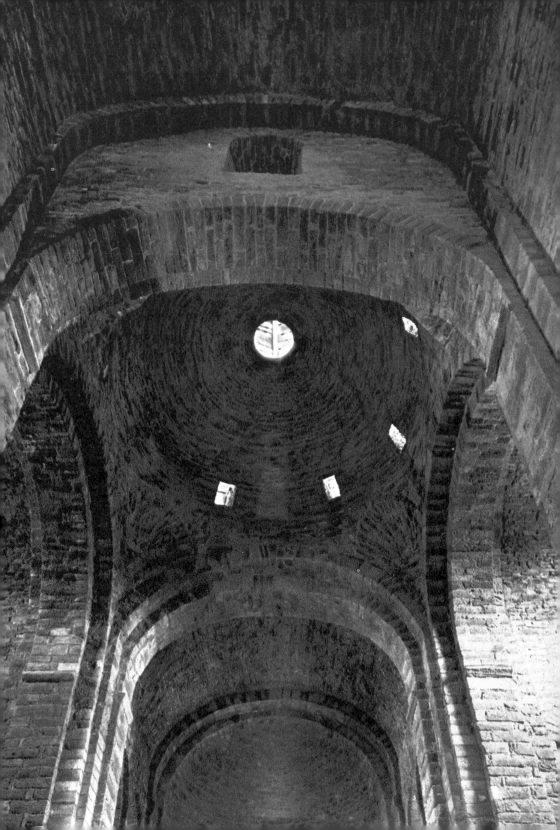

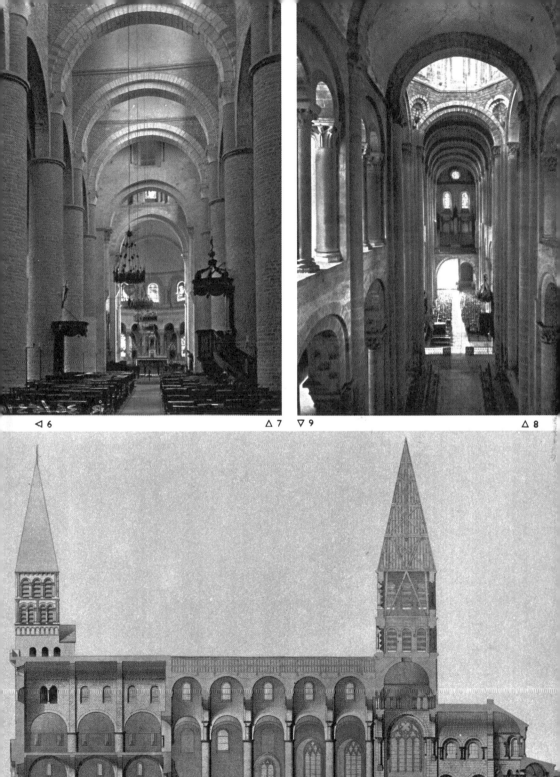

◁ 6 △ 7 ▽ 9 △ 8

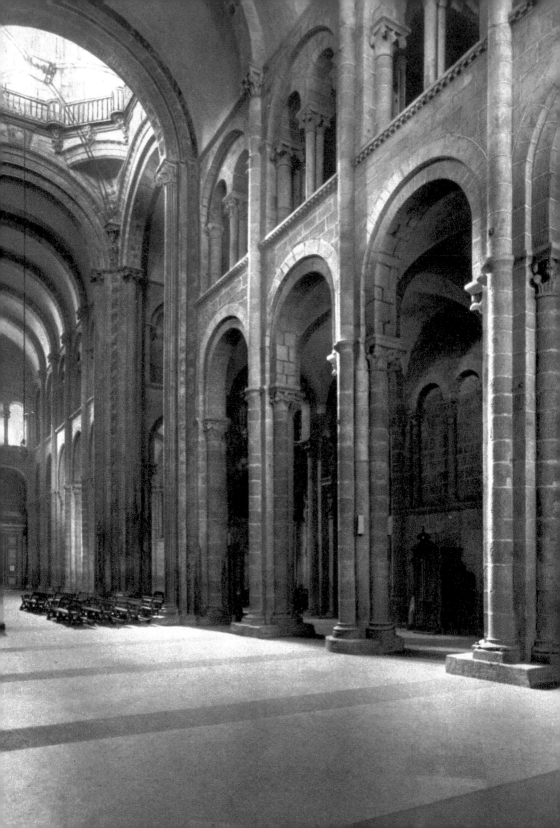

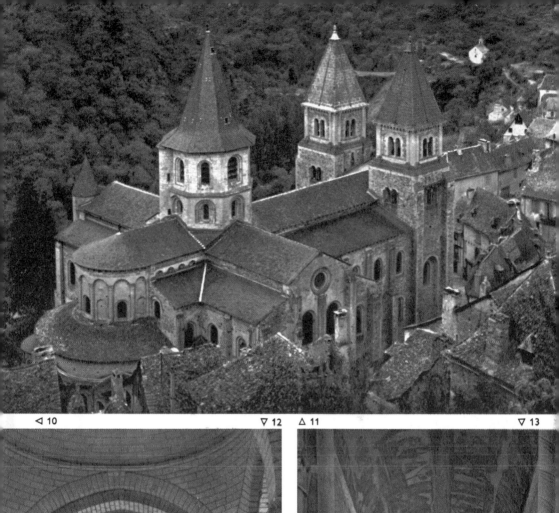

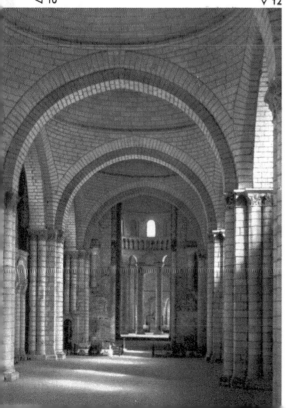

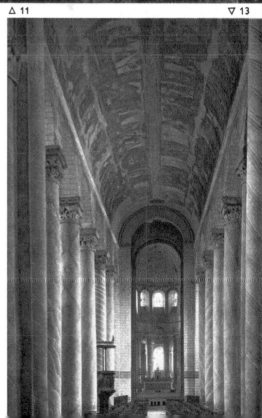

◁ 10 ▽ 12 △ 11 ▽ 13

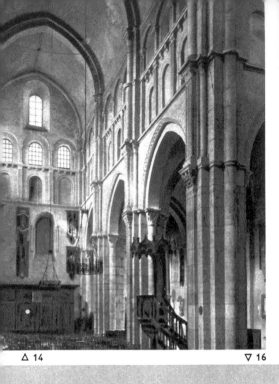

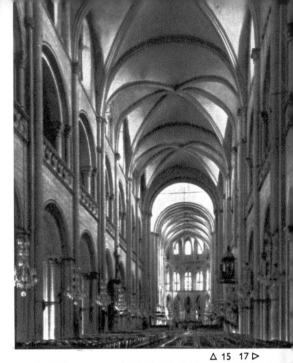

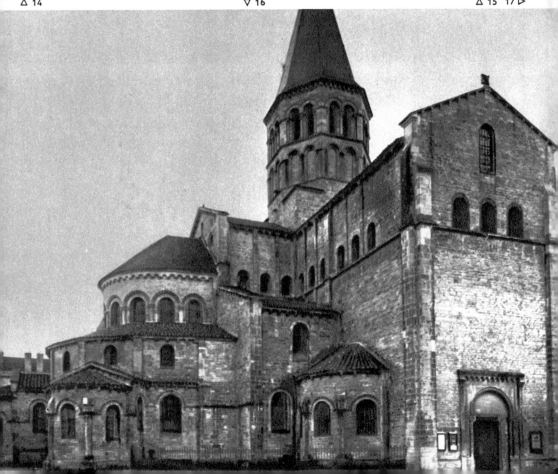

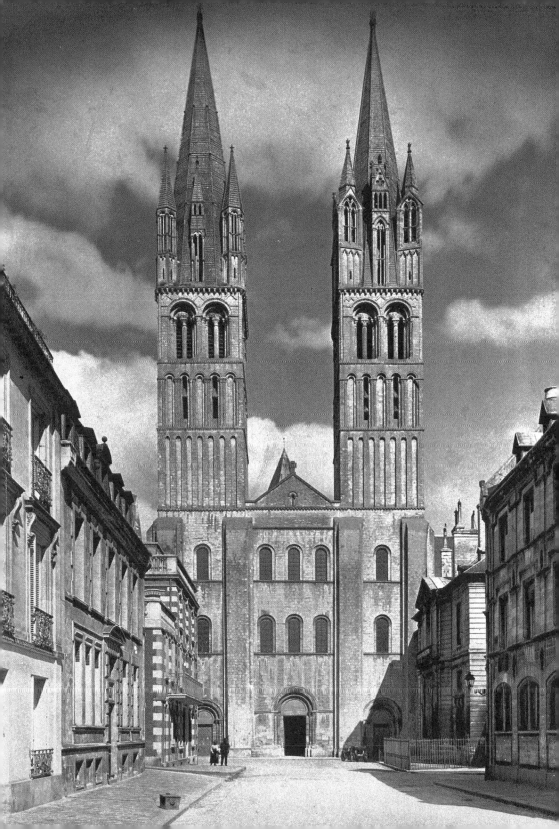

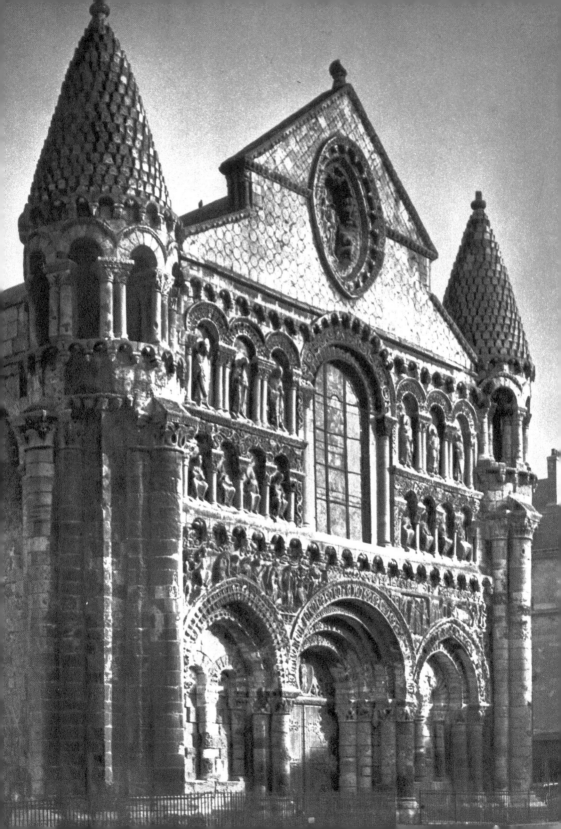

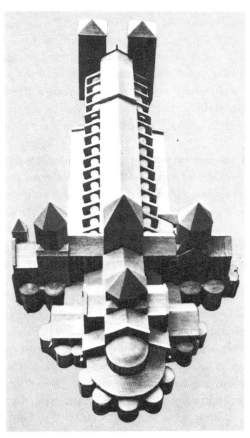

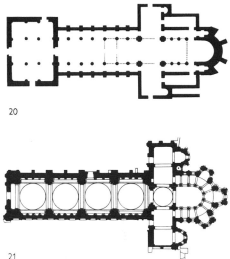

century was largest church in Christendom. Enormous choir with ambulatory and five radiating chapels. Two transepts, minor with two apses and crossing tower, major with four apses and three towers. Long nave with double aisles. Long-aisled, two-storied narthex and two western towers. Only portion of minor transept survives.

19 ABBEY, CLUNY. Model of third church seen from east (after Conant). Started in 1088 by Abbot St. Hugh. When completed in 12th

20 ABBEY, CLUNY. Plan of second church, aptly described by Conant as learned blending of centrally-planned building (apse, choir, minor transept) with basilican one.

21 ABBEY, FONTÉVRAULT. Plan of church. Conventional east end with ambulatory; single nave of four bays covered by domes.

extended upward emphasizing this division. Closely linked with these innovations were vaults. Many Romanesque churches had only semi-domes over apses and barrel or groin vaults over aisles. The technical problems involved in vaulting wide spans of naves were numerous, and many builders admitted defeat by covering them with timber ceilings. The problem was urgent, for fire was a constant menace, so numerous experiments were made to try to overcome the difficulties.

The most frequently used because the easiest to construct was barrel vaulting, in some regions (Burgundy, Provence) pointed *(27)*, often reinforced with transverse arches *(7)*, which would link with the semi-columns or pilasters dividing the bays and thus complete the division of space into compact units. Groin vaults result from the intersection of two barrel vaults at right angles, and have the advantage of directing the stress to four points, being thus particularly suitable for rectangular bays. In addition, this system made it easy to

◁ 18

place clerestory windows in the upper wall of the nave. By the invention of rib vaulting, which was a logical outcome of the groin vault through constructing stone arches at their intersection, the ground was prepared for further revolutionary changes and for the evolution of Gothic architecture. At the crossing, that is, where the nave and the transept meet, it became usual to build a tower which was resting, toward the interior, on a dome supported by squinches (if the tower was octagonal) or on pendentives (if it was square) *(9, 11, 16, 19)*. A series of domes was occasionally used to vault the nave, as in a group of 12th-century churches in western France *(12)*.

The preoccupation with vaulting problems was not peculiar to any one region, though the earliest experiments were made by the builders of the so-called First Romanesque churches in Lombardy. This distinctive group of churches found in the regions from northern Italy to Catalonia, up the Rhone valley and the Rhine, to the Low Countries, was built from the end of the 9th century to the first half of the 11th [Cardona in Catalonia *(1, 5, 6)*, Tournus in Burgundy *(2, 7, 9)*]. In all churches of this type, besides certain decorative features such as the so-called Lombard arches and pilasters, there was a strong interest in finding a solution to the vaulting problem. Tournus Abbey is a striking example, for there, three different types of vaults were employed, as if to test them all *(9)*.

The groin vaulting of the nave of Speyer Cathedral made at the end of the 11th century, soon followed by similar achievements at Mainz and at Maria Laach *(23)*, demonstrate well how widespread was the preoccupation with this most urgent and difficult problem. The use of the rib vault in some Romanesque buildings in Lombardy probably goes back to the middle of the 11th century, but this was only a local experiment which was not followed up, and thus remained isolated and no more than an architectural curiosity. The Anglo-Norman invention of the rib vault (for there is no evidence that it was in any way indebted to Lombardy) was, on the other hand, the beginning of one of the most fruitful developments in medieval architecture.

The vaulting, though its primary aim was to make the building safer, helped considerably in the spatial composition. By the use of transverse arches, the articulation of bays was more complete. The space within a Romanesque church is defined by masonry that is orderly and well defined, with rational, rhythmical accents. In addition to the vertical division of bays, the interiors were articulated horizontally by imposts and string-courses, giving the reassuring impression of orderliness and harmony.

This masonry, in the early period, was of rubble, but soon ashlar became widely used. The technical improvements were rapid and, by the 12th century, the mastery of working in all types of stone, including marble and granite, was truly astonishing. At times, the masons cut the stones into fanciful shapes, fitting them together perfectly, as a means of decoration. But more important was the care with which the arcades, the galleries, the doorways, and the windows were articulated by means of moldings. These features, which were at first simply hollows in the masonry, were given a variety of subtle shapes and invested with ornamental functions.

On the exterior, two parts of the building were given special emphasis, the east end and the façade. Except for the group of German churches with apsidal terminations at both the

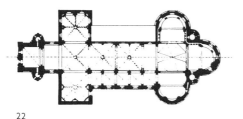

22

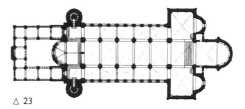

△ 23

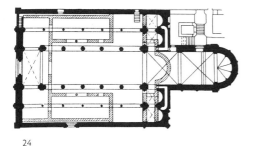

24

▽ 25

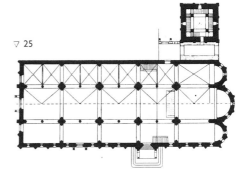

22 CHURCH OF HOLY APOSTLES, COLOGNE.
Plan. Trefoil plan adopted in Rhineland
c. 1040 at St. Maria im Kapitol, Cologne.
Plan of Holy Apostles (c. 1190) simplified
version of it, omitting ambulatory. Massive
square west tower, octagonal crossing
tower, and two stair turrets flanking eastern
apse.

23 ABBEY, MARIA LAACH. Plan. Founded 1093,
completed 1156, though subsequently (after
1170) east choir rebuilt and, between 1220
and 1230, present atrium added. Double
apses (toward east and west) and two tran-
septs. Six towers.

24 S. ABBONDIO, COMO. Plan, Started 1060s;
dedicated 1095. Five-aisled basilican church
without transept and choir ending in apse.
Two chapels flank choir, each with apse in
thickness of wall. Above these, tall square
towers.

25 MODENA, CATHEDRAL. Plan, Started 1099
by architect Lanfranc, ready c. 1120. Nave
of four bays with alternating system of sup-
ports, Transept does not project beyond
body of church. Three-apse east end. To
north of transept is free-standing campa-
nile. Church built of bricks with ashlar for
exterior of walls.

26 ABBEY, FONTENAY. Plan of church and con-
ventual buildings. Founded as Cistercian

monastery by St. Bernard in 1119. Existing
church, built between 1139 and 1149, ear-
liest surviving Cistercian building in France.
Rectangular east end typical of Cister-
cian churches. Large cloister with monastic
buildings around it. Over seventy Cistercian
churches of same design were built.

27 ABBEY, FONTENAY. Nave toward west.
Pointed barrel vault with transverse arches
influenced by earlier Cluniac buildings in
Burgundy. General character more akin
to early Gothic than Cluniac architecture.

28 ST-ÉTIENNE, BEAUVAIS. North transept.
c. 1140. Enriched high Romanesque ex-
terior with diaper gable, and rose window
in form of Wheel of Fortune, with figures in
relief, rising and falling.

29 ST-TROPHIME CATHEDRAL, ARLES. Porch of
west façade, c. 1170. Porch, applied to a
plain wall, stands out by its elaborate sculp-
tural enrichment, inspired ultimately by
classical models.

30 SPEYER CATHEDRAL. Main apse and choir
from east. Imperial cathedral first built
c. 1030, under Conrad II. Reconstructed
under Henry IV 1082–1106, when east end
received present form. In lowest part are
windows of crypt. Tall blind arcades above
enclose apse windows and higher still,
Lombard-inspired open gallery (*Zwerg-*

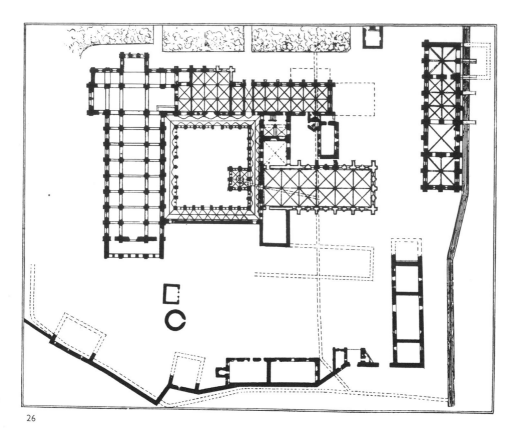

26

galerie), which continues around whole building. Gable modern reconstruction. Square towers flank choir.

31 SPEYER CATHEDRAL. Crypt under choir and apse, view toward east. Built c. 1030, under entire transept and choir. Groin vaults with arches, constructed of two types of stone to achieve color contrast, rest on twenty freestanding columns with heavy cubic capitals.

32 OUR LADY, MAASTRICHT. West front, early 11th and mid-12th century. Tall *Westwerk* flanked by two turrets. Clear affinity between this building and 12th-century *Westwerke* at, for instance, Maria Laach (see *35*).

33 CHURCH OF THE HOLY APOSTLES, COLOGNE. East end c. 1190. Trefoil arrangement of choir and transept, combined with choir towers, as at Speyer, and with arcading of Italian inspiration.

34 KÖNIGSLUTTER, COLLEGIATE CHURCH OF STS. PETER AND PAUL. From east. Staggered apses derived from Cluny II, but articulated

in Romanesque manner and richly decorated, particularly by means of arcaded corbel table.

35 ABBEY, MARIA LAACH. *Westwerk* with three towers, first half 12th century, atrium 1220–30. Traditional Carolingian and Ottonian forms modified by Romanesque enrichments.

36 CHURCH, CASALE MONFERRATO. View across narthex. First half 12th century. Use of rib vaulting, with two pairs of parallel ribs intersecting under right angles and spanning wide space, influenced by Muslim buildings.

37 S. ABBONDIO, COMO. View from west. 1063–95. Five-aisled design reflected by "stepped" form of façade, divided into five bays by buttresses with applied shafts.

38 S. ABBONDIO, COMO. Interior toward east. Huge cylindrical piers with cubic capitals support wooden ceiling; rib vaulting in sanctuary and apse.

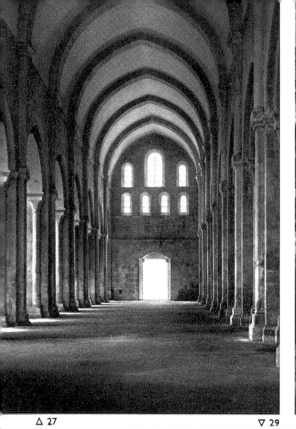

△ 27

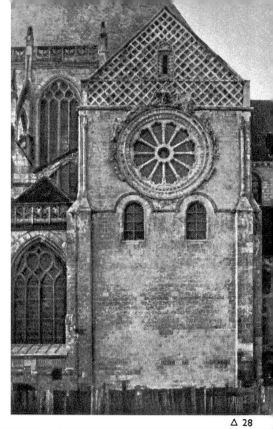

△ 28

▽ 29

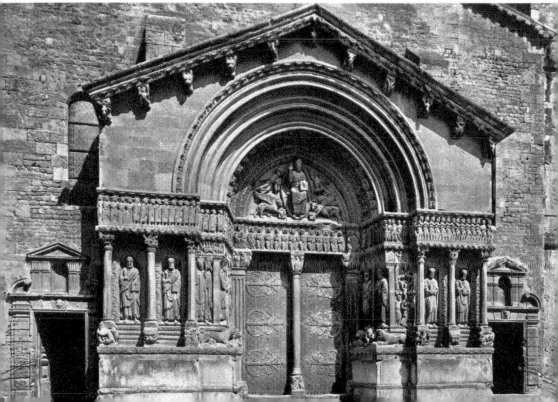

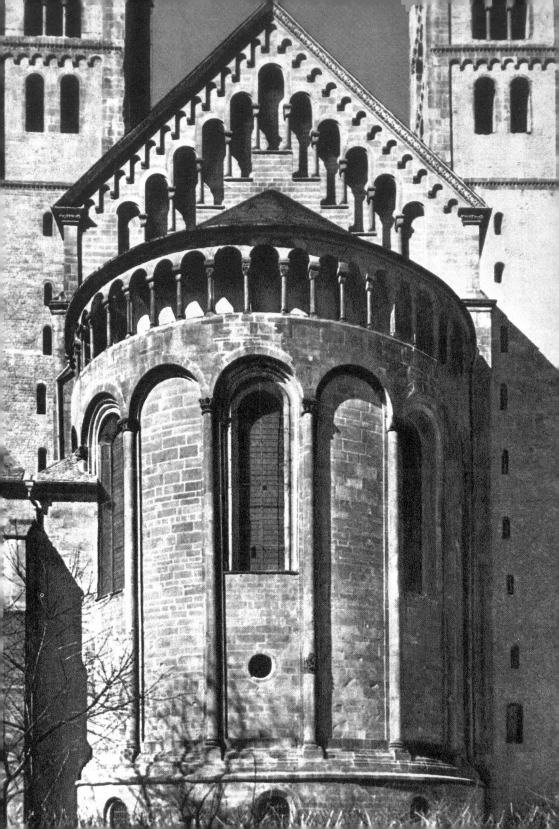

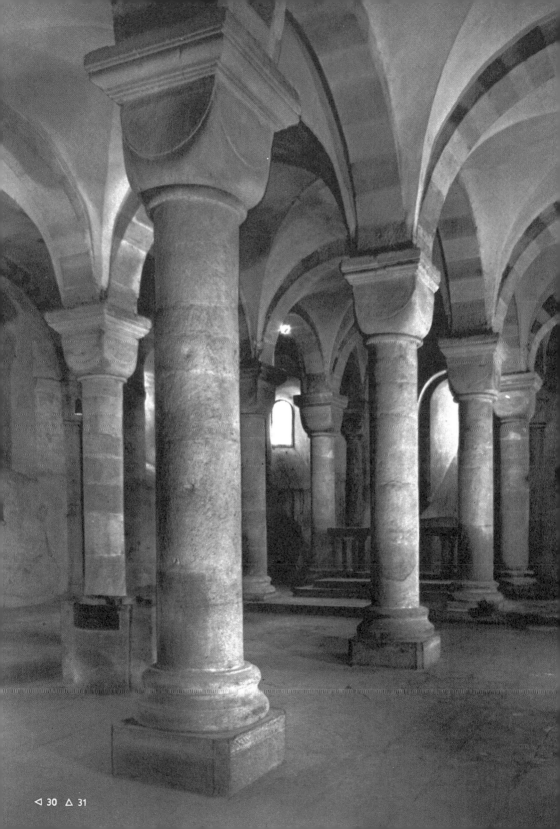

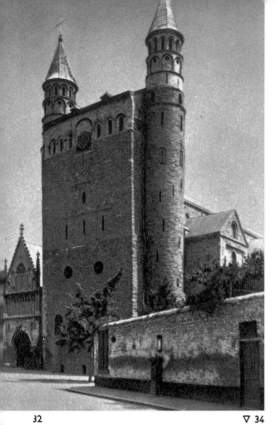

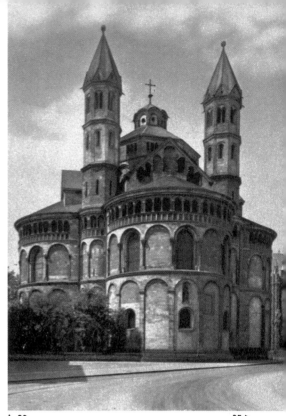

32 ▽ 34 △ 33 35 ▷

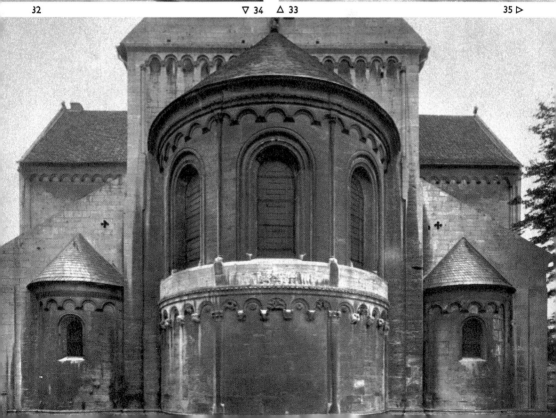

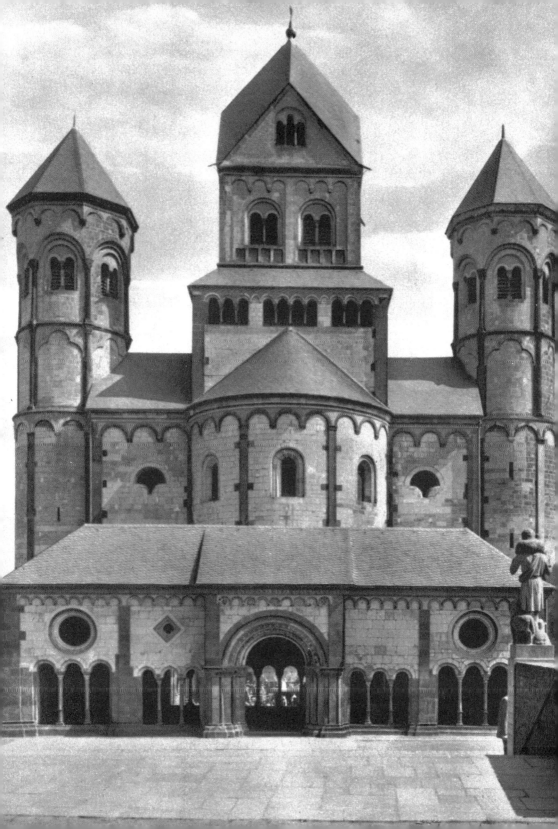

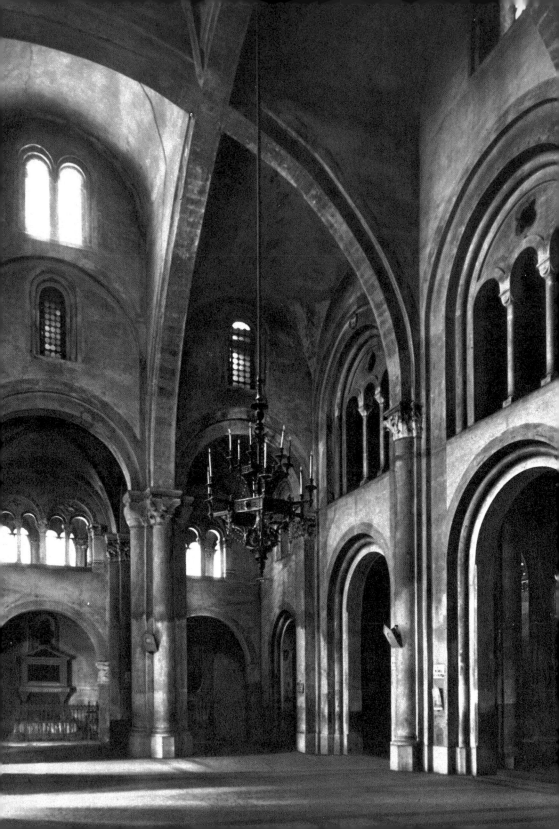

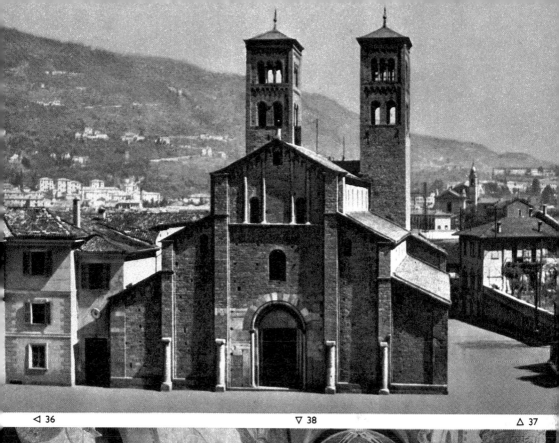

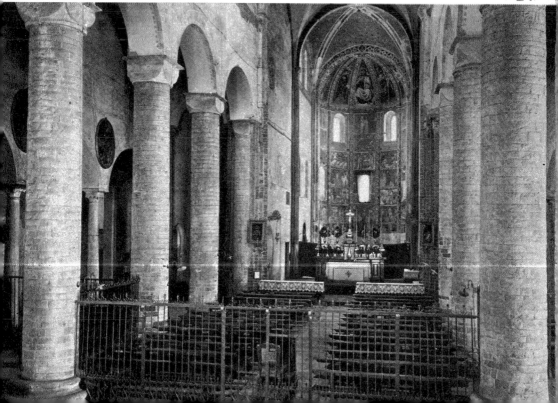

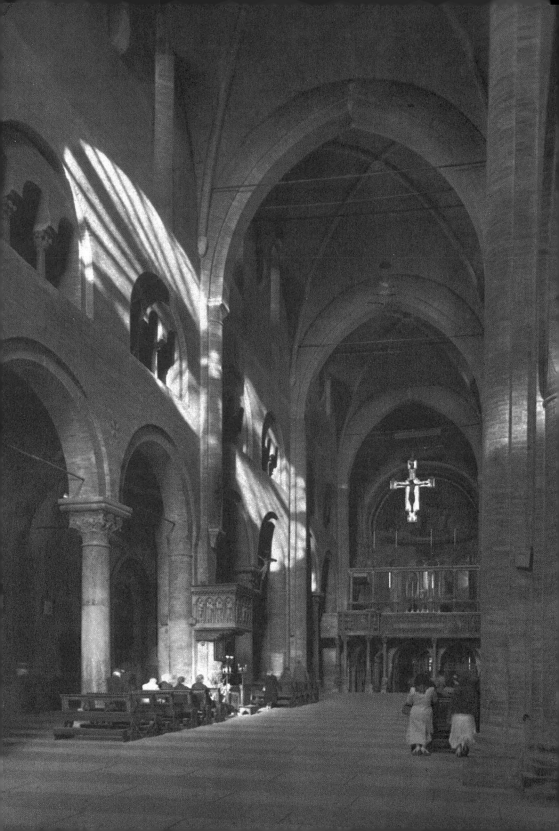

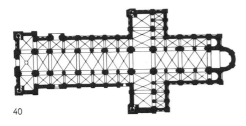

40

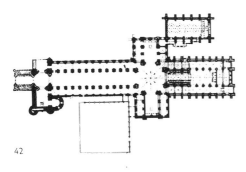

42

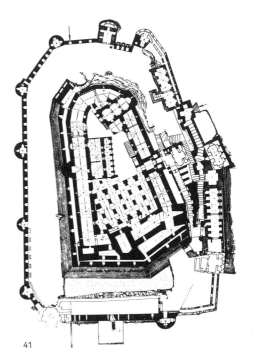

41

39 MODENA CATHEDRAL. Interior of nave toward east. Early 12th century. Brick structure with alternating supports carrying false gallery of triple openings and clerestory, looking superficially Norman. Pointed transverse arches supported wooden ceiling, replaced by vaulting in 15th century.

40 DURHAM CATHEDRAL. Plan. Choir started 1093, finished 1104, and nave by 1133. Three-apsed east end destroyed in 13th-century enlargement of choir. Narthex added late in 12th century. Alternating system of supports used throughout. Two western towers and one over crossing. First entirely rib-vaulted church in Europe.

41 CASTLE, KRAK DES CHEVALIERS (Jordan). Plan. Mid-12th and 13th centuries. Built by Knights of St. John about middle of 12th century. Extensively rebuilt after earthquake of 1170, when outer curtain wall with towers constructed.

42 ELY CATHEDRAL. Plan. Benedictine abbey, cathedral since 1108, rebuilt between c. 1085 and 1140. Nave and transepts survive, but three-apsed choir enlarged in 13th century and crossing tower collapsed in 14th century. Western transept (north arm does not survive), with axial tower, added late in 12th century and porch in early 13th century.

east and west ends, there is no ambiguity about which is which. The rounded forms of the apses, whatever their arrangement, indicate that this is the east end and that behind their walls are altars and shrines. The roofs rise step by step, from apses to sanctuary, and are crowned by the mass of the central tower *(16, 19)*. As in the interior, here, too, unit is added to unit, forming a harmonious whole.

The west fronts vary in type. The basilican façades repeat the arrangement of the interior, as if they were a section made of solid masonry *(37, 43)*. The screen façades conceal what is inside and usually suggest that the church behind is larger than in fact it is *(18, 44)*. The tower façades consist most frequently of two towers flanking the main entrance *(17)*, but there are also churches with a single tower in the center of the façade, or with three towers

◁ 39

and even more. Since Carolingian times, multitowered churches were favored in Germany, and some spectacular Romanesque examples exist with as many as six—two at the crossings, two in the west front, and two flanking the choir.

Not all Romanesque churches were large abbeys and cathedrals. In fact, the majority were village churches of modest dimensions. Although their design and plan were less ambitious, they often reflect the form of some important church of the region which might have been subsequently rebuilt or destroyed.

From what has been said so far, it should be clear that Romanesque builders shared certain preoccupations and used in their buildings numerous common features. The liturgical needs were roughly the same in Spain, Germany, or Hungary, for example, and this had a unifying effect on architecture. Monastic connections and frequent travel, whether on pilgrimages, church business, political missions, or for trading purposes, resulted in the easy spread of artistic ideas. But in spite of all this, there were differences between countries or regions strong enough to distinguish national or regional building characteristics. There were numerous reasons for this—the availability of certain materials, strong local traditions, climatic conditions, and others. The timber churches of Scandinavia *(60)* were not a practical proposition in Italy and, on the other hand, the marble façades so frequent in Italy would have been out of the question in Norway. The soft and durable stone available in, say, western France and Normany was admirably suited to intricate moldings, while the granite in Brittany was not. But it would be wrong to attach too much importance to materials. Granite in Galicia, in northwestern Spain, was used even for sculpture, with admirable results. After their conquest of England, the Normans, until they discovered a suitable local stone, imported shiploads of stone from the quarries of Caen to build their enormous churches and castles. In Lombardy, stone was not difficult to obtain and yet brick was frequently preferred.

Nowhere can the influence of established tradition be more clearly demonstrated than in Germany. The two-apse plan and the grouping of towers, invented by Carolingian builders, persisted in Germany and decisively affected some of the most important buildings there in the 11th and 12th centuries. In fact, in countries with rich artistic traditions, above all in Italy, the link with the past remained strong throughout the Romanesque period. In northern and central Europe, on the other hand, where stone building was a comparatively new skill, the inspiration behind Romanesque buildings was to a large extent a foreign importation, with Germany, supplying models or transmitting them from other countries.

Regional schools of architecture emerged during the 11th century and blossomed in the 12th. At the beginning of the Romanesque period, in the first half of the 11th century, except for the First Romanesque type, which was particularly well established along the Mediterranean coast, there were as yet no definite schools. Certain important buildings exercised a considerable influence—for example, Cluny II, built in the 10th century—but political and economic conditions, though steadily improving, were not ripe for such a rapid development as occurred from about 1050 onward. This early period in Germany was of great importance, but since it rightly belongs to the Ottonian period, it is treated in Hans Holländer's book on early medieval art in this series.

To list all the regional schools of the Romanesque period would be a very lengthy task, and so only a few will be mentioned as examples. Of the Italian schools, the earliest, and one that had the greatest influence in and outside Italy, was that of Lombardy. Developed out of the First Romanesque during the 11th century, it evolved many outstanding features. Some, like rib vaulting *(38)*, was of local importance only; others such as the screen façade (as in Pavia, *44*), the trefoil plan (S. Fedele, Como), and the exterior covered galleries which evolved from the "Lombard arches," spread to other regions and countries. The screen façades of western France have obvious Lombard connections, while the trefoil plan and the exterior galleries were adopted by many builders in the Rhineland *(30, 33)*.

The neighboring province of Emilia contains a string of important Romanesque churches (Modena, *39*) with, what is unusual in Italy, three-storey elevations, and some with two-tower façades, and these exercised a widespread influence. They were easily accessible, being on the Via Emilia, the main road from the north to Rome. The Tuscan school, of which the main centers were Florence, Pisa, and Lucca (this last, an important pilgrimage center by virtue of the miraculous crucifix, the Volto Santo), was deeply influenced by classical traditions, which were blended with elements derived from Lombardy. The magnificent marble churches with arcading or inlaid polychrome facades are the most striking monuments of the school *(45, 46, 48)*.

In Rome, with its wealth of monuments of past ages, building was continued in a conservative manner, and in the history of Romanesque architecture, as later in the Gothic, is of no great importance. Its greatest contribution during this period was in the field of monumental painting.

The South was brought into the orbit of Romanesque art as a result of the Norman conquest of the mainland, accomplished during the second quarter of the 11th century, with Sicily following suit a little later. The peculiar circumstances there—the long political and artistic connections with Byzantium and the Arab occupation of Sicily, the lively culture of the free trading cities of Naples, Amalfi, and others—provided a rich, cosmopolitan background for artistic life under Norman rule. The Romanesque architecture of Apulia especially, with Bari as its center, exhibits a blending of Norman, Lombard, Tuscan, and local elements. The church S. Nicola at Bari, built for the relics of the patron saint from 1089 onward, became an important pilgrimage center, and its influence on the development of local architecture and sculpture was overwhelming. The three-storied elevation of Modena Cathedral in Emilia *(39)* was influenced by S. Nicola and, as will be mentioned later,

43 S. ZENO MAGGIORE, VERONA. View from southwest. Earlier building enlarged and completed by 1138. Exterior dressed with marble. Stepped, basilican façade similar to that at Como (*37*), but far richer in decorative devices, such as blind arcading, corbel tables, rose window (late 12th century), and portal emphasized by porch.

44 S. MICHELE, PAVIA. West front. First quar-ter 12th century. All three bays under one gigantic arcaded gable with few windows, except in central bay. Three deeply recessed portals entirely covered with sculpture. Bands of reliefs across façade.

45 CATHEDRAL, BAPTISTERY, AND CAMPANILE, PISA. View from southwest. Cathedral of five-aisled basilican type started 1063; dedicated 1118. Nave extended westward and

completed c.1170. Baptistery started 1153 and campanile 1173, and both finished much later. Complex of marble buildings, using extensively blind arcadings as well as open galleries.

46 S. MINIATO AL MONTE, FLORENCE. West front. Church of Benedictine monks started 1018. Basilican façade covered with multicolored marble casing in mid-12th century. Color effect further emphasized by use of a mosaic above window.

47 MONREALE CATHEDRAL. Central and southern apses, 1174–82. This type of decoration was familiar to Normans from their country of origin, but immediate inspiration for rich polychrome decoration was Islamic.

48 S. MICHELE, LUCCA. West front, end of 12th century. Late example of Tuscan façade inspired by that of Pisa. Marble incrustations based on oriental textiles.

49 TROIA CATHEDRAL. West front. Lower storey started 1093, inspired by Pisa Cathedral. Upper storey with rose window c.1200.

50 S. TOMASO, ALMENNO SAN BARTOLOMEO. View from west. Late 11th century. Example of round Romanesque church in Lombardy. Central dome with lantern rests on eight columns. Gallery opening toward center. Exterior articulated by half-columns with cubic capitals, supporting arcades, reminiscent of First Romanesque.

51 ST. JOHN'S CHAPEL IN THE WHITE TOWER, LONDON. Interior toward east. Built by William the Conqueror, c.1080. Castle chapel, adjoining great hall, it formed part of main keep. Austere and massive structure, with barrel vaulting in nave and triforium and groin vaulting in aisles.

52 DURHAM CATHEDRAL. Nave toward east. Early 12th century. Ribbed vault, with transverse arches, rests on enormously massive walls and alternating compound and cylindrical piers. Under roof of aisles are semi-arches abutting vaulting. Extensive use of chevron ornament on ribs, arches, and columns.

53 ELY CATHEDRAL. North side of nave, from east. First forty years of 12th century. Unlike Durham, nave not intended to be vaulted, and tall shafts merely articulate walls.

54 ABBEY, TEWKESBURY. South side of nave, toward east. Started c.1087 and completed early in 12th century, vaults added in 14th century. Very tall cylindrical piers and low wall passage with clerestory above. In transept and choir were galleries on arches spanned between piers, thus producing four-storey elevation.

55 TOURNAI CATHEDRAL. Nave toward east, first quarter of 12th century. Four-storey elevation with emphatic stress on horizontal rows of arches. Original ceiling of timber. Trefoil east end early Gothic.

56 PREMONSTRATENSIAN ABBEY, JERICHOW. View from northeast, third quarter of 12th century. Earliest Romanesque brick building north of Alps, influenced by Lombardy, where this material was used since Roman times.

57 KALUNDBORG CATHEDRAL (Denmark). View from northeast. Started c.1170, built entirely of brick. Centrally planned church with five octagonal towers. (See 65.)

58 SVATY JAKUB, KUTNA HORA (Czechoslovakia). Church of St. James, from south, c.1165. Single nave and tower, richly decorated with sculpture, typical of late Romanesque village churches in many parts of Europe.

59 ST. PROCOPIUS, STRZELNO (Poland). View from northwest. Built of granite, c.1160, it consists of round nave with two apses on north side, rectangular sanctuary, and round west tower.

60 BORGUND. Stave church, from south, c.1175. One of large group of Norwegian timber churches constructed of flagpoles bound together and roofed with shingle.

61 FONTÉVRAULT ABBEY. Kitchen, mid-12th-century (restored). Built on octagonal plan with apses at each side. Each apse contains fireplace and is covered with conical roof with perforated chimney. More chimneys at base of central pyramidal roof and one at very top.

62 CASTLE KEEP, CONISBOROUGH. 1180–90. Round with heavy buttresses topped by turrets, it contained well, storerooms, great chamber, chapel, retiring room, and bedchamber. Turrets used as cisterns for water; one was an oven and one a pigeon loft.

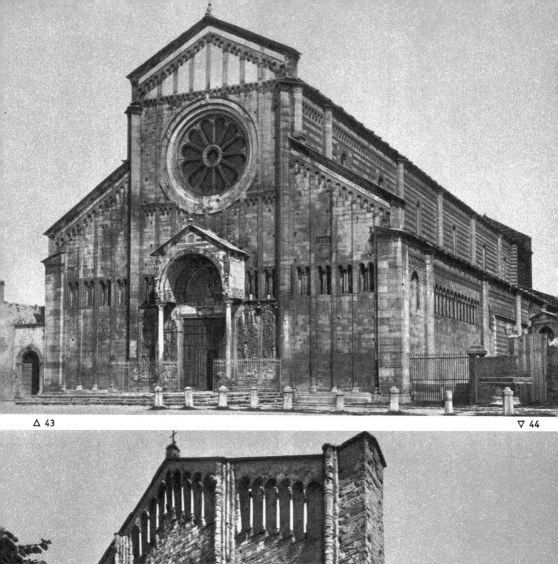

△ 43

▽ 44

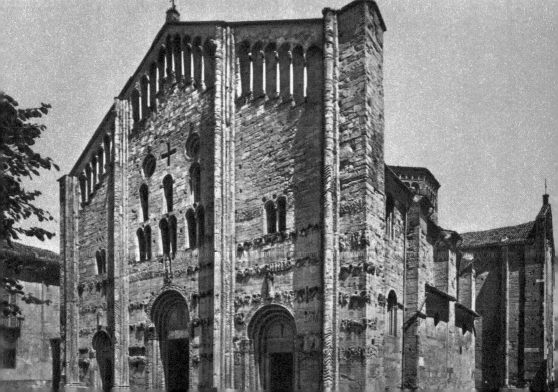

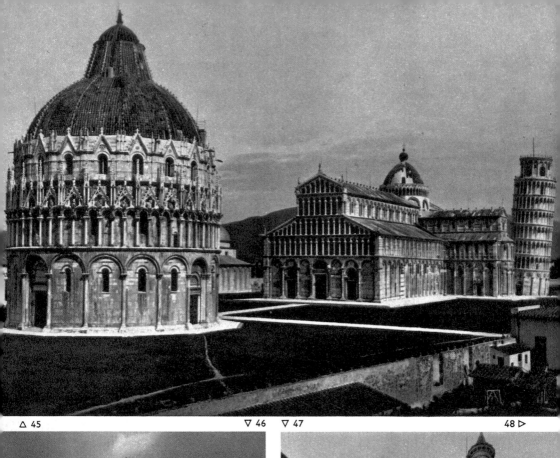

△ 45 ▽ 46 ▽ 47 48 ▷

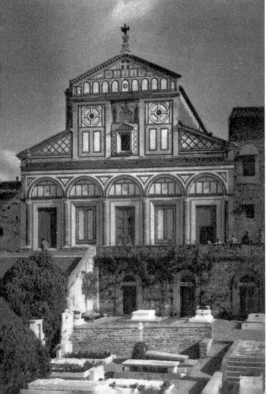

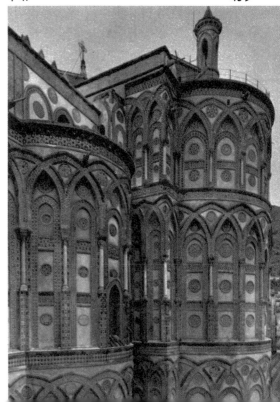

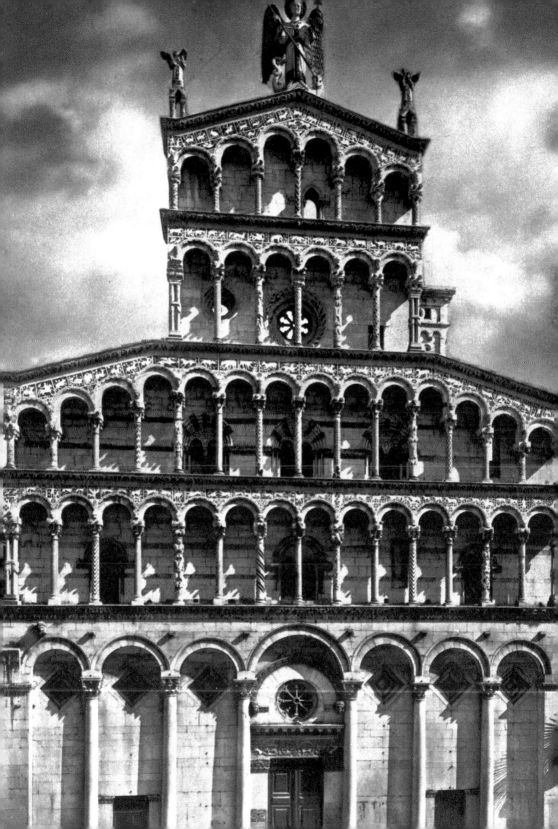

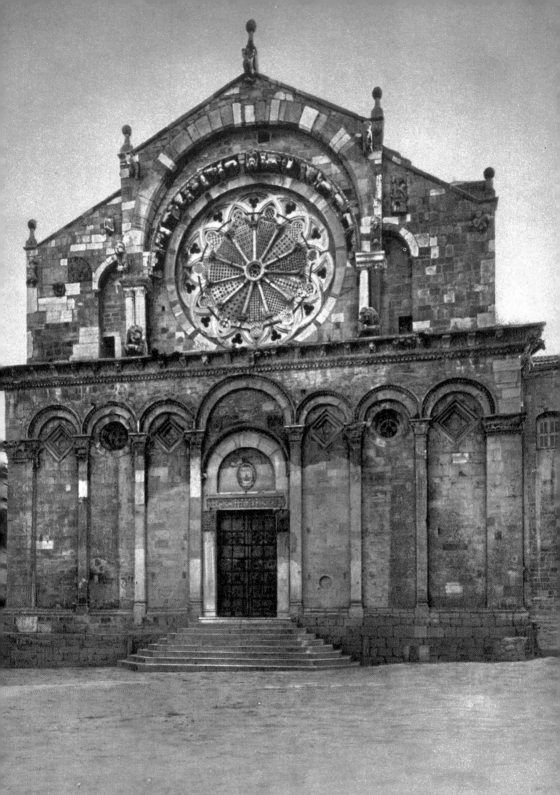

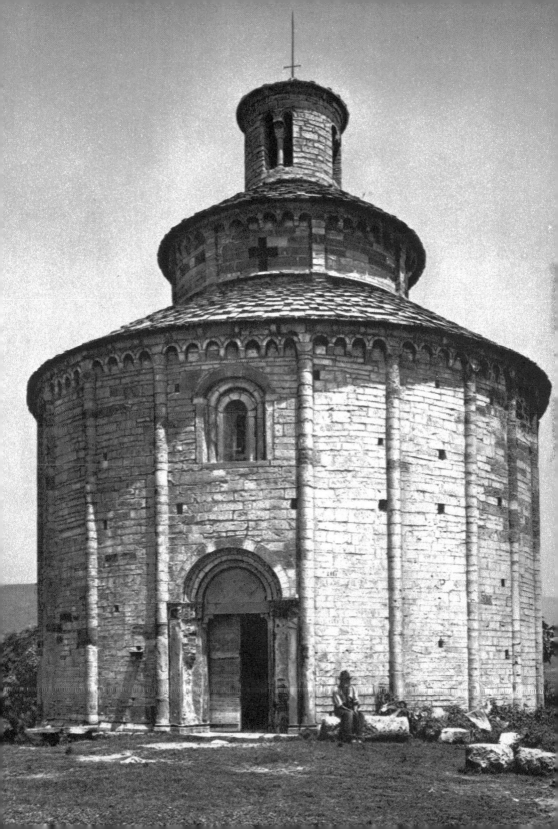

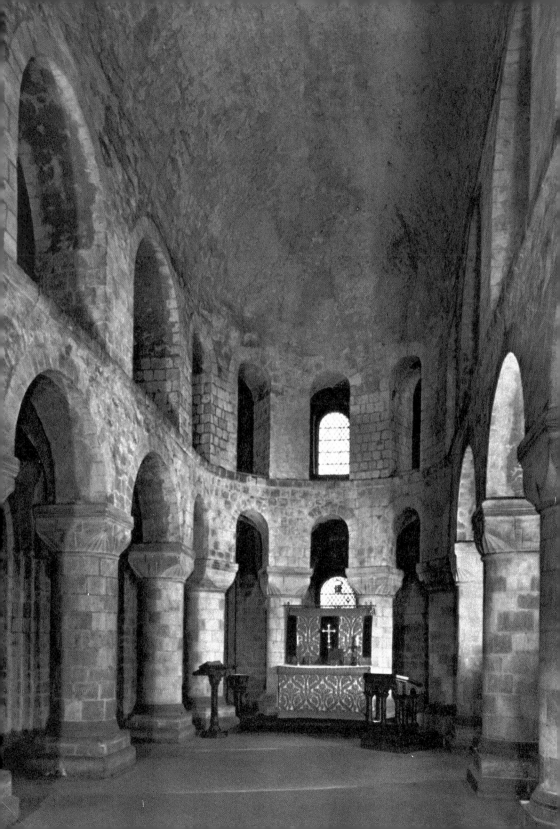

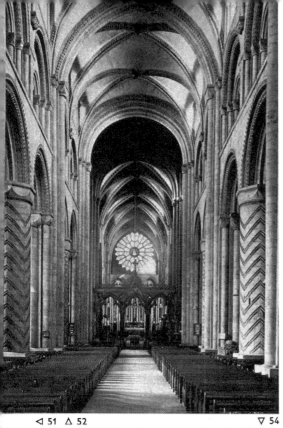

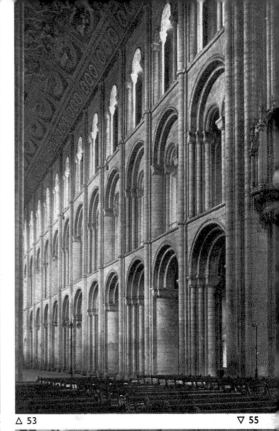

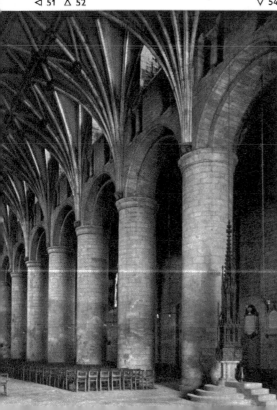

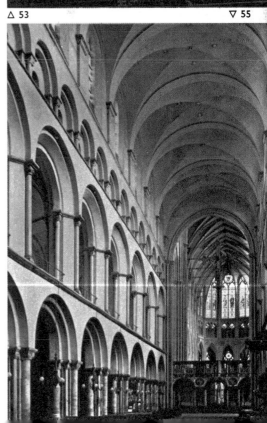

◁ 51 △ 52 ▽ 54 △ 53 ▽ 55

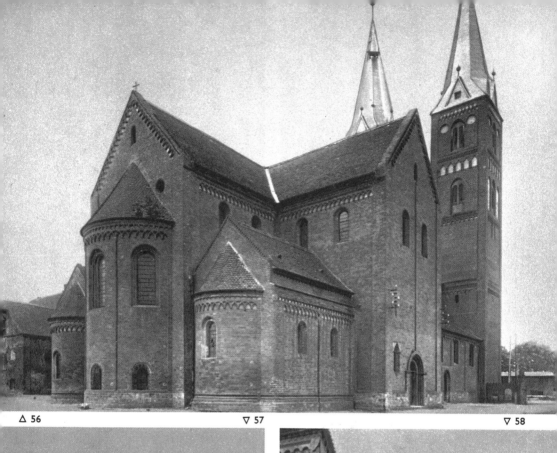

△ 56 ▽ 57 ▽ 58

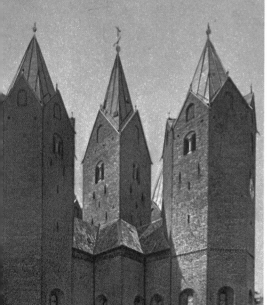

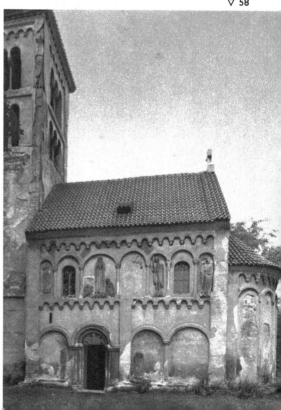

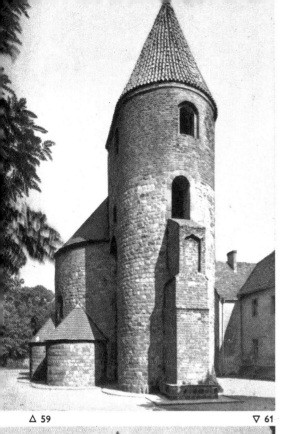

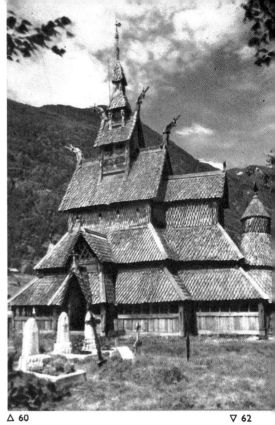

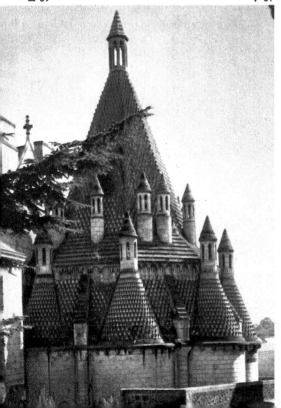

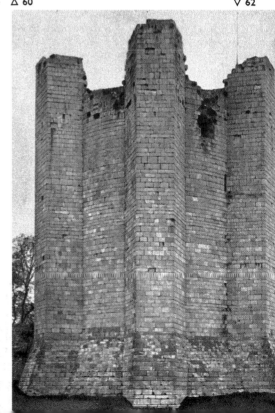

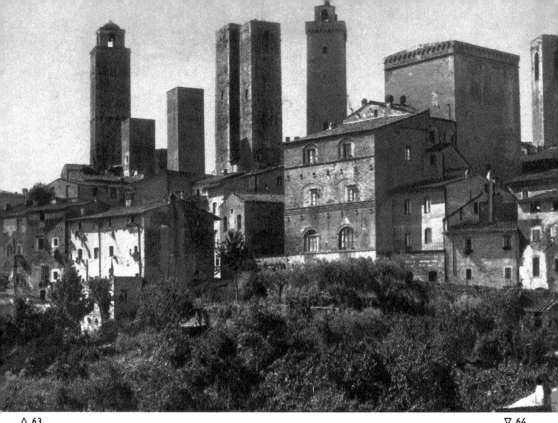

△ 63 ▽ 64

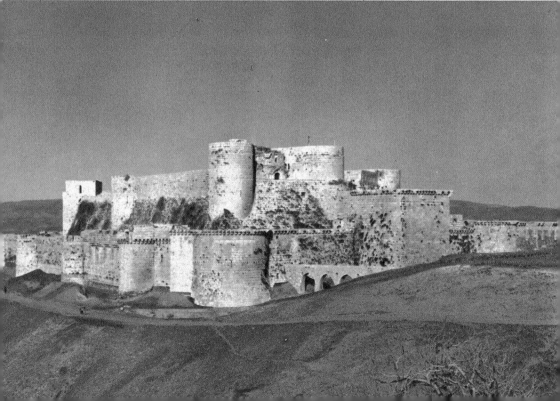

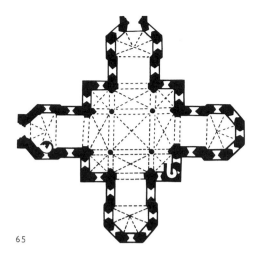

63 SAN GIMINIANO. General view of town with towers, 12th and 13th centuries. Built for private defense and as refuge in time of fire.
64 KRAK DES CHEVALIERS. Castle from southwest with keep-like complex in upper castle, and curtain wall with towers in lower.
65 KALUNDBORG CATHEDRAL. Plan. Square nave with four granite columns supporting vault and square tower. Four extensions ending in five-sided apses on which rest octagonal towers.

65

the origin of the Emilian school of sculpture is connected with the remarkable sculpture of Apulia.

Under the rule of the Norman kings, Sicily became one of the most brilliant centers of the arts and was perhaps best known for its unrivaled mosaics. But as the mosaics are Greek, so also are some of the buildings. The Normans' tolerance toward their conquered subjects also resulted in the continued existence of Muslim art. The Romanesque art of the great cathedrals of Cefalù, Palermo, and Monreale (47) combined monumentality with an almost oriental love for rich decoration. It is not certain whether the favorite motifs, the intersecting arches and the chevron, were introduced into Sicily from Normandy or from Muslim art, but the pointed arches and honeycombed roofs are undoubtedly Islamic (see 36).

During the 11th and 12th centuries, Venice was more in the orbit of Byzantine art than of Romanesque, but in Dalmatia, which lost its independence in 1105 to become part of the kingdom of Hungary, an interesting mixture of Italian elements from Lombardy, Emilia, and Apulia is found.

In 987, the Capetian dynasty came to the throne of France, but it took more than a hundred years before the royal power was able to impose some semblance of unity between the various, practically independent provinces. The political divisions of the country were reflected in the architecture. However, the unifying force was the church, including the monastic orders, which knew no frontiers. The early Romanesque period, which covers roughly the first three quarters of the 11th century, saw the expansion of the First Romanesque from the Mediterranean coast northward (Tournus, 2, 7, 9). There were also other important and interconnected developments. The monastic reform spread from Burgundy to Normandy and with it some architectural forms. In fact, most monastic centers became also centers of building activity. During this period, most of the features of the plans and elevations that became standard in the later period were in the experimental stage. The staggered plan of the 10th-century church at Cluny (the so-called Benedictine plan) had a wide following, but the ambulatory plan (probably first used as early as 946 in the crypt of the cathedral at Clermont-Ferrand) was adopted in a number of churches in the Loire (Tours, Orléans)

and rapidly spread to other regions and countries. This type of plan was later adopted in the larger pilgrimage churches on the route to Santiago de Compostela (Limoges, Conques, *3*, Toulouse, Santiago, *4*). The third church at Cluny (Cluny III, started in 1088) was also built on this plan *(19)*.

Of Cluny III, the most important church in Burgundy and one of the greatest achievements of Romanesque architecture, only a small part survives. Its impact was enormous, but it was beyond the means of anyone to attempt to imitate it, except on a much reduced scale and in simplified forms, as at Paray-le-Monial *(14, 16)* or at Lewes in England. In such Burgundian churches as Autun Cathedral or Vézelay Abbey, only certain details are based on Cluny. In both Cluny and Autun, for instance, there is a clerestory in spite of the pointed barrel vaulting and both have tribunes. Vézelay is groin-vaulted throughout, so the clerestory there is quite normal.

Cistercian architecture, which was evolved in Burgundy, had an even more widespread influence, from one end of Romanesque Europe to the other. When the abbey church of Cluny III was completed in the second decade of the 12th century, the power of the Cluniac order was on the decline and its place was taken by the Cistercians. They took from Cluniac architecture the pointed arch, but evolved a new plan for their churches, of which Fontenay is the earliest surviving example *(26, 27)*. The prodigious expansion of the order coincided with the appearance of the early Gothic style, and thus the earliest forms of Gothic architecture were introduced to some parts of Europe by the Cistercians.

In Provence, as in Burgundy, the pointed barrel vaulting was a favored form. The churches there are of comparatively modest dimensions, and their most striking feature is in the use of decoration based closely on classical models of which there were, and still are, numerous examples in the area *(29)*.

The school of western France, the main centers of which were in the domains of the dukes of Aquitaine, favored two main types of churches. One was the three-aisled barrel-vaulted type, with very tall side aisles *(13)*; the other was without aisles and the nave and transept (if there was one) were vaulted by a series of domes *(12, 21)*. The west fronts of these churches are usually screen façades, remarkable for the lavish use of sculpture.

Other important regional schools developed in Auvergne, in Languedoc, in Champagne, and in the North, but by far the most important and progressive was that of Normandy. In their plan, the Norman churches followed both the Benedictine and the ambulatory types. All major churches have a three-storied elevation, with prominent galleries and clerestories with wall passages. The prominent wall shafts and, where they exist, the alternating supports, emphasize the bay system *(15); the* west fronts incorporate two prominent towers with a large tower over the crossing *(17)*. The Norman school was already fully developed when, in 1066, the conquest of England opened wonderful opportunities for its further expansion *(51)*. The Anglo-Norman churches surpass those of the Norman school by their gigantic size. The native Anglo-Saxon buildings were practically swept away in the wake of the unprecedented building activity that took place from one end of the country to the other. The inventiveness of this Anglo-Norman school is best illustrated at Durham *(40, 52)*, where the cathedral-abbey (1093–1133) was vaulted throughout with ribs. A distinctive group of churches

with four-storey elevations, built in western England (Tewkesbury, *54*, Gloucester, and others), also demonstrates the originality of the Anglo-Norman Romanesque builders. Both their inventions, rib vaulting and four-storey elevations, became important elements in the development of Gothic architecture in northern France *(55)*. It would be a mistake to think that English Romanesque architecture drew its inspiration from one source only, namely Normandy. Close contacts existed with other regions as well and, for instance, the west fronts of Lincoln or Ely cathedrals seem to reflect the influence of German architecture rather than French *(42, 53)*.

German Romanesque architecture emerged out of Ottonian and, in fact, the Ottonian period corresponds to the early Romanesque in other countries. The great attachment to traditional Carolingian forms gives large German buildings, especially in the Rhineland, their distinctive character *(23, 35)*. The *Westwerke*, the double-apse plans, the profuse use of towers, and the alternating system of supports in which two vaulted bays of the aisles correspond to one of the nave, were widely used. The greatest achievement of German Romanesque architecture is found in the imperial cathedrals, led by Speyer *(30, 31)*, monumental in size and technically audacious (groin vaults over the nave c. 1080–1100). It is strange how little contact existed between German and French Romanesque architecture, except in the so-called Hirsau school, which came in the wake of the monastic reform based on Cluny *(34)*. Much closer links existed between Lombardy and Germany, to their mutual advantage. As the tower system of S. Abbondio at Como *(24)* is due to northern influences, so the open exterior galleries of Speyer *(30)* are derived from Italy. In fact, such galleries became a recurring feature in German Romanesque architecture and are found even as far north as Scandinavia (Lund Cathedral). The influence of German Romanesque buildings was widespread, stretching from Alsace and the Low Countries in the west *(32)* to the borders of Poland and Hungary *(58, 59)* in the east. In those countries, as well as in Bohemia, German architectural influences were strong, as they were also in Denmark *(57, 65)*, while in Sweden and Norway they were competing with elements based on the Anglo-Norman school.

Within such extensive areas, several regional schools were evolved, the most important being those of the Lower Rhineland (with the Meuse region), of Westphalia, of Saxony, and of southern Germany from Alsace and Switzerland to Austria.

In Spain, Romanesque architecture was the natural successor to the First Romanesque of Catalonia and the Mozarabic buildings of the 10th century. The successes of the wars of reconquest (Toledo was taken in 1085) opened new territories for artistic development, and the widespread Cluniac reform of the monasteries paved the way for the invasion of French Romanesque forms. The ever-increasing popularity of pilgrimages to Santiago de Compostela brought Spain into closer contact with the rest of Europe. Thus Romanesque churches in Spain display elements that are of local origin, combined with those evolved elsewhere, predominantly in France and to a lesser extent in Italy. The cathedral of Santiago *(4, 12)*, except for a few decorative elements taken from Islamic art, belongs to the group of pilgrimage churches typified by, for instance, Conques Abbey *(3)*.

If by and large, the 11th century was a period of experiment and the 12th century was the era

of the blossoming of Romanesque architecture, it would be logical to expect that the creation of the early Gothic style in the middle of the 12th century in the Ile-de-France brought to an end the further development of Romanesque architecture. Even in France, however, the spread of the new style was at first restricted chiefly to the northern provinces. Consequently, the end of the Romanesque style in architecture varied from region to region. In some countries, notably in Germany and Italy, the resistance to French Gothic forms prolonged its existence until the 13th century.

The secular architecture of the period is very imperfectly known, since buildings of a utilitarian or military character were subjected to even more frequent and drastic changes than churches, and few survive in their original form *(61, 63)*.

Castles were built as centers of feudal power, and they had the function not only of defending it but also of impressing the population. They had also to be habitable and, as far as possible, comfortable. Often their elevated position is, in itself, impressive. They vary enormously, according to the situation and shape of the site and to their exact function. Eleventh-century castles depending for their defense on the keep were introduced into England by the Normans and were perfected there during the next century *(62)*. However, this system was revolutionized by the Crusaders in their vast fortresses in the Holy Land, by the introduction of concentric curtain walls reinforced by numerous towers *(41, 64)*.

No important building of the Romanesque period was without decoration whether sculptural or painted. And it is to these subjects that we shall next turn our attention.

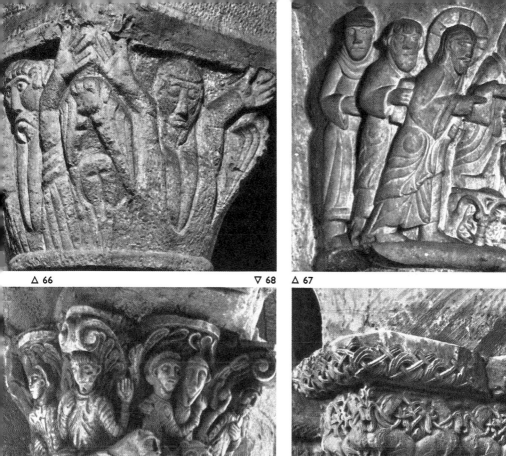

△ 66

△ 67

▽ 68

▽ 69

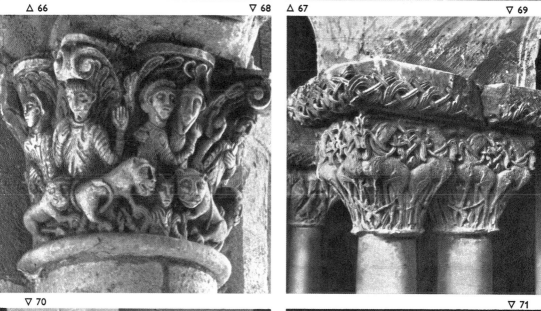

▽ 70

▽ 71

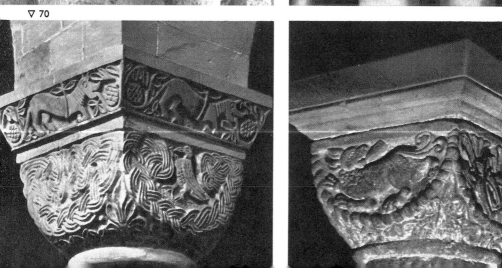

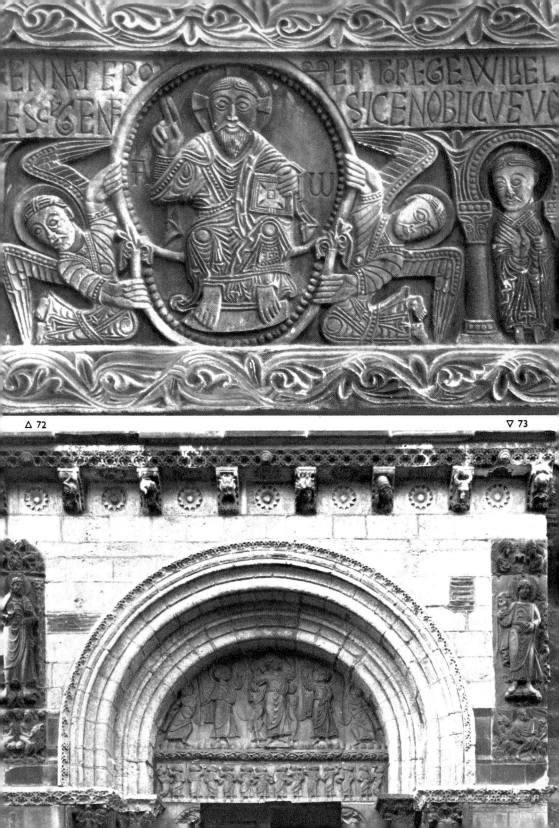

ENNATERO ... ERTBREGEWILLEL
ES ... ENF ... SICENOBIICVEVO

△ 72

▽ 73

SCULPTURE

To most people the term Romanesque sculpture brings to mind a large church portal, dominated by a tympanum carved with an apocalyptic vision, usually the Last Judgment or other biblical subjects. Moissac, Autun, and Vézelay are the best-known examples of such portals, the crowning achievements of a long development. Much work of a modest character was undertaken by several generations of sculptors before such heights were reached. For sculpture, like all the other arts, declined and almost disappeared during the period following the disintegration of the Carolingian empire. In those perilous times, sculpture must have been considered an expendable luxury. When life became safer and more settled, when, to use the well-known phrase of the Cluniac chronicler Raoul Glaber (1002–3), "the whole earth … was clothing itself everywhere in the white robe of churches," the sculptor was again able to take up his tools.

During the early Romanesque period, it is essential to distinguish two separate lines of development in sculpture: on the one hand, the work of architectural sculpture and, on the other, of carving church furniture and movable objects.

Sculptors who carved church furniture and luxury objects such as book covers in ivory, cult images in wood covered with sheets of precious metal, who made shrines, baptismal fonts, bishops' thrones, and the many other items required by liturgy and customs, had access to such church treasures as had survived pillage and fire, and followed the technique and style of these ancient models.

66 WINGED HALF-FIGURES SUPPORTING ABACUS. Capital in crypt. St-Bénigne, Dijon. 1001–18. Imitating classical capitals with Atlas figures. Organic treatment of forms, emphasizing structure of capital.

67 RAISING OF LAZARUS. Capital in Panteón de los Reyes, S. Isidoro, León. c.1060. Linear folds inspired by Mozarabic book paintings. One of earliest Romanesque capitals with narrative subject.

68 UNIDENTIFIED SUBJECT. Capital in tower porch, St-Benoît-sur-Loire Abbey. c.1067. Many Romanesque capitals combined classical, Corinthian form with figures. One of large number of figured capitals in this abbey.

69 DECORATIVE TWIN-CAPITAL. Cloister, S. Domingo Abbey, Silos. Late 11th century. Unlike previous examples, basic form is block-shaped. Closely-knit "arabesque" decoration of Islamic inspiration.

70 DECORATIVE CAPITAL. Quedlinburg Schloss-kirche. c.1100. Cubic form derived from Byzantine block capital, particularly suited to flat surface decoration.

71 DECORATIVE CAPITAL. Crypt, Canterbury Cathedral. c.1120. Cubic form introduced into England from Germany. Motifs based on local illuminated manuscripts.

72 CHRIST in MAJESTY. Detail of marble lintel, west portal, St-Génis-des-Fontaines Abbey. Dated by inscription, 1019–20. Earliest sculptured Romanesque lintel. Christ in mandorla supported by two angels, flanked by six apostles. Relief in two planes; arbitrary, linear draperies.

73 PORTE MIEGEVILLE. St-Sernin, Toulouse. c.1115–18. Recessed portal enclosing tympanum with Ascension and on lintel twelve apostles. Carved corbels support lintel. In spandrels, Sts. Peter and James and subsidiary subjects. Similar plastic style developed along pilgrimage route to Santiago de Compostela.

The revival in the making of these luxury objects was rapid, and in the 10th and 11th centuries the standards achieved were already high. In Ottonian Germany especially, works in ivory, in all kinds of metal, whether embossed or cast, objects carved in wood, stone sculptures, and stucco for interior decoration,.equaled anything that had been achieved in the past in similar fields. Other countries, Italy, France, Spain, and England, followed suit, if at a slower pace. The centers in which art flourished most actively were monasteries, though in 10th- and 11th-century Germany, the patronage of the imperial court and of princely bishops was of the greatest importance. Dynastic links with Byzantium gave Ottonian Germany an added impetus through works of art which arrived from Constantinople and became available as models. Furthermore, the Italian policy of successive emperors brought Germany and Italy into close contact, which had important results in the artistic field. Thus, by the middle of the 11th century, artistic life in Germany was unrivaled anywhere else in Europe, and movable objects and even German artists carried the influence of German art to other lands. However, this prodigious flowering of the luxury arts in Germany was not matched by a parallel development in architectural sculpture. In this, the leading role was played by Mediterranean countries, Italy, France, and Spain. It is true that architectural sculpture was not entirely absent in Ottonian buildings but, on the whole, it was restricted to nonfigurative capitals.

In Italy, France, and Spain, the earliest attempts at architectural sculpture were also confined to capitals. But very soon, when imitating classical prototypes, chiefly Corinthian capitals found in the numerous Roman ruins or reused in later, Christian buildings, the sculptors introduced figural motifs, single figures, or even scenes. While doing this, they tried to preserve the structure of the Corinthian capitals with the small acanthus leaves (*Kranzblätter*), a second row of large leaves (*Hochblätter*), the caulicoli, from which emerge sixteen volutes—eight large ones, unrolling in pairs to form prominent angle volutes, and eight small ones, extending toward the centers of the four sides of the capital, above which are rosettes. Quite often, following all or some of these elementary forms, Romanesque sculptors substituted figures for the acanthus and volutes (*66, 68*), preserving the structure of the Corinthian capital, so logical and harmonious, but adding to it a certain animation and a new meaning. The figure, whether human, animal, or imaginary, often had to be distorted to fit the required shape and function. Gradually, the sculptors began to delight in these distortions, and it became almost the rule that, whatever form they used, it was subjected to this process of transformation, away from the forms found in nature.

This was in keeping with the contemporary love of the miraculous and fabulous. The imagination of medieval men knew no limits. Their deep, unquestioning faith led them to believe the most naive stories. As they believed, without a shadow of doubt, in every miracle, they also believed in the existence of the most unlikely creatures. The world was full of them. Most were in the service of devils and they were lying in wait everywhere, a constant threat to mortals. Others were created by God, strange creatures of the East, half-human, half-animal, to whom the word of the Gospels should be carried. All these fabulous creatures found their way into the works of Romanesque sculptors. What amounted almost to an obsession with the monstrous and fabulous is found in all countries throughout the 11th

and 12th centuries, and it is not surprising that such a state of mind was severely criticized by such a purist as St. Bernard of Clairvaux. He denounced the extravagance of decorating churches with "costly yet marvelous vanities" but, above all, he objected to the use of non-religious art in monastic houses.

Crude at first, executed with primitive tools, 11th-century capitals were the chief field for experiments. In their search for patterns, the sculptors frequently consulted objects that came their way—Roman sarcophagi and other sculptures, barbaric metalwork, which must have been found frequently in graves while church foundations were being excavated and in chance discoveries.

With the greater demand for sculpture, more stonemasons devoted their skill to it. If, at the beginning of the 11th century, an occasional sculpture was executed by a mason whose main task it was to cut stones and set arches and vaulting, by the end of the century the art of sculpture developed to such an extent that it demanded a specialist, a sculptor. He must have been paid according to his skill and, in some instances, achieved considerable fame and recognition. Some sculptors, proud of their distinction and status, signed their work in a prominent place, at times in an immoderate, boastful way.

Toward the end of the 11th century, in many parts of Europe, an important development took place. If before, the work of the mason-sculptor working on a building site and the work of a specialist in church furnishings seldom show they had any contact in their work, these two independent streams now became fused into one. There can be no doubt that the furniture maker, who was skilled in many techniques, had a higher status and probably higher earnings. He was literate, and he was working in close contact with learned ecclesiastics. By the end of the 11th century, these men are found working on architectural sculpture. The sculptor Ursus, who carved the bishop's throne at Canosa and who was brought up in the tradition of workshops probably producing cult images, ivories, and other similar works in the luxury arts, was also employed on carving window frames and doorways for S. Nicola at Bari. Bernard Gilduin (known as Gilduinus), the sculptor of the marble altar at St-Sernin at Toulouse, worked in the same place on carving capitals. The sculptor of the superb capitals at Cluny (82) was certainly not an ordinary mason-sculptor. The delicacy of his work, the refinement of his technique, and the learned iconography he used—all testify to the fact that he had turned to architectural sculpture after having worked in other media, perhaps ivory or stucco. But if the sculptors in the luxury arts gave a new standard to architectural sculpture, their work would have been less successful had they not benefited from the experiments of the mason-sculptors of the 11th century. Growing out of the masons' workshop, Romanesque sculpture was a natural extension of architecture; in fact, it was an integral part of it. The Ottonian sculptors of St. Pantaleon in Cologne or the early Romanesque sculptors of St. Emmeram in Regensburg produced exellent figures, but these figures had an existence independent from the buildings even if they were attached to them. The sculptor of the Porte Miègeville at Toulouse (73) integrated his sculpture with the portal design to such an extent that it is impossible to separate the one from the other—both architecture and sculpture are one. This unity between the architectural setting and its sculptural decoration is one of the greatest achievements of the Romanesque period. The

great Romanesque portals of Moissac, Autun, and Vézelay were the result of this perfect unity.

If the chief field for 11th-century sculpture was the capital, from the end of the 11th century the main emphasis was on the portal. At first, simple, with only a carved frame, it gradually developed into a highly articulated opening, exploiting the thickness of the wall by a number of recessed orders, which lead the eye step by step into the interior. The carved lintel, which was an early form of enrichment for the doorhead (72), was replaced by a more imposing tympanum with a lintel. At first small, and with modest sculpture, the tympanum developed very rapidly into a gigantic, dominating feature which, for safety, required a central support, the trumeau. Early tympana could be made of one block of stone, but the fully developed examples had to be made from several large stones joined together.

Though some 11th-century churches had three portals in their main façades, they were usually plain (see 17). Three richly carved portals, however, became almost the rule in the 12th century. In addition to portals, other external features such as windows, corbel tables, and friezes were frequently carved. In some regions, notably in Lombardy and western France, sculpture was at times extended to whole façades (18, 44).

Even in the earliest stages of development, sculpture of a religious character was competing with grotesque and monstrous subjects, to which St. Bernard took such strong exception. Narrative biblical subjects are found not infrequently in the 11th century (67, 68), and they increased in numbers as time went on. It was the tympanum, however, that gave sculptors an opportunity to go beyond simple biblical scenes. Much thought went into the iconography of the large tympana. The subject matter had a complex theological meaning, full of the symbolism so beloved by medieval thinkers. The Revelation of St. John the Divine was an especially important source. Its visions of "things which must shortly come to pass" (Revelation 1:1) fired the imagination of medieval man. The concluding visions of the general resurrection, the judgment of souls, and the Heavenly Jerusalem became favorite subjects for the great tympana, offering sculptors great opportunities for giving visual form to these frightening but wonderful events that were to come. The resulting works, such as the tympana at Moissac (75), Autun (85), Vézelay (86) and Chartres (96), are among the most deeply religious and moving works of the Middle Ages.

As in architecture, there was no single Romanesque style of sculpture. Sculpture, moreover, was not static, it was ever changing and developing. It was also conditioned by local traditions, and there was a vast difference between, for instance, those in Mediterranean lands and those in England and Scandinavia. Yet certain principles and aims were common to all regions. During the experimental period of the 11th century, when sculptors were, so to speak, learning their art from the beginning, the differences of style between regions were very marked. The Spanish sculptor who used as his model Mozarabic illuminations (67) produced works totally different from his German near-contemporary (97), who was brought up in Ottonian traditions, and both of them had nothing in common with the Italian sculptor (111) who sought inspiration in the decorative art of the Longobard period. But very soon the same fundamental tendencies appeared in all sculpture, the same love of decorative effect, of geometric forms, of conceiving figures as part of their architectural

setting, with which they are united in shape and volume. As in architecture, where each part was articulated and the whole was a sum of units harmoniously knit together, so in sculpture the same process was at work. Each form, whether human, animal, or ornamental, was composed of complex, enclosed, independent units. The whole composition was conceived as a skillful interlocking and balancing of such forms. If we analyze any great Romanesque composition, for instance, the portal of Vézelay (86), we shall realize how truly masterful this system is, how one basic form is added to another, how interdependent they are, and how, taken together, they present a miraculous unity. The tympanum and its surrounding arches and trumeau are not only integrated in a highly satisfying manner but, at the same time, they articulate the vast opening. They are not just an added decoration but are an integral part of the surrounding masonry.

The figures on the jambs of the Vézelay portal illustrate the preoccupation of 12th-century sculptors with the problem of extending the iconographic program from the tympanum to all parts of the portal. Spanish sculptors started this development by carving columns with figures (123), while the Italian sculptor Niccolò experimented with figures on portal jambs (113). The credit for the invention of the column figure, or at least the use of the invention on a large scale in three adjoining portals, goes to the sculptor of St-Denis Abbey (89). This new method by which the figure was projecting from the column, being an integral part of it—and not, as in Spanish examples, carved on the surface and into the thickness of the column—gave new opportunities and opened up a new line of development, which led to the formation of the Gothic style. The portals of Etampes and Chartres (94 and 96) stand on the borderline between the two styles.

The age that started with the lintel at St-Génis-des-Fontaines (72) and ended with the *Portails Royaux* at Chartres (96) was indeed a period of great achievement.

Although the sculpture of Chartres was created by the genius of French artists, it was based on experiments carried out in a number of regions, many of them outside France.

We have mentioned the work of Ursus at Canosa and Bari, of Gilduinus at Toulouse, of Niccolò at Ferrara, and of an anonymous sculptor at Santiago de Compostela. They and a score of other innovators contributed indirectly to the achievements at St-Denis and Chartres. The flow of artistic ideas was remarkably quick. Sculptors of fame were often commissioned to work in places far apart.

74 CHRIST IN MAJESTY WITH SYMBOLS OF EVANGELISTS. Marble relief. St-Sernin, Toulouse. c. 1100. One of seven reliefs, original position unknown. Work of Bernard Gilduin (Gilduinus). Earlier sculptures by him include capitals and altar. Porte Miègeville later stage of this style.

75 APOCALYPTIC VISION. Tympanum of south portal. Moissac Abbey. c. 1115–20. Christ in center surrounded by symbols of evangelists, two angels, and twenty-four elders of the Apocalypse (Revelation 4). Iconography based on Spanish illuminations of the Commentary on the Apocalypse by Beatus. Supernatural character exceptionally well achieved by varying size of figures, solemn

expressions, and restless, agitated forms. Plate draperies derived from Cluny (*82*). Pointed arches decorated with foliage, lintel with rosettes, and supported by trumeau (*77*).

76 SALOME RECEIVES HEAD OF ST. JOHN THE BAPTIST FROM HEROD. Twin-capital, from cloister, St-Étienne Cathedral, Toulouse. Musée des Augustins. c.1130. Large number of capitals and figures from chapter house display new style in Languedoc: natural proportions, gentle gestures, soft draperies, rounded forms. This style influenced proto-Gothic sculpture of St-Denis.

77 ST. PAUL. Detail of trumeau, Moissac Abbey. c.1115-20. Front face decorated with lions and lionesses, sides with figures of Jeremiah and St. Paul. Through elongation perfect unity achieved between sculpture and architectural form. Refined, crisp modeling.

78 DETAIL OF TRUMEAU. Souillac Abbey. c.1120-25. Portal related to Moissac; only portions survive. Struggling beasts typify forces of evil.

79 ABRAHAM RECEIVES SOULS IN HEAVEN. Detail of tympanum, west portal, Conques Abbey. c.1130-35. Portion of Last Judgment. Largest Romanesque tympanum, originally under porch. Much original polychromy survives. Short, immobile figures. Style connected with Auvergne.

80 KISS OF JUDAS. Detail of frieze, St-Gilles-du-Gard. c.1160. Idea of frieze and style inspired by classical art. Romanesque sculpture in Provence closer to Italian than to French art.

81 ANGELS BLOWING HORNS FOR THE LAST JUDGMENT. Details of west portal, St-Trophime Cathedral, Arles. c.1170. Classicizing style closely related to St-Gilles.

82 FIRST TONE OF PLAINSONG. Capital from Cluny Abbey. c.1095. Musée du Farinier, Cluny. One of eight capitals from ambulatory, representing Virtues, beauty of monastic life, and Paradise. Two capitals devoted to eight tones of church music, identified by inscriptions. Early use of plate drapery, subtle modeling of figures, acanthus of almost classical purity.

83 EVE. Fragment of lintel from north portal, Autun Cathedral. Musée Rolin, Autun. c.1125. Work of Gislebertus. Scene represented Fall of Adam and Eve. Unusual horizontal position of figures, rare representation of nude female figure. Soft, almost tender modeling of body.

84 SUICIDE OF JUDAS. Pilaster capital from Autun Cathedral. Musée Lapidaire, Salle Capitulaire. c.1125-30. Like most capitals of cathedral, by Gislebertus. Highly dramatic rendering of scene combined with decorative use of foliage.

85 LAST JUDGMENT. Tympanum of central portal, Autun Cathedral. c.1130. Signed by Gislebertus. Christ, severe judge, divides elect from damned. Resurrection of dead on lintel. Plain arch originally contained twenty-four elders of the Apocalypse. On outer arch Seasons, Labors of Months, Signs of Zodiac. Trumeau 19th-century reconstruction of lost original, which had Lazarus, patron saint of Autun, whose relics were enshrined in choir. Profoundly moving work full of drama and compassion. Figures of differing sizes underline visionary character of scene.

86 MISSION OF APOSTLES. Tympanum of central portal in narthex, Vézelay Abbey. c.1130. Rays of light link Christ with apostles. Around are strange races of earth to whom Gospels to be carried. Idea of universality of church. Dynamic, painterly style. John the Baptist on trumeau, apostles on jambs. Important development in portal sculpture anticipating column figures of St-Denis.

87 APOCALYPTIC VISION OF CHRIST IN MAJESTY. Tympanum of outer portal of narthex. Charlieu Priory. c.1140-50. Last and most dynamic stage of Burgundian Romanesque sculpture. High tension and drama achieved through movement. Inventive iconography: Agnus Dei at apex of arch, Virgin assisted by angels among apostles on lintel.

88 SOUTH PORTAL. Church of St. Peter, Aulnay-de-Saintonge. c.1130. Four recessed arches decorated with religious and grotesque subjects. Sculpture placed radially, one motif to each voussoir.

74 ▷

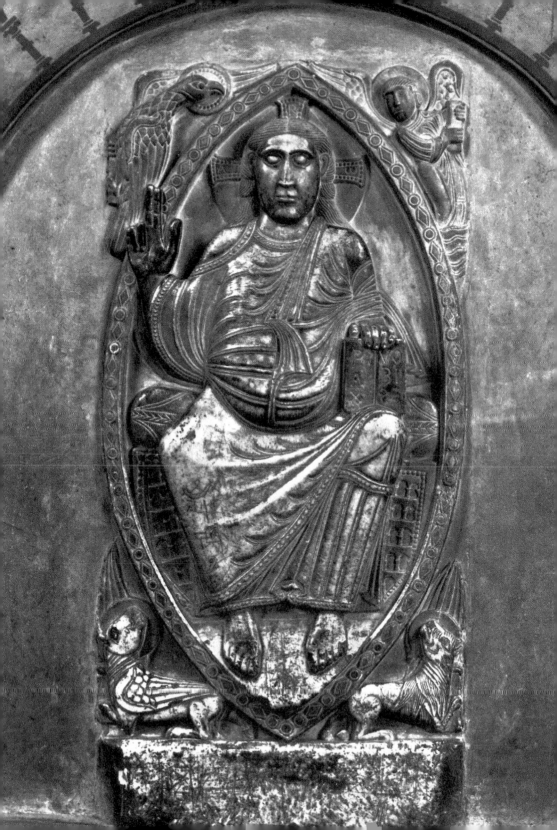

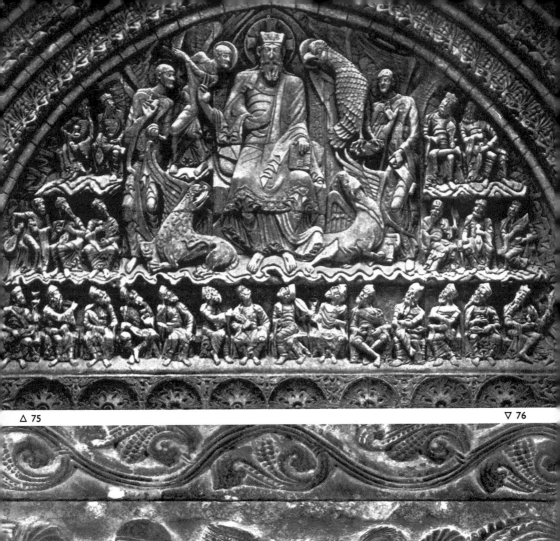

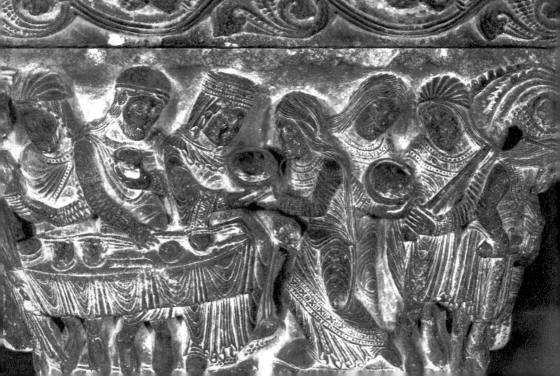

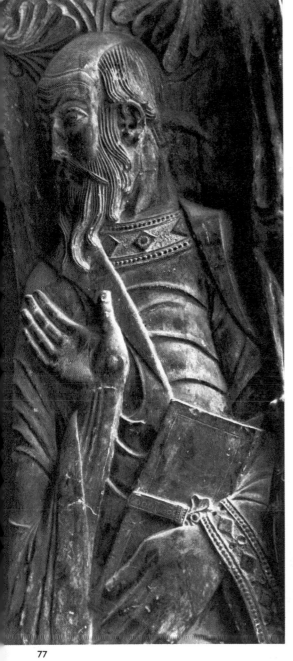

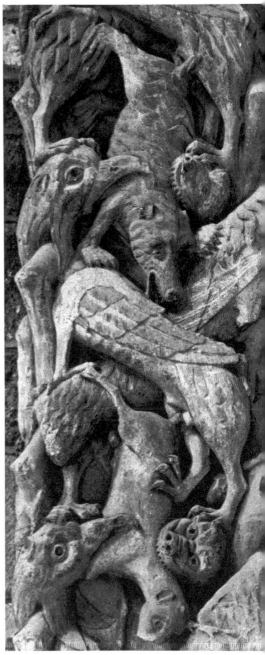

77 78

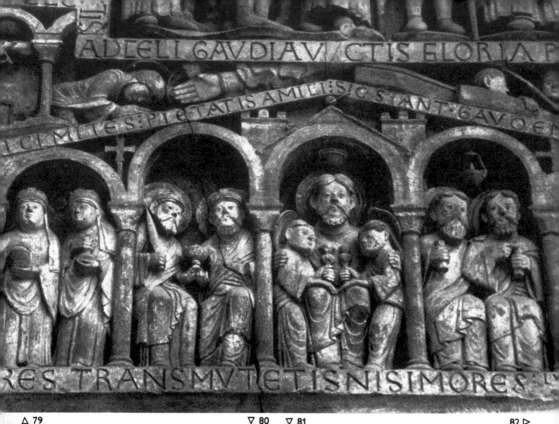

ADLELI GAVDIAV CTIS ELORIA P
ES PIETATIS AMIL SIC S ANT GAVO E
RES TRANSMVTETIS NISIMORES

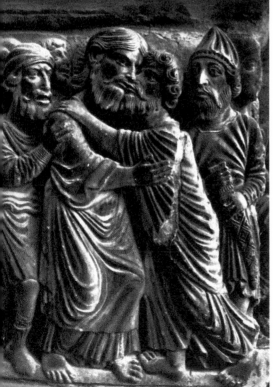

△ 79 ▽ 80 ▽ 81 82 ▷

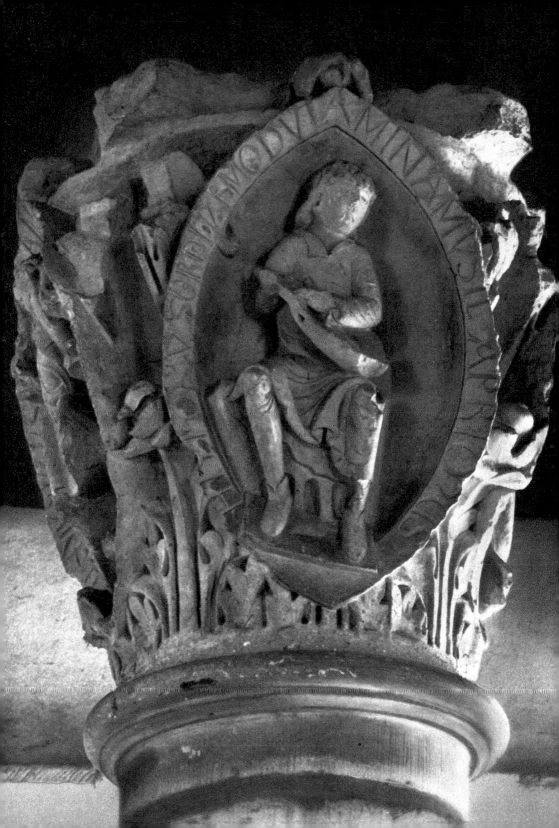

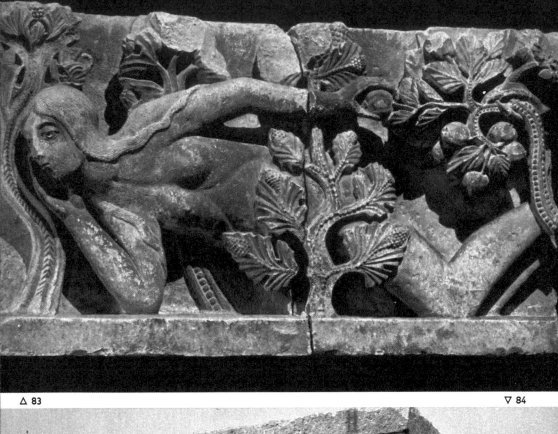

△ 83

▽ 84

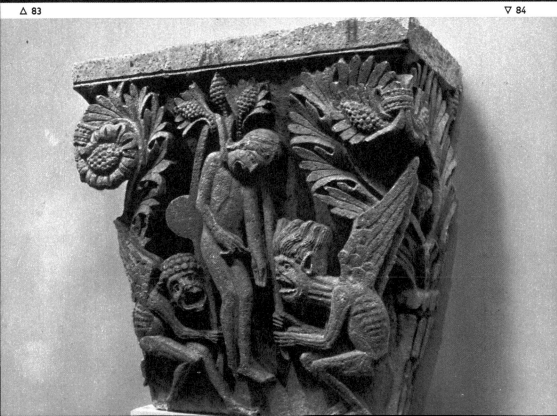

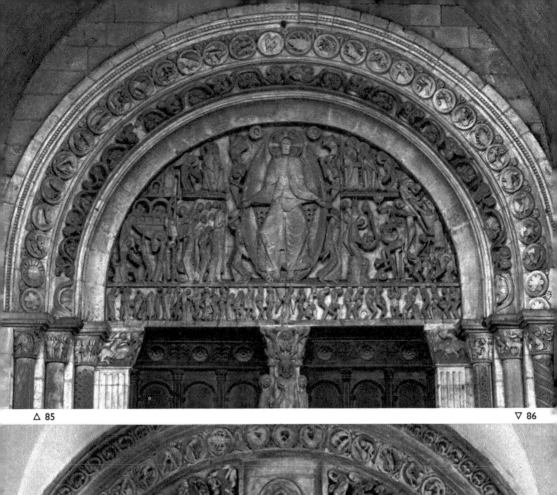

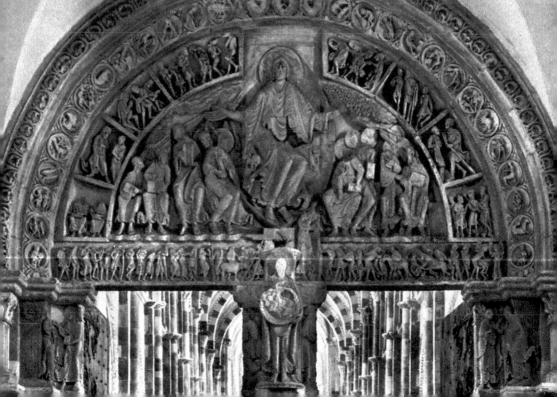

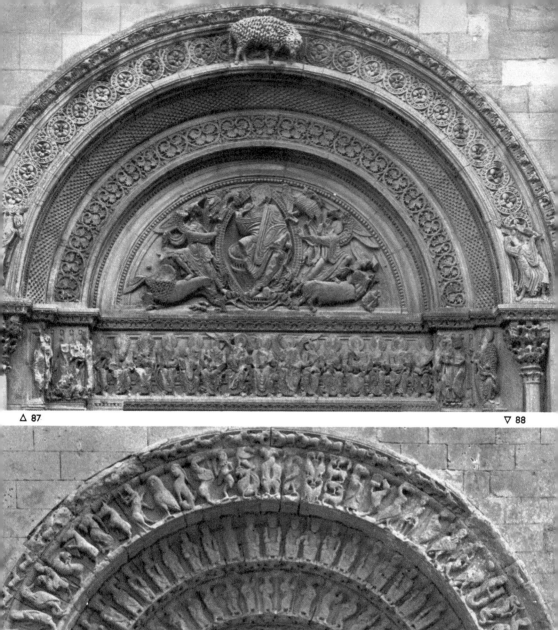

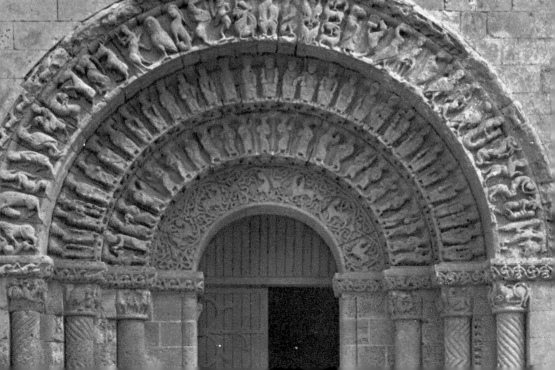

But the movement of artists was only one of the many ways in which artistic fashions and styles spread. It is quite clear, for instance, that certain important trade routes were also routes for the movement of artistic forms. The Rhine was certainly one of them. The Via Emilia, the chief road to Rome from the north, was another. The famous pilgrimage routes to Santiago were also unquestionably all-important from the point of view of artistic life. In this case, their precise course is set forth in detail in a 12th-century pilgrims' guide, a precious document describing the four routes crossing France and joining, on the Spanish side of the Pyrenees, into a single road leading to Santiago. All the important shrines on these roads are described for the benefit of the pilgrim, together with all kinds of practical information, such as the quality of the wines and the character and customs of the people of each province through which the pilgrim would pass. It is certain that many artists and patrons traveled along these roads to the holy shrines as pilgrims or on other business. They visited churches, admired them, and, on their return home, imitated them. It is no accident that Conques, Toulouse, León, and Santiago display sculpture that is closely related.

But in spite of these interrelations and exchanges of artistic forms, there were, in the earlier 12th century, definite regional characteristics, some so distinctive as to deserve the name of regional schools. Not all of them correspond precisely to the regional schools of architecture, strong proof that, by then, sculptors were no longer bound to any architectural workshop, but worked independently.

In France, the two earliest regional schools, both initiated at the end of the 11th century, are those of Burgundy and Languedoc. The first, adjoining the imperial lands and in close contact with the empire, shows an indebtedness to German art. (This is usually more readily admitted in the field of painting than in sculpture.) How else can the "miracle" of the Cluny

89 ANCESTORS OF CHRIST. Drawing of two column figures, now destroyed, from west front, St-Denis Abbey. From Montfaucon, *Monuments de la monarchie française*, 1729 to 1733.

90 LAST JUDGMENT. Tympanum of central portal, St-Denis Abbey. c. 1137. Lintel and trumeau destroyed, all heads and many protruding parts 19th-century restorations. Last Judgment scenes extend to voussoirs of inner arch. On other arches elders of the Apocalypse and angels. Both style and iconography fundamentally Romanesque. Voussoir sculpture inspired by western France (see 91). Revolutionary innovation: column figures on jambs, now destroyed.

91 VIRTUES, VICES, AND OTHER SUBJECTS. Detail of west portal, Aulnay-de-Saintonge.

c. 1135. Outer order carved by older radial method. On other arches figures placed along curve and carved on several voussoirs, allowing larger size. This method adopted at St-Denis and by all sculptors of Gothic portals.

92 SIGNS OF THE ZODIAC. South jamb, north portal, west front, St-Denis Abbey. c. 1137. At Autun and Vézelay these subjects were on arches (*85* and *86*). St-Denis sculptor followed Italian tradition in this. Also Italian-inspired figures supporting columns. Colonette on left is copy of original in Musée de Cluny, Paris. Column on right is 19th-century replacement of column figure.

93 LABORS OF MONTHS. South jamb, south portal, west front. St-Denis Abbey. c. 1137. Observations about columns in *92* apply here also.

89

94 SOUTH PORTAL. Etampes Cathedral. c. 1140–50. Early portal with column figures (Old Testament precursors of Christ). Ascension on tympanum and biblical scenes on capitals. General design based on Porte Miègeville, Toulouse (73). Style strongly influenced by Burgundy. Same sculptor worked at Chartres (see below).

95 COLUMN FIGURES. North Portal, west front, Chartres Cathedral. c. 1140–50. Work of Master of Etampes, earliest and most Romanesque of Chartres sculptures.

96 PORTAILS ROYAUX. West front, Chartres Cathedral. c. 1140–50. Crowning achievement of 12th-century sculpture, landmark in development between Romanesque and Gothic styles.

97 SO-CALLED IMAD MADONNA. c. 1060. Wood. Height 112 cm. Diözesan-museum, Paderborn. Given to Paderborn Cathedral by Bishop Imad (1051–76). Originally covered with silver sheets and jewels. Virgin's hands restored. Immobility of pose, broad, monumental forms provide contrast with earlier Ottonian Madonnas.

98 VIRGIN AND CHILD. Second quarter 12th century. Silver on wooden core. Height 60 cm. Beaulieu Church. Composition less unified than in 97. Child frontal and almost detached from figure of Virgin, as in Ottonian ivories. Less Romanesque in conception than previous example. Stylistically connected with later Moissac works.

99 VIRGIN AND CHILD. Middle 12th century. Stone relief. Height 92 cm. Musée Liège. From St-Laurent Church. Mistakenly called Madonna of Dom Rupert (Rupertus of Deutz). *Virgo lactans*, Virgin suckling Child is based on Byzantine prototypes. Tender grouping of Mother and Child rare in Romanesque art. Mosan style, related to works in Maastricht and Utrecht.

100 VIRGIN AND CHILD. Late 12th century. Wood with later polychromy. Height 109 cm. Museo di Palazzo Venezia, Rome. From Acuto (Lazio). Example of interrelation between cult objects and stone sculpture. (Compare with *120*.)

101 ASTROLABE. Late 11th century. Stone. Height (without capital) 61 cm. Museum der Stadt, Regensburg. From St. Emmeram. Rare example of secular sculpture. Kneeling figure of Aratos in pose of Atlas carrying globe. Traditionally associated with Wilhelm von Hirsau in St. Emmeram till 1069.

102 CRUCIFIX. c. 1070. Bronze. Height 100 cm. St. Liudger Abbey, Werden. Originally in Helmstedt Abbey. Simplification of forms, tendency toward geometric patterns, expression through overemphasis of features.

103 LECTERN SUPPORTED BY EVANGELISTS. Middle 12th century. Wood. Height 120 cm. Stadtkirche, Freudenstadt. Originally in Alpirsbach Abbey. Figures carved in round, but form of bodies concealed by robes covered with geometric, angular folds. Decorative treatment of heads by varying forms of hair and beards.

104 TOMB PLATE OF ANTI-KING RUDOLF OF SWABIA. Shortly after 1080. Bronze. Height 197 cm. Merseburg Cathedral. Tombs with effigies of deceased came into use in Romanesque period, and tomb of Rudolf is one of earliest and finest. Idealized image of ruler, not portrait.

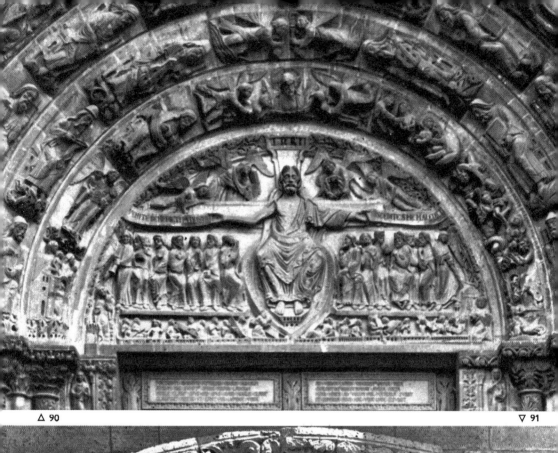

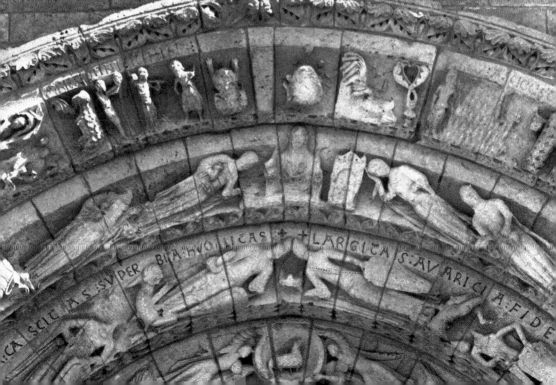

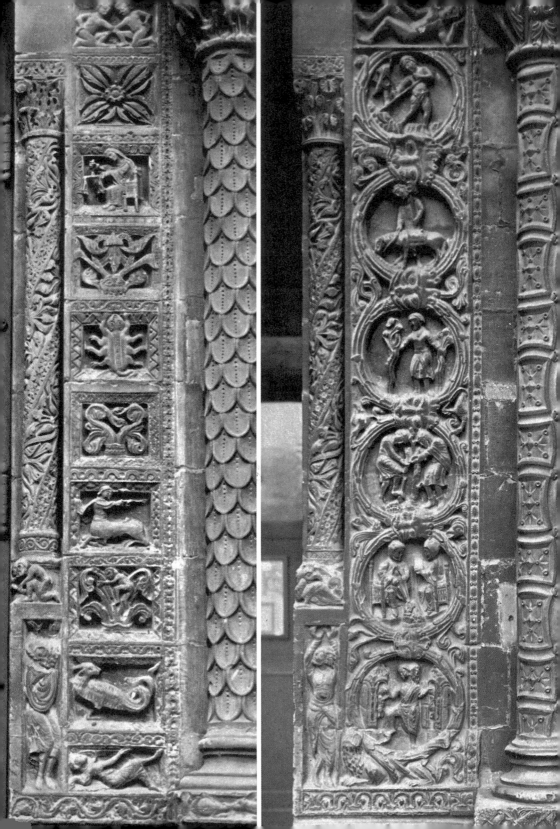

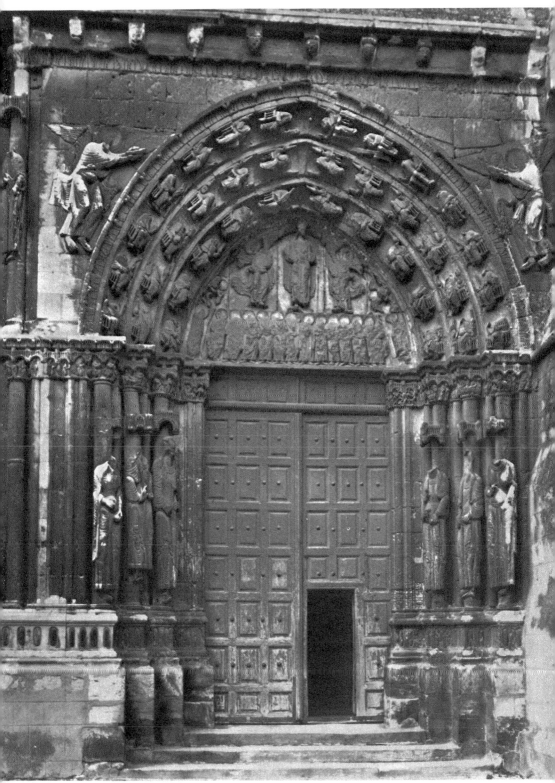

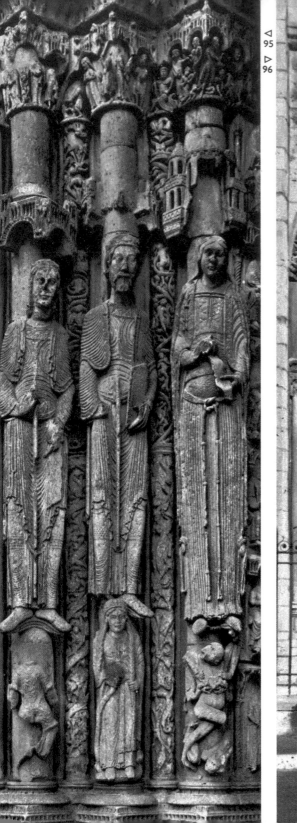

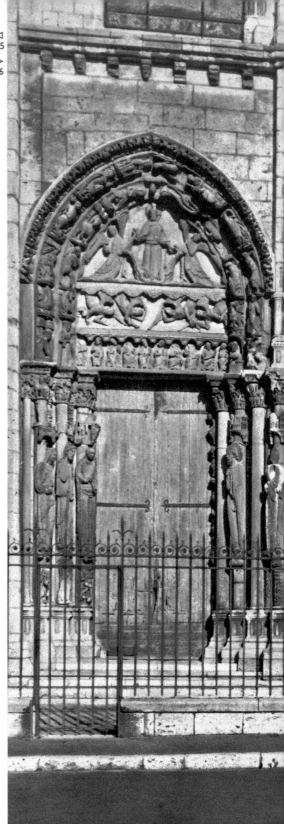

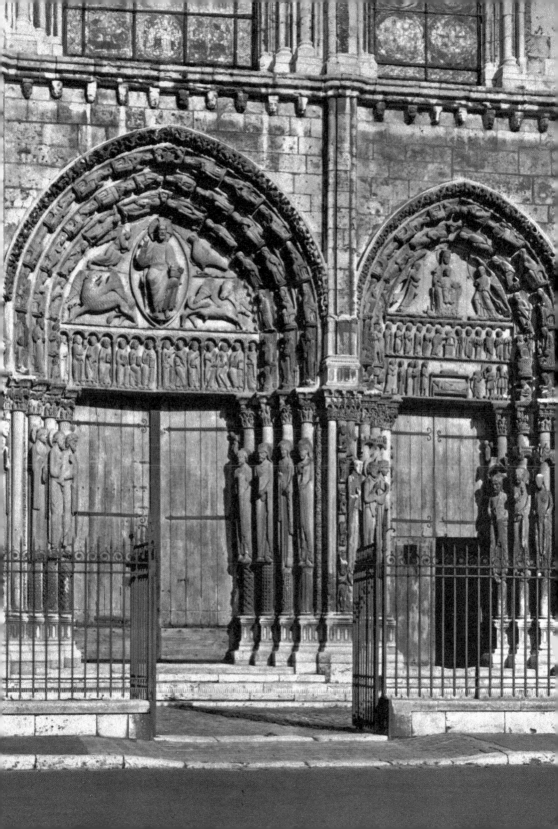

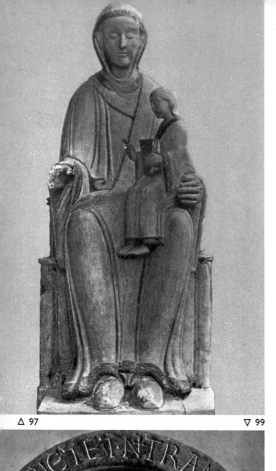

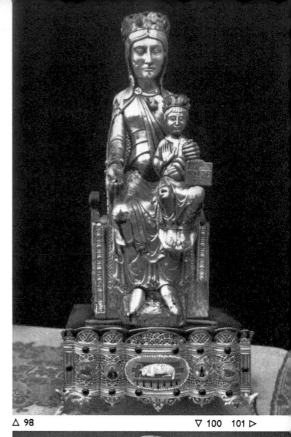

△ 97 ▽ 99 △ 98 ▽ 100 101 ▷

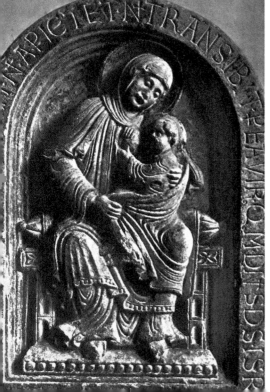

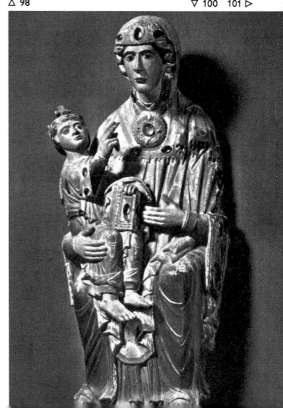

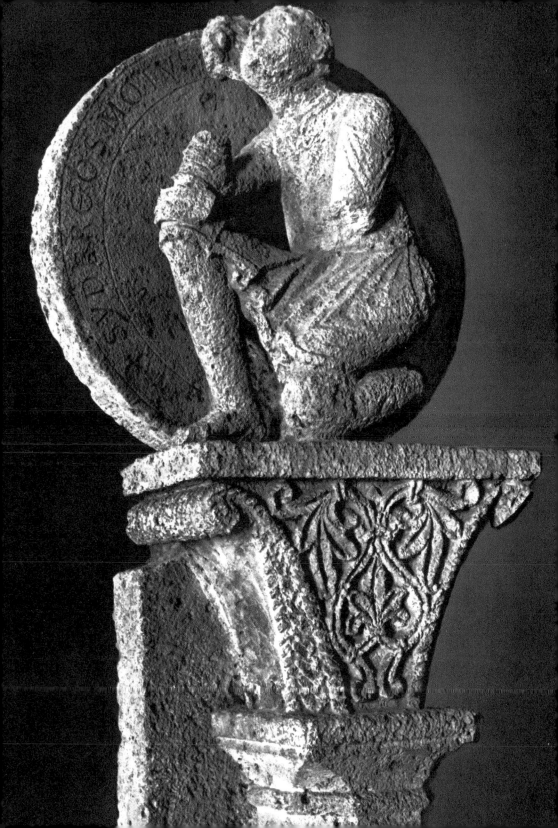

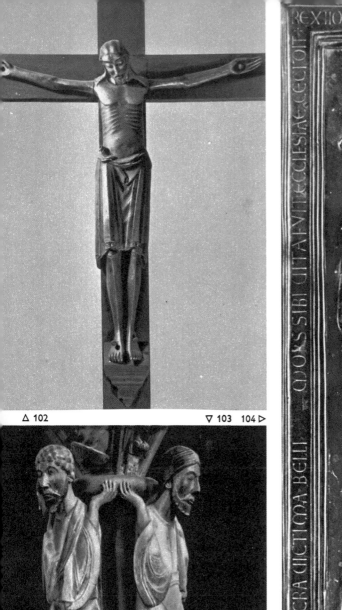

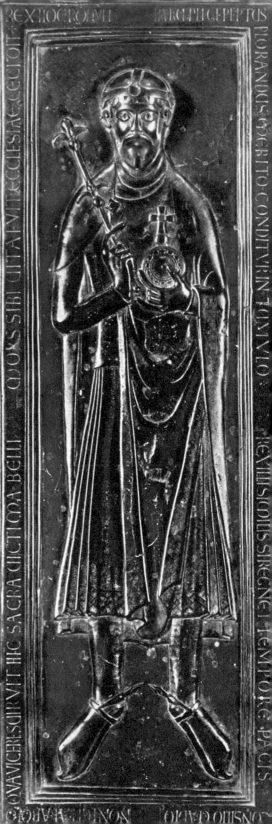

△ 102　　　　　　　▽ 103　104 ▷

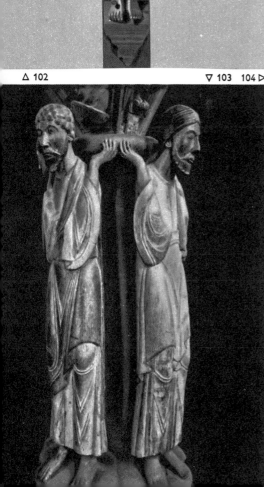

capitals (*82*) be explained? These capitals, if the date c. 1095 is accepted for them, are unparalleled anywhere in Burgundy or in France as a whole. However, the precocious works of sculpture—such as the fragments of a sarcophagus and two reliefs of saints at Werden, the astrolabe at Regensburg (*101*), cult images (*97*), and bronze works (*102* and *104*)— testify to the extraordinary skill and delicacy of style in the works of sculpture in Germany during the second half of the 11th century. The "plate drapery" —a convention of showing overlapping layers of folds as if they were plates of armor — used at Cluny has obvious predecessors in works at Werden and Merseburg.

It is certain, however, that the great portal of Cluny III, known only from engravings and a few fragments, was ready by 1113 and initiated the long series of great Romanesque portals in Burgundy—Autun (*85*), Vézelay (*86*), and even Charlieu (*87*). Cluny was undoubtedly one of the most influential centers of sculptural activity in Europe, and its influence spread in all directions. The style of Gislebertus of Autun and of his anonymous contemporary at Vézelay, though they differed so markedly from each other, both owe something to Cluny.

The school of Languedoc, centered on Toulouse, came into being in the last quarter of the 11th century. Its leading early sculptor was Gilduinus, whose style is a curious blending of classical forms with those derived from the luxury arts of metalwork and ivory carving (*74*). His pupils developed his style further (the cloister of Moissac and the Porte Miègeville, Toulouse, *73*), toward greater plasticity and roundness of forms, accentuated by characteristic folds in the curving relief. The appearance of an almost identical style in Spain, at Jaca, León, and Santiago (*123, 124*), testifies to the close artistic contacts between important pilgrimage centers along the *camino francés*, the French road to Santiago.

The workshop of Moissac, responsible for the portal and its magnificent tympanum (*75*), departed from the style evolved in Toulouse, and it seems reasonable to assume that the change was due, at least in part, to the influence of Cluny. Moissac was a Cluniac monastery whose monks must have been well acquainted with the great works of rebuilding carried out in the mother house. The plate drapery and the idea of a gigantic tympanum were derived from there. The Moissac master must, however, be credited with an originality which alone explains his visionary sculpture. Like all medieval sculptors, he drew freely on a variety of sources without trying to conceal this, but he created something unique, something that even today overwhelms us as almost superhuman. No wonder that his dramatic work was an immediate success as the portals closely related to Moissac, at Souillac, Beaulieu, and elsewhere, testify.

No sooner was the Moissac porch completed when, about 1130, a new style made its appearance in Languedoc, this time in Toulouse, in the cloisters of the abbey of La Daurade, and in the chapter house of the cathedral of St-Étienne. As if in reaction against the turbulent, sharply-edged, angular style of the Moissac master, the new sculpture was gentle in character and soft in modeling (*76*). This third style must have been known to the sculptors of Abbot Suger at St-Denis, for its reflection can be found in the figures of the Wise and Foolish Virgins on the jambs of the central portal. A recent study demonstrated that the figures of the apostles at St-Étienne were not used in a portal (they are not in their original

place but in the museum) but were supporting the vaulting of the chapter house, and consequently they had no influence on the proto-Gothic portals.

To the north of Languedoc, in the region between the Garonne and the Loire, in Poitou, Saintonge, and Angoumois, which for convenience will be described as western France, a highly complex school of sculpture developed during the early 12th century. It is undoubtedly the richest region of Europe in surviving Romanesque buildings, most of which are enriched with lavish sculpture. Much of it is of an ornamental character. The local stone, soft but durable, was not suitable for quarrying in large blocks and so sculpture was conditioned by this fact. No tympana were used in doorways, though sometimes they were carved in niches. The peculiarity of the school was the portal without a tympanum but with numerous recessed arches, carved with considerable virtuosity. At first the arches were carved radially, with a single motif to each voussoir (88). The resulting effect was one of great decorative richness. This method, however, had its limitations, for it restricted the size of the motifs carved. Sometimes around 1130, a dramatic change in the method of applying sculpture to arches was introduced (91), which allowed the figures to be much larger. By placing motifs not radially but along the curve of the arches and disregarding the joins between the stones, it was possible to carve large figures. These arch-figures, as they can be called, proved to be an important innovation, adopted at St-Denis, Etampes, and Chartres and on all subsequent Gothic portals. The column figure was nothing else but a logical extension of the same idea but applied to the lower part of the portal.

The virtuosity of western French sculptors and their love of rich display led them, at times, to cover whole façades with sculptural friezes and figures in niches, leaving practically no plain surfaces (18). Not surprisingly, they were widely imitated not only in France—their influence can be seen even in Normandy and Picardy—but in Spain, and above all in England, especially after the union of western France with England under Henry II Plantagenet.

Another school of French sculpture, in Auvergne, was characterized by a distinctive, strongly classical type of capital and by the triangular lintels of portals. To this school belongs the sculpture of Conques Abbey—though it is in Rouergue and not in Auvergne. Its crowning achievement was the west portal at Conques, which still has traces of the original polychromy, with its enormous tympanum (79). Its heavy, bulky figures lack the virtuosity associated with Languedoc and Burgundy. The Last Judgment represented here is divided into numerous scenes, separated from each other by frames. The iconography and the presentation have nothing of the visionary, turbulent character of Moissac or Autun, but must have been easy to understand by the simple pilgrim coming to the famous shrine of Ste-Foy.

Indebtedness to classical sculpture was in some degree present in practically all Romanesque sculpture, but nowhere was the debt to Roman monuments so strong as in Provence. The school of sculpture here developed late, in the third quarter of the 12th century, when in northern France the transition away from Romanesque was well under way. The school of Provence (29, 80, 81) did not accept the portal with column figures but instead exploited to the full the frieze and the figure in the niche as the chief features of decoration.

The importance of Spanish sculpture, especially of the 11th century, has long been underestimated. The flowering of the luxury arts in Spain stimulated the development of stone sculpture at an early date (*67, 69, 122*). Pilgrimages and monastic links with France established close contacts with artistic activities in Languedoc, Burgundy, and elsewhere. The sculpture of Santiago shows a mixture of styles: purely Spanish elements (*123-25*) are combined with a style related to the Porte Miègeville at Toulouse and to the earliest sculpture at Conques. An interesting relationship also existed between Catalonia and Aragon on the one hand and Italy on the other. This already existed in the 11th century, perhaps facilitated by maritime relations, and continued throughout the 12th century.

It is far from certain whether Spain was always on the receiving end, as is so often believed. Ideas traveled in both directions to the advantage of both countries. High Romanesque sculpture in Spain became less inventive and, though many superb works were still produced, the general love for rich decoration perpetuated the old-fashioned forms derived

105 BAPTISM OF CHRIST. Baptismal font, St-Barthélemy, Liège. Bronze. Commissioned by Abbot Hellinus (1107–18) for Nôtre-Dame-aux-Fonts, cast by Reiner of Huy. Modeled on description of molten sea in temple of Solomon, cast in bronze by Hiram of Tyre, which "stood on twelve oxen" (1 Kings 5:25), though at Liège only ten oxen. Mosan work of extraordinary, classicizing style, unlike contemporary Romanesque art elsewhere.

106 ANNUNCIATION AND ASCENSION. Baptismal font, Nonnenstiftskirche, Freckenhorst. Stone. c.1129. Unlike *105*, scenes placed under arcades and integrated into thickness of stone. Lions at base do not project. Modeling by linear means.

107 DESCENT FROM CROSS. Rock carving on chapel at Externsteine bei Horn. c.1115. Over-lifesize figures of great emotional power. Distortion of forms, especially of Joseph of Arimathea, to emphasize effort of supporting sinking body of Christ. Unusual iconography, e.g., bust of God the Father with banner and holding soul of Christ. At base, Adam and Eve in symbolic juxtaposition: Original Sin and Redemption through Christ's death.

108 LION MONUMENT TO DUKE HENRY THE LION. Bronze. 1166. Between castle (Burg Dankwarderode) and cathedral, Brunswick (Braunschweig). Idea of free-standing monument derived from antiquity. Henry erected this monument as symbol of knightly courage and political power. Based on small-scale bronze aquamanile but given monumental quality.

109 ARCHBISHOP'S THRONE. Marble, inlaid with colored pastes. c.1098. S. Nicola, Bari. Church built specially for relics of St. Nicholas by Elia, abbot of S. Benedetto, who in 1089 became archbishop. For this reason, throne not in cathedral but in pilgrimage church of S. Nicola. One of four 11th-century thrones in Apulia. Upper part with perforated sides and inlaid ornament shows Islamic influence. Slaves supporting the seat inspired by Atlas figures of antiquity. Carved in round, expressing effort of carrying weight. At back, lions attacking men, and two lions supporting footstep. No other sculptor of this early date learned more from classical sculpture than this Apulian master.

110 GOD IN MANDORLA, CREATION OF ADAM, CREATION OF EVE, TEMPTATION. Section of frieze on façade of Modena Cathedral by Wiligelmo. First quarter 12th century. Frieze inspired by classical examples but style very personal, with great sense of volume. Strong probability that Wiligelmo was trained in Apulia.

111 BIRDS PECKING AT GRAPES. Window frame. S. Abbondio, Como. Between 1063 and 1095. Very flat relief of purely decorative character, based on local traditions of Longobard sculpture (8th and 9th centuries). One of earliest works of Lombard school. Windows of Speyer Cathedral and sculpture of Quedlinburg (*116*) are instances of early effect of sculpture of S. Abbondio in Germany.

112 WEST PORTAL. S. Pietro in Ciel d'Oro, Pavia. 1120–30. Triangular gable at top is of classical inspiration. It contains relief of St. Michael flanked by donors, reflecting compositions on Ottonian ciborium in S. Ambrogio, Milan. Tympanum and lintel plain, originally no doubt painted. Alternation of arches with round and rectangular profiles, profusion of flat, decorative sculpture on recessed orders and framing columns, all characteristic of Lombardy. (See also *44*.)

113 CENTRAL PORTAL. Ferrara Cathedral. Signed work of Niccolò, c. 1135. Highly developed portal of eight recessed orders of Lombard type, enclosing carved tympanum with St. George and lintel with New Testament scenes. Carved on square jambs are figures of Virgin and Archangel Gabriel (Annunciation), Prophets Jeremiah (below Gabriel) and Isaiah (below Virgin), while Daniel and Ezekiel are on separate jambs. They are prototypes of column figures. Projecting porch with columns supported by atlases and lions (these last modern replacements). At top, Agnus Dei (compare *87*); in spandrels, John the Evangelist and John the Baptist, two witnesses to Christ (Lamb) as stated in first and last chapters of St. John's Gospel. Spandrel figures derived from Toulouse (*73*). Many other works by Niccolò survive (e.g., *43*). Style less monumental than Wiligelmo's, but more delicate, precise forms of almost metallic quality.

114 PULPIT. S. Giulio, Orta. c. 1115. Carved with symbols of evangelists, abbot (perhaps William of Volpiano, who was abbot here before going to Dijon and Normandy), animals, monsters, and foliage. Exuberance characteristic of Lombardy. Master of this work or his close follower also worked in Germany (see *117*).

115 CAPITALS OF INTERIOR. S. Michele, Pavia. 1110–20. Capitals of pilasters and columns are joined by continuous, frieze-like sculpture, in which motifs based on oriental textiles dominate. In spite of great richness, structure of capitals well emphasized by sculpture. Same idea of continuous capital frieze later used at Etampes and Chartres, but with narrative scenes (*94* and *96*).

116 CARVED IMPOST. South transept, Stiftskirche, Quedlinburg. c. 1100. Flat relief with repetitive motifs of birds and plants derived directly from Lombardy, especially Como (*111*).

117 CENTAUR AND STAG. Capital of tower arch, Mainz Cathedral. c. 1120. Lombard influences on German architectural sculpture can be seen clearly in imperial cathedrals of Speyer, Mainz, and Worms. At Mainz, it is possible to suggest that sculptor from Orta (*114*) was at work. Of two eastern doorways, one probably by him and another by his German follower.

118 PHARAOH'S ARMY IN RED SEA. Detail of marble baptismal font, S. Frediano, Lucca. c. 1160. Bowl made up of six sections, two with Good Shepherd and apostles under pointed arches by inferior artist, signed Robertus Magister, remaining sections with scenes illustrating story of Moses by master who obviously studied antique sarcophagi. He also carved top of font. Classicizing style, similar to that in contemporary sculpture in Provence (*80*, *81*).

119 EAGLE AND PERSONIFICATION OF SIN. Detail of south pulpit, Salerno Cathedral. Marble, between 1153 and 1181. Eagle with outstretched wings supports reading desk, motif universally used on Italian pulpits from at least 11th century. Often figure below is angel or merely decorative device. At Salerno and later at Sessa Aurunca, also in Campania, half-nude man with snake and being clawed by eagle is represented. Naturalism in treatment of body, especially head, shows influence of antique sculpture. Mosaic work on Campanian pulpits, Islamic in style, originated in Sicily.

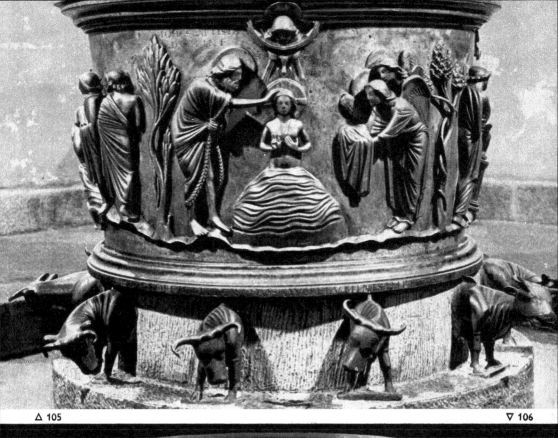

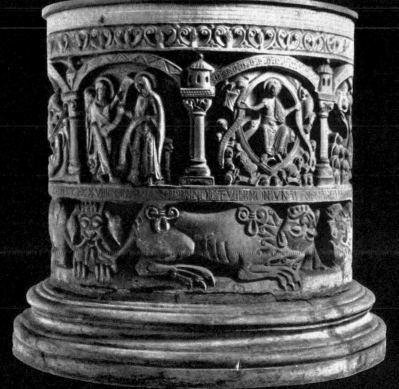

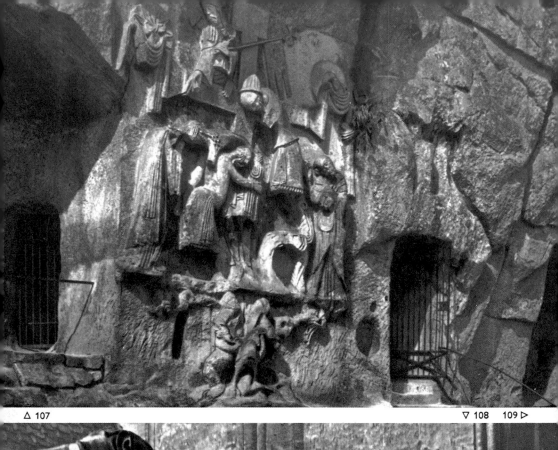

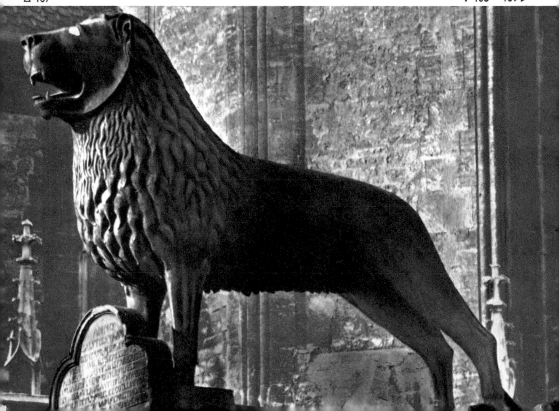

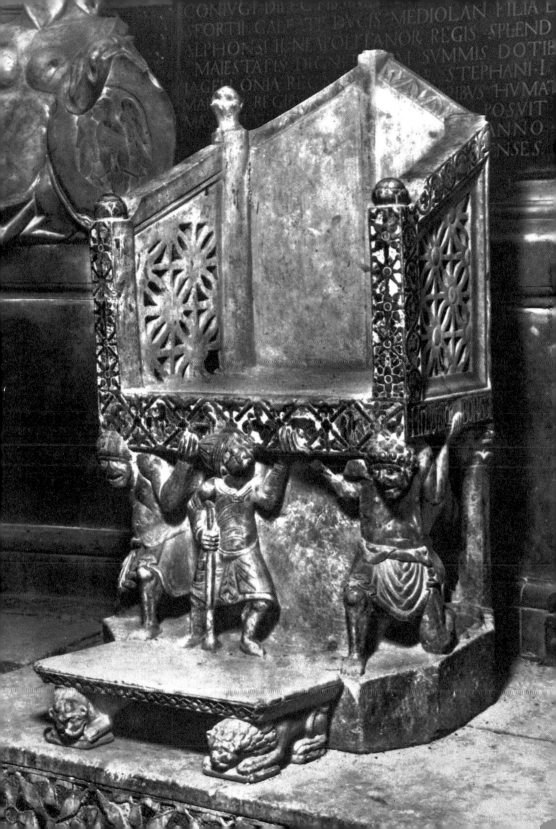

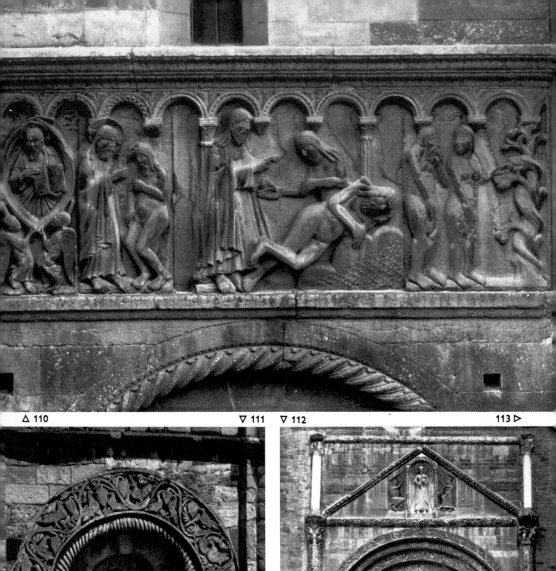

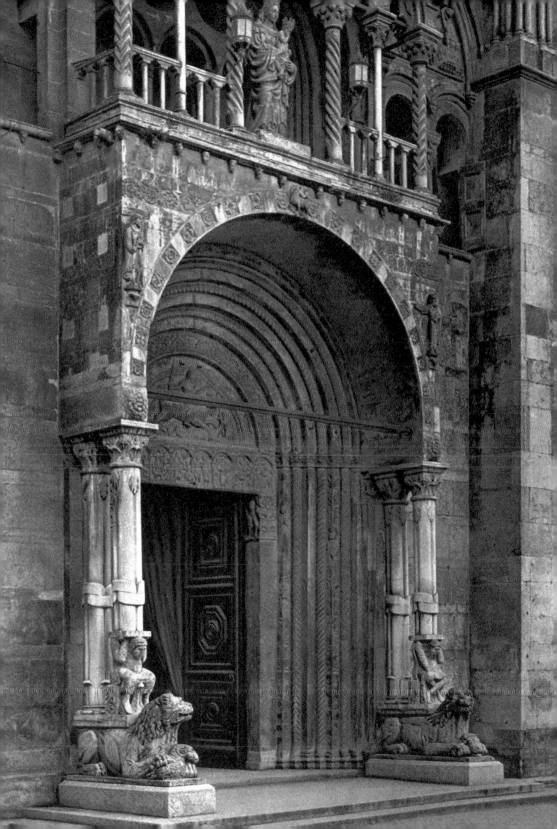

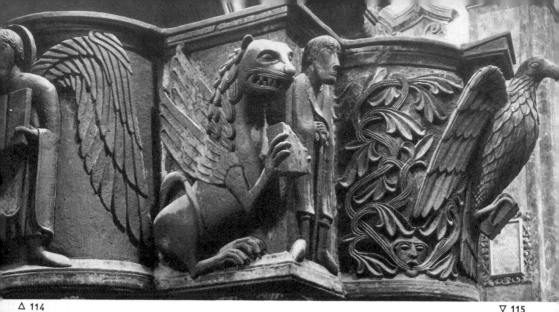

△ 114

▽ 115

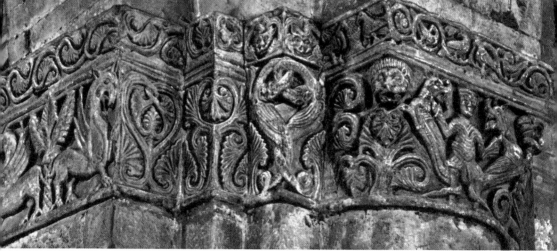

▽ 116

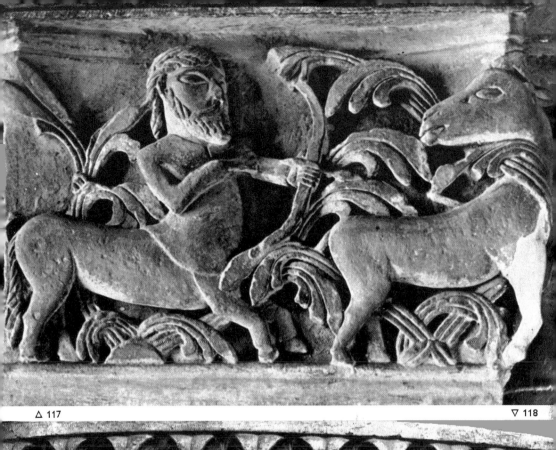

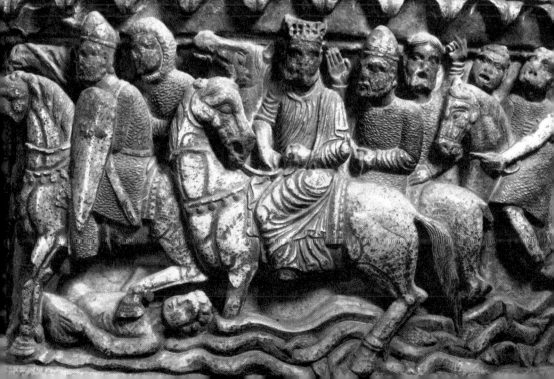

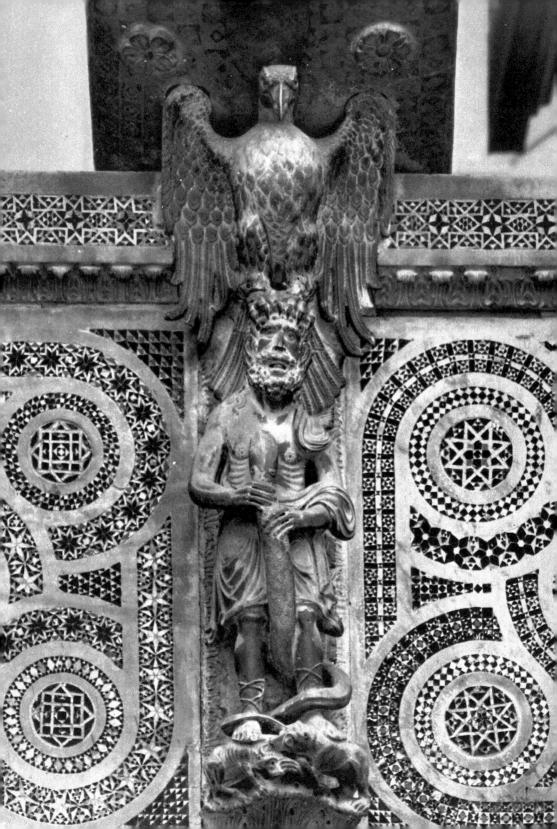

chiefly from western France but also from the proto-Gothic portal sculpture of the Île-de-France, adapting it to purely Romanesque decorative schemes.

The early appearance of Romanesque sculpture in Apulia has already been mentioned. Although it is not generally admitted, there are grounds for believing that Apulia was one of the main sources of inspiration for the art of Wiligelmo, the great sculptor of Modena Cathedral (*110*). His style is less refined than that of contemporary sculpture in Burgundy and Languedoc; on the contrary, his heavy, short, voluminous figures are almost ungainly. Yet they have great expressive power, a rare depth and conviction. Wiligelmo and his school were innovators in many respects. For instance, the portal with sculpture applied to rectangular panels on the jambs was first used in Modena and was repeated at St-Denis (*92, 93*). The school that developed in Emilia and expanded well beyond its borders included a sculptor called Niccolò, who was a worthy successor to Wiligelmo. He also contributed to the development of the portal by employing figure sculpture, cut into the depth of the jambs (*113*), a method imitated at Basel and Petershausen and as far north as Tournai in Belgium and Bury St. Edmunds in England. This method, though essentially different, anticipated the column figures of the French portals. Column figures in the style of Niccolò exist in Italy (Ravenna, Ancona, Piacenza, Perugia), but their dates are probably later than those of St-Denis and, in any case, they had no local following.

The school of Lombardy was, as far as its influence was concerned, the most popular of all the Romanesque schools of sculpture. It developed toward the end of the 11th century in Como (thence *corrente comasca*, as this style is sometimes called), as well as in Milan, Pavia, and numerous other centers, and within a short time became a favorite form of decoration in large parts of Europe. Fundamentally, it was an ornamental sculpture, in which religious subjects played a secondary role. Evolved on capitals (*115*), it spread to portals (*112*) and other features (*111, 114*) and, in extreme cases, invaded the whole façade (*44*). Armenian sculpture has been at times invoked as the source of these somewhat over-decorated churches, but that seems unlikely. We know, for instance, that, before its restoration, Modena cathedral had a façade which was decorated not only with the frieze of Wiligelmo but also with a veritable lapidarium of re-used Roman sculpture. The love of such a rich display of sculpture—un-Romanesque, since it was not integrated with the architecture—was rather the exception than the rule. It is likely that Lombardy was one of the sources of the sculpture of western France, but there the decoration was controlled by the architectural forms, as it was also in the best Lombard examples (*112*).

The *corrente comasca* spread to Germany (*116, 117*), to England—Ely Cathedral has, for instance, three portals of Lombard inspiration—to Scandinavia, and to Poland. The heyday of its development in Italy was the first half of the 12th century, but its effects north of the Alps were felt in some cases in the late 12th century—for example, the portal, the *Schottentor*, of St. Jakob in Regensburg.

Of other numerous local schools of sculpture, that of Tuscany deserves a special mention. At first it was not very distinguished, but by the middle of the 12th century it produced works of great beauty and importance. In common with the Provençal school, it developed a style so deeply indebted to classical art that it is sometimes described as proto-Renaissance.

◁ 119

The pulpit made for the cathedral of Pisa (now in Cagliari), the work of one Guglielmo of c.1160, is one of the masterpieces of the school, as is the baptismal font in S. Frediano in Lucca (*118*). It is enough to compare these works with the sculpture of Provence (*81*) to see that their close stylistic similarity is not only due to common, Roman sources but that there was a direct relationship between them, though it is not nearly so certain that the style originated in Provence and that it was not, in fact, the other way round.

The strong classicizing trend was marked in practically all Italian sculpture of the late 12th century. It was present in Campania (*119*), Apulia, Lombardy, and Emilia, as well as in the art of Benedetto Antelami of Parma (*120*), who belongs to the transitional period. But while in France the transitional period led to Gothic, in Italy it developed into the even more strongly classical art of Nicola Pisano.

We have already stressed the importance of Ottonian art in the development of Romanesque sculpture. The influence of Ottonian ivories and metalwork on the early sculpture of Roussillon, Burgundy, and Spain is evident, and it is very likely that future studies will reveal that the extent of these influences was far greater. Strangely enough, in Germany no great schools of architectural sculpture existed—certainly nothing comparable to the richness, variety, and high level of French development. We have stressed the beneficial results of the fusion of two distinct activities which were present in the 11th century, that of architectural sculpture and that of making sculptured objects. In Germany, architectural sculpture was, to a large extent, an importation, chiefly from Lombardy (*116, 117*). Regional schools developed rather late, as, for instance, in the Lower Rhineland, Alsace, Saxony, and Bavaria. Some superb works were produced, like the isolated rock carving at Externsteine (*107*) and numerous important, but usually small, tympana. The portal never assumed the same importance as in France, Italy, or Spain.

As in the 11th century, the 12th century in Germany was dominated by works of sculptors specializing in making carved objects for the interior of churches. In this field, German artists, the true successors of the Ottonian period, remained supreme. Their works are usually of the highest quality, and the inventiveness in their shapes and types of decoration seem infinite (*97, 102–4, 106*). Not surprisingly, these works owed more to Ottonian art than to the contemporary architectural sculpture of France or Italy.

English Romanesque sculpture, like architecture, was at first an importation from Normandy and was confined chiefly to capitals. Not until the early 12th century did regional schools make their appearance. Lombard influences, at first paramount, were superseded by an influx of forms from western France. These started to reach England from about 1130 onward, an early example being a regional school in the west of England, centered in Herefordshire, where the direct influence of Aulnay and Parthenay-le-Vieux can be detected. English sculptors were open to influences from many quarters. In interior sculpture, a German-inspired style is not infrequent (*128*). At times, in one decorative scheme, several models were used, as, for instance, at Lincoln Cathedral, where the portal had column figures, one of the earliest imitations of St-Denis outside France, while the frieze above (*126*) was following the example of Wiligelmo's work at Modena (*110*). By and large, monumental sculpture was rare in England (*127*), and ornamental works were more favored.

In this respect English and Scandinavian sculpture were similar, perhaps the result of a common Viking heritage. English influences were dominant in Scotland and, to a lesser extent, in Ireland, where direct artistic contacts with western France also existed. English decorative sculpture played some role in Scandinavia, but the main formative influence there came from Lombardy. In some cases, this Lombard style was used in an almost pure form, by migrant artists (as at Lund), but in the stave churches of Norway it was transformed into a highly original, dynamic form, in which the Viking taste for the elaborate, zoomorphic interlace was still alive (*134*).

In the countries of eastern Europe, where there was no tradition of stone sculpture, foreign artists easily found employment. In Poland, the predominant influences are those of Saxony (*131*) and Lombardy, while some striking examples in Hungary demonstrate a direct contact with Emilia as well as Lombardy.

The precarious Crusading Kingdom, where the building of castles was more vital than the decorating of churches, was not a suitable place for the emergence of a local school of sculpture. Such sculptors as were available were predominantly Frenchmen, and to them we owe some extremely beautiful pieces (*132, 133*) in which, although the French style is recognizable, there is an exotic element of almost oriental richness, perhaps due to the influence of local conditions.

120 PORTAL OF THE VIRGIN. Baptistery, Parma. According to inscription on lintel, work started in 1196 by sculptor Benedictus (Benedetto Antelami). Virgin and Child in central niche, Adoration of Magi on left, Joseph on right. On arch, twelve prophets holding medallions with busts of twelve apostles. On lintel, subjects particularly suited to baptistery: Baptism of Christ and Death of John the Baptist. Blending of styles from Provence and Ile-de-France, without, however, essential features of French portals of transitional period, such as column figures or voussoir sculpture.

121 CENTRAL PORTAL. Borgo S. Donnino (Fidenza) Cathedral. By Antelami and workshop. Early 13th century. Composition owes something to Provence (frieze) and northern France (voussoirs), but also new elements such as figures (David and Ezekiel) in niches. Here sculpture is autonomous and thus anticipates Renaissance.

122 DOUBTING THOMAS. Panel on cloister pier, S. Domingo de Silos. Late 11th century. While capitals of cloister (69) are based on Islamic models, the several panels are based on early Romanesque ivories and Mozarabic illuminations. Plate draperies perhaps connected with Cluny III (82). Resulting style delicate, linear, precocious.

123 APOSTLE. Detail of marble column, Puerta de las Platerias, Cathedral, Santiago de Compostela. c. 1105. Three slender marble columns carved with pairs of figures under arcades, three pairs above each other. Arrangement unprecedented. One figure is St. Peter, others probably apostles and saints. Stylistically related to sculpture in Toulouse prior to Porte Miègeville (73), but delicacy of workmanship suggests connection with ivories.

124 KING DAVID AS MUSICIAN. Granite relief on west side of Puerta de las Platerias, Santiago de Compostela. c. 1120. Closely connected with mature "pilgrimage style," e. g., Porte Miègeville and portals of S. Isidoro, León. Round undulating soft forms; high relief emerging from neutral background.

125 PUERTA DE LA PLATERIAS. Cathedral, Santiago de Compostela. Early 12th century,

with some later additions. As at Toulouse, here aisles around transept dictated necessity of twin portals to avoid placing single portal in front of pillars. Santiago had two such portals, but north one destroyed and some sculptures reused on Puerta de las Platerias, twin portals of south transept. Originally (c. 1105) portals had no tympana; these many reliefs, and spandrel sculptures were added later. Cusped windows of Islamic design.

126 TORMENTS OF DAMNED. Detail of frieze, west front, Lincoln Cathedral. c. 1145. Imitation of Wiligelmo's frieze at Modena (110), but extended iconographically to include New Testament scenes and Last Judgment. Portals below based on St-Denis and one included column figures. Scenes of torments in hell on frieze given prominence. Vigorous, plastic style unusual in chiefly linear, decorative sculpture in England.

127 SIX APOSTLES AND FLYING ANGEL. Tympanum in south porch, Malmesbury Abbey. c. 1165. Three sides of porch decorated with sculpture as, e. g., at Moissac. Over inner portal, Christ in Majesty; on side walls, apostles. In spite of French elements, style very individual, powerful, almost brutal. Overemphasis in modeling of folds, exaggeration of gestures and expressions.

128 HEAD OF APOSTLE. Detail from *Christ at Gates of Bethany*. Chichester Cathedral. c. 1120. Two reliefs and fragments of others were part of screen. Second relief shows Raising of Lazarus. Inspired by Ottonian models (e. g., Hildesheim column). This may explain similarity in facial types to relief at Externsteine (107).

129 TOMBSTONE OF CRUSADER AND HIS WIFE. Chapel of dukes of Lorraine, Nancy, from priory of Belval. Third quarter 12th century. Said to be tomb of Count Hugues I de Vaudémont, believed dead during Second Crusade (1147) but who returned sixteen years later and died soon afterward. Dressed as pilgrim to Holy Land; shown embracing his wife. Tenderness never expressed in this way in Romanesque tombs elsewhere. Work of west German sculptor. Sculptures at Verdun and Metz are similar stylistically.

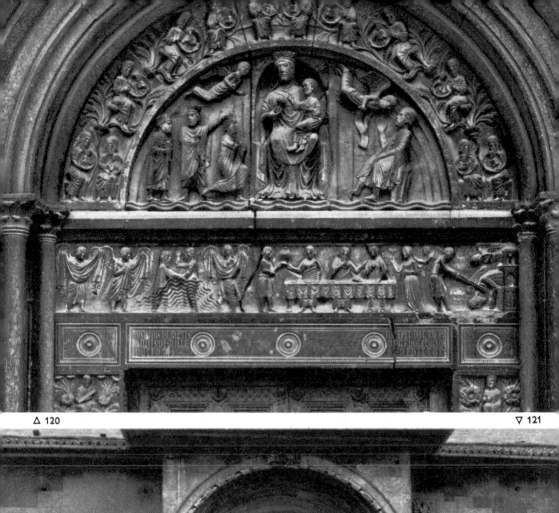

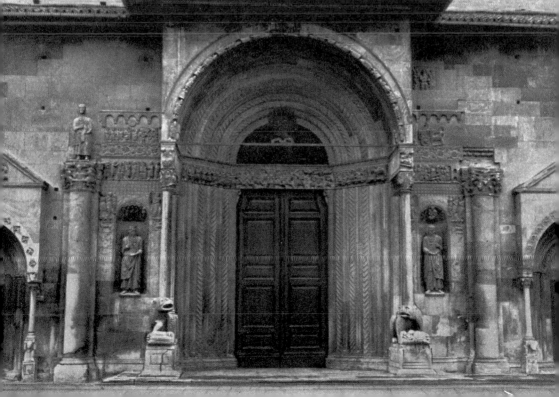

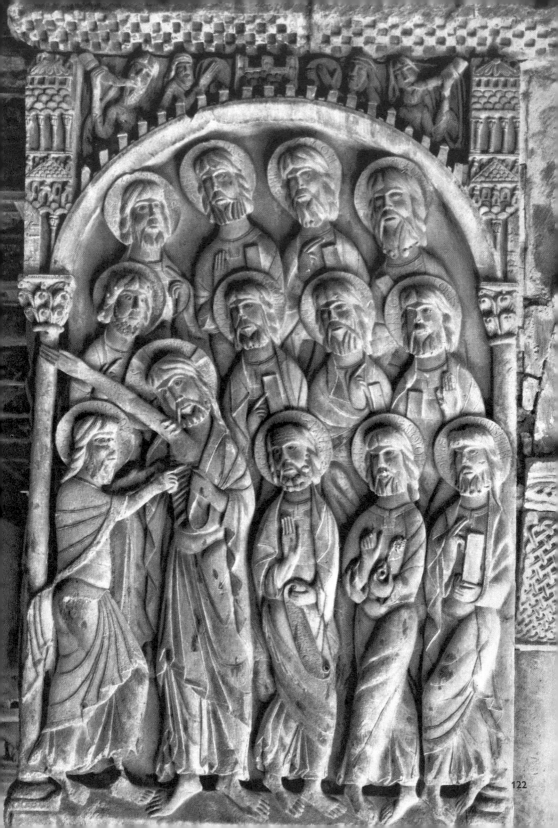

122

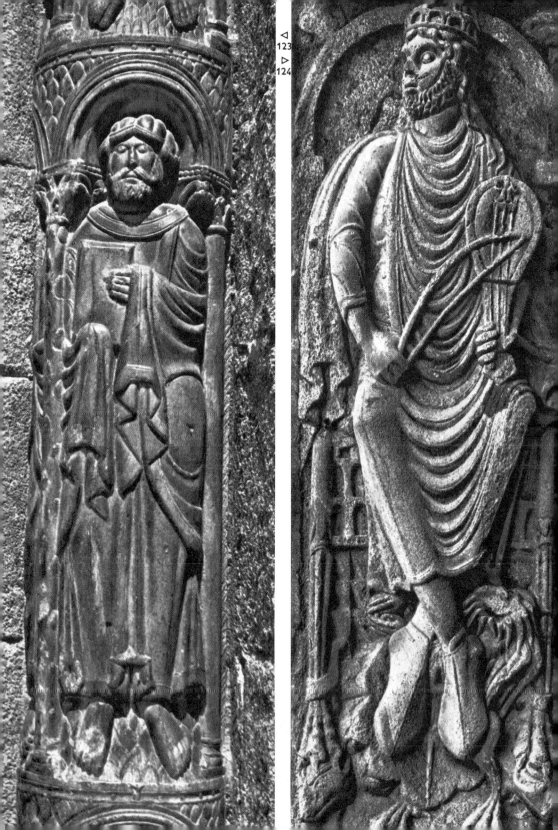

◁ 123
▷ 124

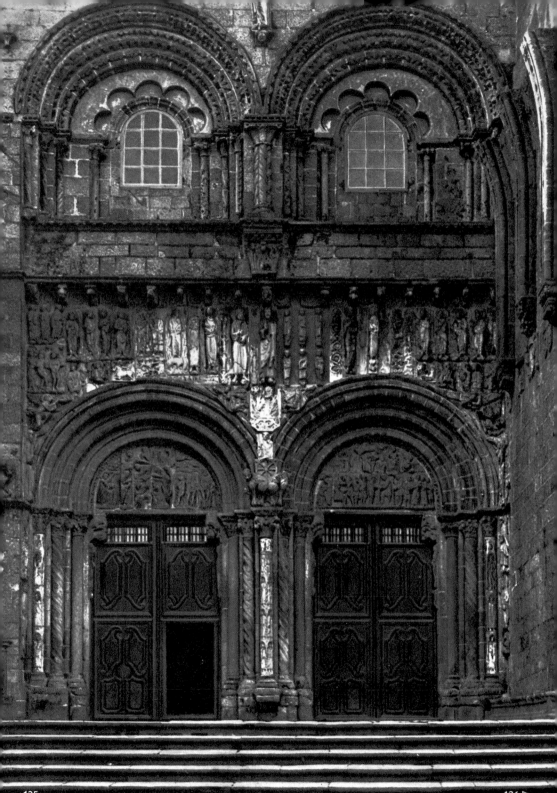

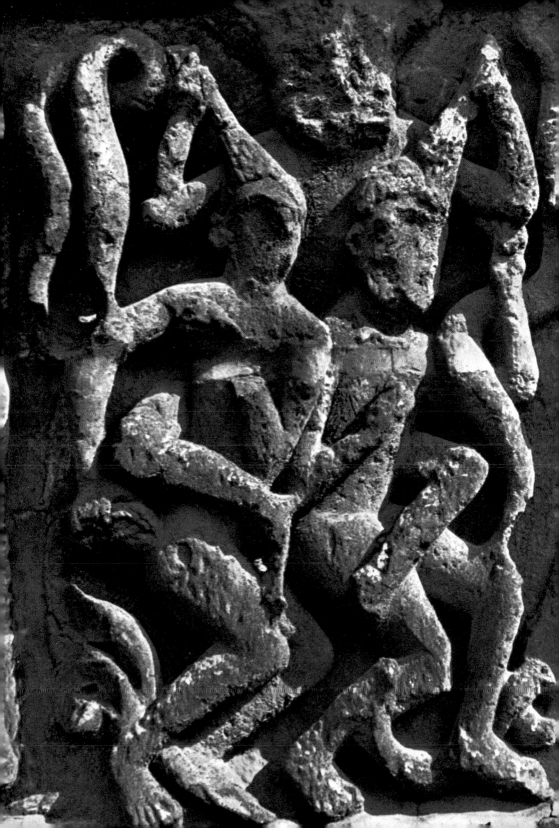

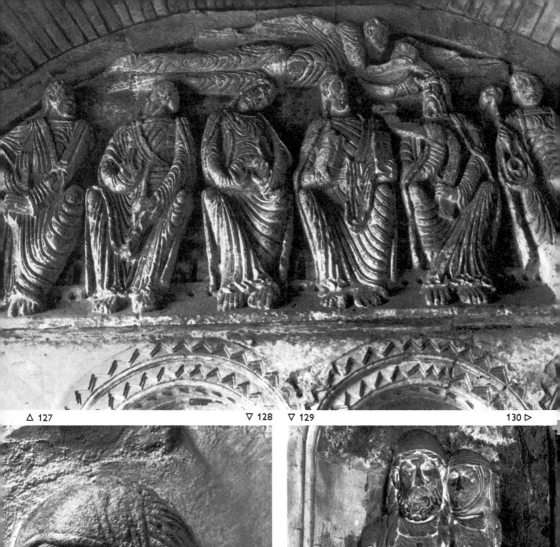

△ 127 ▽ 128 ▽ 129 130 ▷

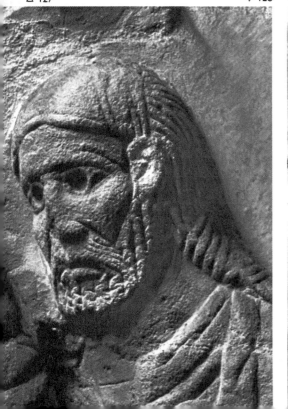

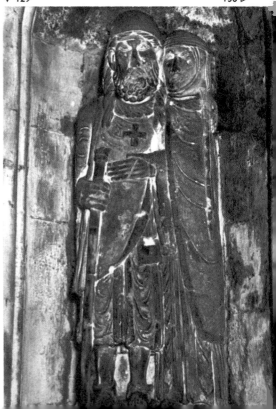

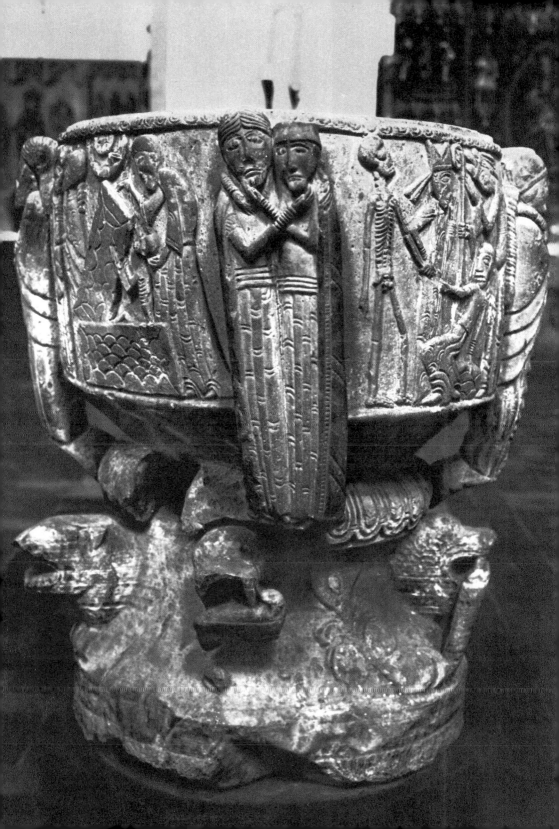

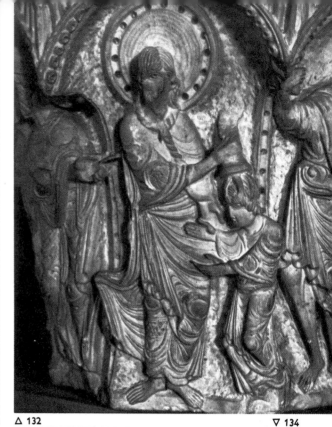

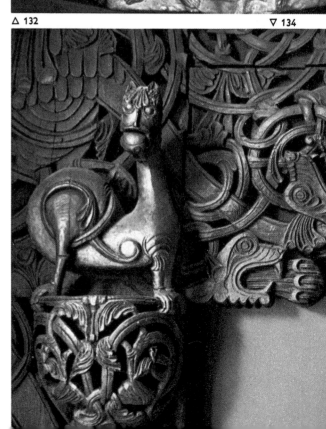

130 BAPTISMAL FONT. Tryde Church. Second half 12th century. One of group of highly original fonts in Scania (Skåne) in Sweden (which was part of Denmark in the 12th century). No other part of Europe, except England, had such variety of fonts as Scandinavian countries. Beasts at base are imitations of Italian lions supporting columns and at times fonts. On bowl, scenes in low relief probably from life of St. Aya (not Stanislaus of Cracow as is often claimed since he was canonized only in 13th century). Pairs of figures (including two, probably Christ and Ecclesia, embracing) link bowl with base.

131 VIRTUE. Detail of column. Church of Premonstratensian Nuns (Holy Trinity), Strzelno (Poland). c.1170. Large columns of nave arcade carved with superimposed arcades representing Virtues and Vices. No parallels exist for so richly decorated interior columns, but style derived from Saxony (Hamersleben, Huysburg, Hildesheim).

132 DETAIL OF CAPITAL. From cathedral, now in Franciscan Monastery, Nazareth. Third quarter 12th century. Five capitals from this church survive, executed by French sculptor of great talent. In agitation of forms, close similarity to late Burgundian school (e.g., 87), but closest parallel exists among capitals at Plaimpied in Berry. Extensive use of drilling and concentric folds of draperies, characteristic of both groups of sculpture.

133 TORSO. Brought from Holy Land. Duke of Devonshire Collection, Chatsworth. Arbitrary, concentric folds, very deeply undercut. Stylistic connection with previous example, but more extreme agitation.

134 DETAIL OF PORTAL. From Ål Church (Norway), Universitetets Oldsaksamling, Oslo. Wood. c.1150. Great number of similar portals of stave churches survive. Their decoration combines animal and plant interlaces of pure Viking origin with acanthus and lions of Italian derivation, but transformed out of recognition by native Scandinavian taste for complicated patterns.

METALWORK

Contrary to the modern idea that the works of the so-called applied arts or minor arts are somewhat inferior to the products of the major arts, such as architecture, sculpture, and painting, medieval men placed these works very high in their estimation. Contemporary texts speak more often of such objects than of, say, architectural sculpture. The case of St-Denis Abbey, for instance, is quite typical. When Abbot Suger sat down to write *De rebus in administratione sua gentis* (On what was done under his administration), he only casually mentioned the three portals of the west front but was very detailed in his description of what he calls the "ornaments" of the church: the golden altar frontal, the golden crucifix, the stained glass windows, the candlesticks, the golden chalice, the sardonyx chalice, the gold vessel in the form of a boat, the crystal vase adorned with gems and gold, the porphyry vase with a gold and silver eagle setting, and many other items. Some of these objects still exist, and no wonder Suger was so proud of them, for they are of superb craftsmanship and of great beauty. Medieval men were, of course, impressed by the material value of objects made of gold and adorned with precious stones, but they also appreciated the workmanship. Suger himself uses the phrase *Materiam superabat opus* (the workmanship surpassed the material).

Thanks to modern scholarship, we realize that, not infrequently, these works of the luxury arts—it is better to call them that rather than the somewhat derogatory term minor arts—were in the forefront of artistic development, and we know that large-scale sculpture and wall painting often followed their example and imitated their style. Unfortunately, objects made of precious materials were exposed to more dangers than those made of stone. In times of economic need they were often pawned and never recovered or were melted down to be sold. They were often pillaged or stolen in wars or revolutions and even in peacetime. As they were always in use, they required repair and alteration. Changing fashions caused them to be discarded or completely reworked. The great treasuries of monasteries were especially subjected to ruthless treatment during the various periods of the suppression of the monastic orders. In England particularly, the destruction of objects of the luxury arts in churches was almost total, because of the Reformation and the onslaught by the Puritans in the 17th century against all "superstitious" objects. Thus our knowledge of the English luxury arts is confined to a very small number of pieces that left England during the Middle Ages or those that were hidden or lay buried in tombs. But even though we can never have a satisfactory knowledge of this branch of artistic achievement, the surviving material makes it possible to reach certain general conclusions.

The techniques used in making Romanesque works in metal were numerous and complex. They demanded a skill that could be acquired only by long training. We are fortunate in having a treatise on the various arts, *De diversis artibus* (On Diverse Arts), which, written in all probability c. 1100, gives a detailed account of the techniques then in use. The author of this famous book was a monk and priest, Roger, writing under the name Theophilus. He was a practicing craftsman, with a detailed and practical knowledge of many techniques, more especially those of working in metal. There are good reasons for believing that he was

a German, and the identification of Roger-Theophilus with Roger of Helmarshausen, a monk and metalworker (*143*), is plausible. Theophilus devoted the largest part of his treatise to metalwork, and his text is a mine of information about workshop equipment and tools, about various metals and their properties, about casting, punching, making repoussé, engraving, gilding, enameling, vernis brun, niello, openwork, and about making various objects such as chalices, censers, organs, and bells.

Since Carolingian times, German craftsmen had aquired great skill in metal techniques, and these were revived and reached new heights of perfection during the Ottonian period. The German reputation for skill in metalwork is well reflected in the term *opus teutonicum* (German work) given to a screen made c. 1065 of bronze, gold, and silver at Beverley Minster in Yorkshire, not because it was necessarily made by German craftsmen but because metalwork was a technique associated with the excellent German workmanship in this medium.

During the Romanesque period, three main geographical centers of metalwork existed in the empire: Saxony, the Meuse valley, and the Lower Rhineland. In Saxony, bronze casting on a large scale had been practiced since the early 11th century. The Hildesheim doors (*136*) and the so-called Bernward column, also at Hildesheim, are the best-known Ottonian works in bronze in the province, and they have worthy Romanesque successors in the tomb plate of Rudolf of Swabia in Merseburg, of c. 1080 (*104*), a work of great elegance, and the monument to Henry the Lion in Brunswick, of 1166 (*108*), a unique example of the symbolic representation of a 12th-century ruler, set up in a public place. Toward the middle of the 12th century, Magdeburg became an important center with an international reputation for the casting of bronze. It is likely that the early bronze panels of S. Zeno at Verona (*135*) were made by the Magdeburg founders, who, on their return, used some of the motifs of the sculptural decoration of S. Zeno executed by Niccolò, in their subsequent works namely, the tomb of Archbishop Friedrich von Wettin (d. 1152) in Magdeburg Cathedral and the bronze doors made for the cathedral at Plock in Poland, now in Novgorod in Russia.

One of the most important and influential metalworkers in Saxony was undoubtedly Roger of Helmarshausen, active early in the 12th century, who was probably, as has already been mentioned, the Theophilus who wrote the artists' manual. His surviving works include two portable altars, one of Sts. Kilian and Liborius (*143*) in Paderborn Cathedral and the other of St. Blaise made for Abdinghof Abbey, but now also in Paderborn (Franciscan Church). In these works, based on Byzantine models, he evolved a linear, dynamic figure style that was to be widely imitated for a long time to come.

No greater contrast can be imagined between Roger's agitated figures, built up of small forms which are closely defined by engraved outlines, and the nearly contemporary style of the Mosan school, which developed in the Meuse valley, with Liège as the chief center. Mosan art was the most distinctive and its development the most consistent of all 12th-century regional schools. It included all media—painting, sculpture, ivory carving, as well as metalwork. The names of three Mosan artists of succeeding generations span the century: Reiner of Huy, Godefroid de Claire, and Nicholas of Verdun. The first executed the cast bronze baptismal font at Liège (1107–18) (*105*), which is a masterpiece of European art. The figures, unlike those in the works of Roger of Helmarshausen, are truly three-dimensional;

135 EXPULSION FROM PARADISE. Detail of bronze doors, S. Zeno Maggiore, Verona. c. 1140. Doors consist of two wooden wings with cast bronze panels nailed to them. They exhibit two different styles, one usually dated to late 11th century, the other to late 12th century. However, earlier panels were probably made not in 11th century but when portal was nearing completion, c. 1138. Inspired by Ottonian doors at Hildesheim (*136*). Artist simplified figures, reducing them to bulky, geometric shapes, but gave them life and character by psychological observation. Probably work of Magdeburg workshop, which later made doors now in Novgorod.

136 EXPULSION FROM PARADISE. Detail of bronze doors, Hildesheim Cathedral. Commissioned by Bishop Bernward for St. Michael's, 1015. Biblical scenes derived from Carolingian illuminations. Cast in two solid wings. Constant inspiration for Romanesque artists (*135* and *137*).

137 CREATION OF ADAM. Detail of embossed silver gilt shrine of St. Isidore, given by Ferdinand I and Doña Sancha in 1063. Treasury, S. Isidoro, León. Influenced by Hildesheim doors, notably in more plastic treatment of heads than bodies. In contrast to natural forms of Ottonian work, figures here conceived in geometric terms.

138 JOURNEY OF THREE MAGI and below STORY OF ADAM AND EVE. Detail of bronze doors, Porta di S. Ranieri, Pisa Cathedral. By Bonannus of Pisa, c. 1180. Cast in twenty panels fixed to wooden core. Bonannus made doors for central portal (destroyed) and in 1186 for Monreale in Sicily. Strong Byzantine elements in his style, present also in contemporary Pisan stone sculpture. Some scenes (e. g., Expulsion, bottom right) copied from Byzantine ivories.

139 ST. HADELINUS HEALING A MUTE WOMAN. Detail of St. Hadelinus shrine, originally in Celles Abbey, now in Visé Church. Silver gilt, vernis brun for haloes. c. 1140. Earliest of Mosan shrines. Strong three-dimensional quality, already present in Liège font (*105*), also present here. Soft, rounded folds emphasize structure of human body.

140 ST. ADALBERT PLEADING FOR SLAVES BEFORE PRINCE BOLESLAV II OF BOHEMIA. Detail of cast bronze doors. Gniezno (Gnesen) Cathedral. c. 1170. Two wings cast in solid pieces. Each scene firmly framed and each wing has border of "inhabited scrolls." Relief flat, draperies arbitrary, decorative. Some scholars wrongly claim Mosan origin. Indebted to illuminated manuscripts for style and iconography, since Adalbert (d. 997) was comparatively new saint, without established iconography.

141 RELIQUARY TRIPTYCH OF HOLY CROSS. Silver gilt, embossed. Ste-Croix, Liège. Height 55 cm. c. 1160. In center, two angels (Veritas and Judicium) display relics of the True Cross (given by Emperor Henry II) inscribed *Lignu[m] Vit[a]e*. Above, enamel plaque with angel (Misericordia). In lunette below, Elect. On wings, busts of apostles; on top, Christ showing his wounds. One of series of Mosan works continuing soft, classicizing style first found in Liège font and leading toward proto-Gothic sculpture in Ile-de-France.

142 FIGURE SUPPORTING THE SO-CALLED KRODO-ALTAR. Cast bronze. Originally in cathedral, now museum, Goslar. Early 12th century. One of four supporting figures, inspired by classical representations of Atlas supporting heaven. Should be compared to Bari Throne (*109*). Artist in Lower Saxony conceived freestanding figure more in geometric shapes, while Apulian sculptor followed antique model more closely.

135 ▷

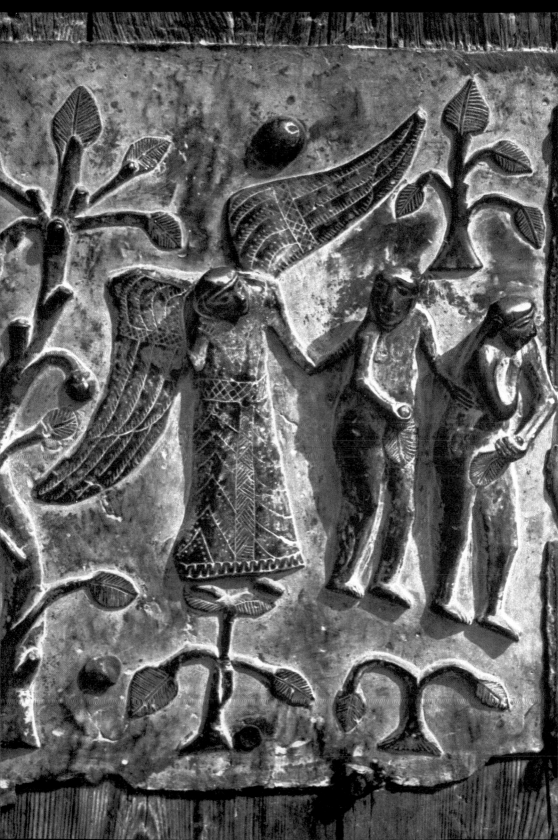

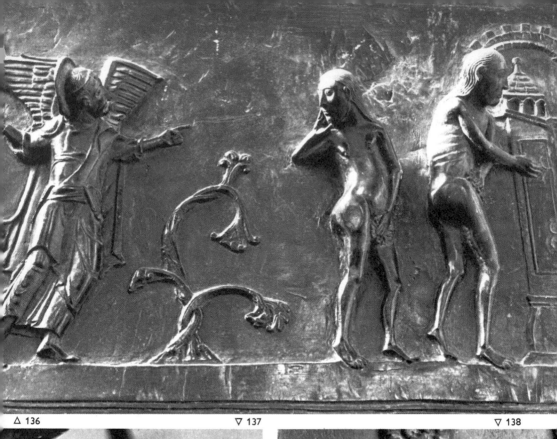

△ 136 ▽ 137 ▽ 138

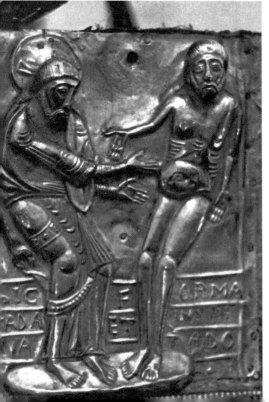

There's a top image with text, and a bottom image.

Top border text: "CORDE · PRECES · SOLVIT"

Within the top image there are inscriptions: "HADEWIND", "H MUTA", "P...", "POPVL..."

CORDE · PRECES · SOLVIT

△ 139

▽ 140

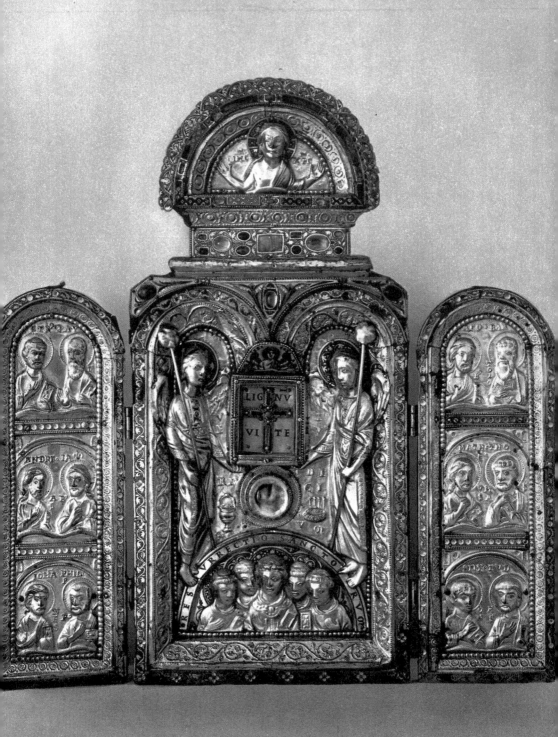

142 ▷

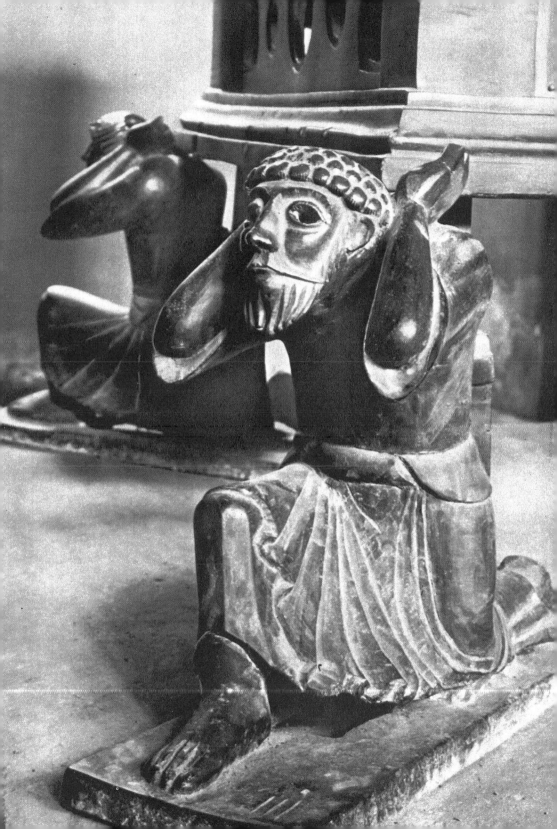

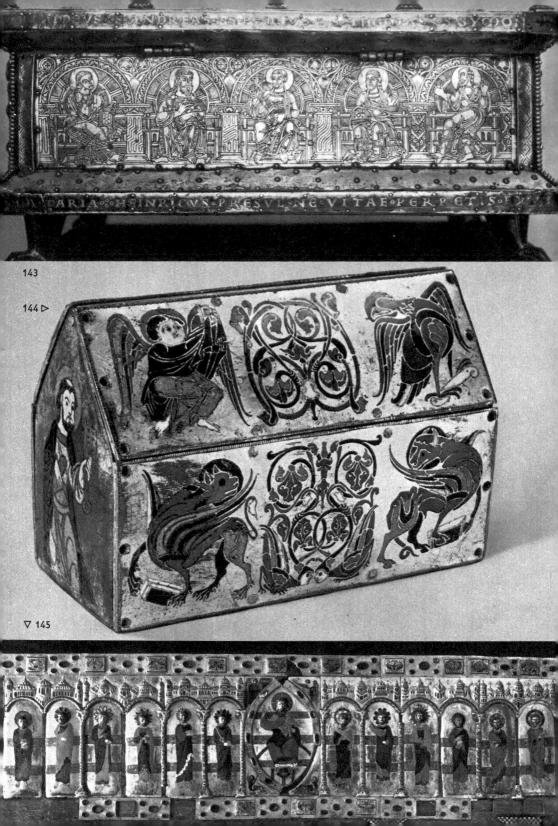

143

144 ▷

▽ 145

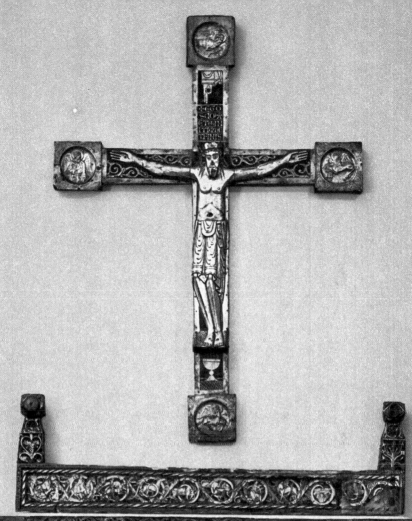

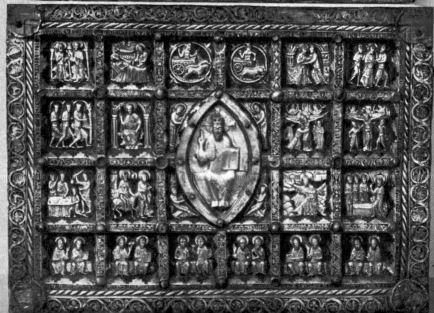

146

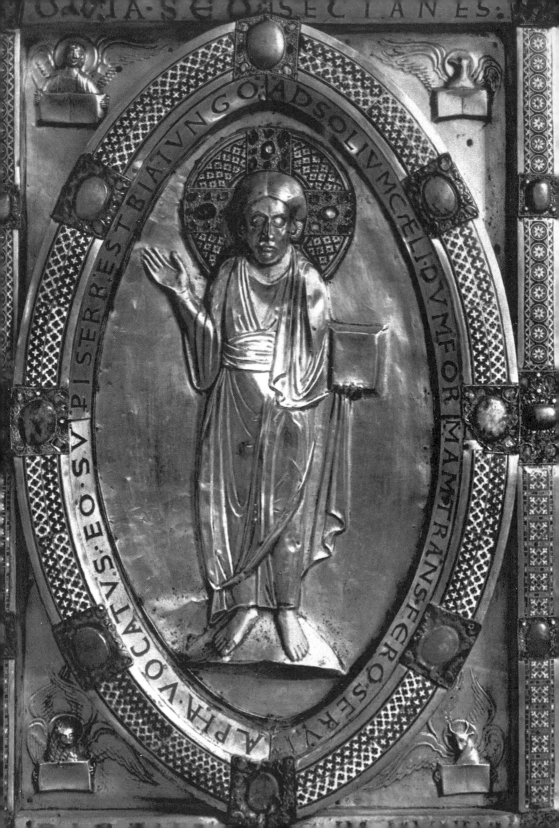

the structure of the human form is well understood and anatomically correct, while the movements and gestures are natural. Yet these figures are not in any way naturalistic; on the contrary, they are idealized. The gentle, rounded forms are clearly not taken from nature but derived from some models of a vaguely "classical" type. It has been convincingly suggested that Reiner's style was based on Ottonian ivories from Liège, which were derivatives of the Metz school if ivories dating from the second half of the 9th century and which in turn were inspired by late classical sources.

The classicism of the Liège font was not due to the whim of one artist but was obviously a trend that embraced all artistic production, most notably manuscript painting. Moreover,

143 St. Peter and Four Other Apostles. Long side of portable altar of Sts. Kilian and Liborius. Given by Bishop Heinrich von Werl (1084–1127). Made by Monk Roger of Helmarshausen, c. 1100. Engraved silver. Height 16.5 cm. Paderborn Cathedral. Chief source of Roger's dynamic style was Byzantine "damp-fold" drapery, a device by which the draperies, as if wet, cling to the body, revealing its shape and movement. Thin folds, often merely two parallel lines, further emphasize the body underneath. Roger adopted and modified this device to achieve all-over pattern of enclosed forms, embracing figures and backgrounds. Everything expressed by strictly linear means, unit added to unit. Yet by this ornamental, geometric, abstract method he made figures appear almost three-dimensional. This is Romanesque style *par excellence*.

144 Four Symbols of Evangelists. Reliquary casket. Champlevé enamel. Metropolitan Museum of Art, New York. c. 1150. Among saints represented is St. Martial whose relics were particularly venerated at Limoges. Limoges became center of enamel production in 12th century and this object was probably made there in spite of similarity to Spanish works.

145 Christ in Majesty and Twelve Apostles. Altar frontal from S. Domingo de Silos. Gilt copper with champlevé enamel plaques. Height 85 cm., length 235 cm. Third quarter 12th century. Museo Arqueológico, Burgos. Enamel figures hieratic, of Byzantine inspiration. Heads cast in relief. Clear, rich colors, lavish use of ornament and architectural framing. Border with semiprecious stones and small plaques with animals and scrolls, similar to those in *144*.

146 Altar from Broddetorp Church (Vestergötland, Sweden), now Statens Historiska Museum, Stockholm. Embossed gilt copper, vernis brun. Consists of altar frontal, low retable board with finials and crucifix. Frontal: Christ in Majesty in center, four angels support mandorla. Above, plaques of Sun and Moon in chariots; below, six plaques each with pair of apostles. On remaining twelve panels, scenes from New Testament beginning with Annunciation, ending with Ascension. In corners symbols of evangelists (damaged) and four more on arms of cross. Lavish borders with scrolls in vernis brun. In same technique, inhabited scrolls on retable board and scrolls on cross. One of group of Scandinavian altars of 12th century in which influences from England and Germany are mingled. Viking taste for agitated forms still surviving.

147 Christ in Mandorla with Symbols of Evangelists. Detail of altar frontal. Gilt copper, embossed, cloisonné enamel. Height of whole 78 cm. Commissioned by Abbot Harting, c. 1130. Gross-Komburg Church. Compact, massive, frontal figure of Christ, with well-defined outlines, brings to mind figures of evangelists at Freudenstadt (*103*), but garments are more natural, arranged in gentle curves, result of contact with Mosan art.

◁ 147

it was the form of expression that continued to develop throughout the 12th century, culminating in the work of Nicholas of Verdun.

The Visé shrine of St. Hadelinus, c. 1140 (*139*), is in a direct line of descent from the style of Reiner of Huy but, as if the artist could not free himself completely from the conventions of Romanesque art, the figures are still built up of separate units with a heavy stress on their ornamental values.

It is in the works from the middle of the 12th century onward, especially in enamels attributed to Godefroid de Claire and related works, that the figures acquired greater plasticity and organic unity. The folds of the garments are tubular and their existence is no longer merely decorative but structural in the sense that they serve as a means of suggesting the structure and movement of the bodies underneath. This new phase in the development of Mosan metalwork and painting (e. g., *148*) exercised a widespread influence on adjoining regions, the Lower Rhineland, northeastern France, and even England. Out of this style developed the art of Nicholas of Verdun and the whole artistic movement that brought Romanesque art to an end.

Metalwork in the Lower Rhineland, with Cologne as the main center, was no less important for the general history of art than that of the Mosan region, with which it had close contacts. The famous Werden crucifix *(102)*, a large cast bronze work of c. 1070, was perhaps made in Cologne, although it was originally at Helmstedt in Saxony. The reason for suggesting that the crucifix was made in Cologne is based on the fact that the closest stylistic parallels for it are to be found in manuscript paintings made in Cologne. However, the attribution of the Werden cross to Cologne is open to some doubt since the large-scale bronzes of the period are predominantly Saxon and the only comparable bronze crucifix (though somewhat later), at Minden, is unquestionably a Saxon work. The Rhenish equivalent of the classicizing style that developed in the first half of the 12th century in the Meuse valley was the work of Eilbertus of Cologne and his followers, active in the second quarter of the century. It was probably in this outstanding workshop that the technique of champlevé enamel was revived in northern Europe (e. g., shrine of St. Victor at Xanten, c. 1129). In the portable altar by Eilbertus from the Guelph Treasure in Brunswick Cathedral (now in Berlin), the figures of the prophets on the sides of the altar are executed in champlevé, which still closely resembles the cloisonné technique with metal bars separating each color. Consequently, the style is rather rigid. But the apostles and New Testament scenes on the top of the altar are in a more fluid style, which combines the liveliness and movement of Roger of Helmarshausen with the soft plasticity of Mosan art.

Cologne metalworkers excelled in making reliquaries of elaborate shapes, often in the form of miniature domed churches, and they often combined a metal structure embellished with enamels, with ivory figures placed in the niches. But the most important Cologne shrines are those that show a Mosan influence. The huge St. Heribert shrine at Deutz, across the Rhine from Cologne, made c. 1160 in the form of an antique sarcophagus—it is 153 cm. long, 68 cm. high—is covered with enamels and embossed figures and ornaments.

Aachen was already established as a center for metalwork in Carolingian times, when the bronze doors and balustrades for the minster were cast. Of Romanesque works, the most

outstanding are those associated with the patronage of Frederick I Barbarossa. They include the bronze gilt candelabrum, given by the emperor in commemoration of the canonization of Charlemagne in 1165; the baptismal silver-gilt bowl, engraved with the scene of the emperor's baptism, which was given between 1155 and 1171 to Count Otto von Kappenberg, the emperor's godfather; and the portrait bust of the emperor, which was used subsequently as a reliquary (153). These works, strongly influenced by Mosan "classicism," precede, by a few years, the arrival of Nicholas of Verdun in Cologne. Having completed the pulpit (now made into an altar) at Klosterneuburg in 1181, he was undoubtedly collaborating on the shrine of St. Anno at Siegburg, completed in 1183, and soon afterward turned to making the shrine of the Three Magi in Cologne and the shrine of the Virgin at Tournai, completed in 1205. With these works by the greatest of Mosan artists, Romanesque art became a thing of the past.

English metalwork of the Romanesque period was closely connected with developments on the Continent. The celebrated Gloucester candlestick (152) of c. 1110 is a masterpiece of craftsmanship in delicate and intricate bronze casting. Its motifs are derived from early Romanesque manuscript paintings of the Canterbury school, but the general shape is based on the Ottonian silver candlesticks of Bernward of Hildesheim. Also connected with manuscript painting models is the doorknocker of Durham Cathedral (154), perhaps the most original of all Romanesque knockers, of which many examples survive all over Europe. English enamels are deeply indebted to the Mosan style but are nevertheless distinctive. Perhaps the most independent, stylistically, is the plaque with the Last Judgment, a composition full of agitation and in a linear style similar to that found in English manuscript painting of the second quarter of the 12th century. A fairly large number of 12th-century lead fonts survive in England, and their types and their distribution suggest the existence of a flourishing industry, which mass produced these objects. But since England was, during the Middle Ages, the chief lead producing country in Europe, this was to be expected. The only bronze doors mentioned in documents were those made in the second quarter of the 12th century for Bury St. Edmunds Abbey, and they were destroyed after the abbey was dissolved in 1539. The huge Easter candlesticks mentioned in medieval documents—the one at Durham Cathedral spread across the whole width of the choir—all perished. Several large metal candlesticks still survive in other countries, and some of these have been attributed to England. At Rheims there is the foot of a candlestick which must have been very large indeed, and another, complete, was given, in modern times, to Milan Cathedral. The former is of the second quarter of the 12th century and the latter is of the transitional phase, c. 1200, and some scholars believe that they were made in England.

A large group of bronze-gilt altar frontals of Danish workmanship—which survive in Denmark and Sweden (146)—combine elements of English and Saxon inspiration.

French metalwork, like that in England, is known from isolated examples which make the study of the general development very difficult. The production of cult images carved in wood and covered with embossed sheets of precious metals had a long tradition in the central regions of France, the famous one at Ste-Foy in Conques being the oldest existing example. It is chiefly from the 10th century, with older portions, and has been altered and

repaired many times. There are a few Romanesque cult figures of this type (98). Enamels were no doubt introduced into France from the Meuse region (151), but the beginnings of the industry which developed so prodigiously in the second half of the 12th century and in the 13th century at Limoges are obscure, especially as some early enamels are very close in style, colors, and designs to those for which a Spanish origin seems very likely (144, 145, 149, 150).

In Spain, the early influence of Ottonian artists and imported works led to a blossoming of all the luxury arts, including metalwork. The reliquary of St. Isidore at León (137), made c. 1063, although it is a repoussé silver and partly gilt work, was unquestionably inspired by the Ottonian bronze doors at Hildesheim (136). Very soon, however, Spanish works evolved a style that was less dependent on foreign models but turned for inspiration to native, Mozarabic sources, and this was often combined with decoration of Islamic origin. The famous Arca Santa, a large silver reliquary given to the cathedral at Oviedo by Alfonso VI and his sister Doña Urraca in 1075, consists of repoussé scenes on the sides and engraved ones on the top. It is a work of great richness. The agitated figures have a linear quality which suggests a connection with manuscript painting, and the Kufic script used as an ornamental border hints at some contact with the sophisticated culture of the Arabs, who still possessed large parts of the Peninsula.

The artistic crosscurrents from many directions, which characterized the whole of Romanesque art in Italy, are also very visible in the metalwork surviving there. Byzantine elements were dominant in Venice, where very competent imitations of Greek models were made. But Byzantine works were popular in other parts of Italy as well. For instance, engraved bronze doors were frequently commissioned in Constantinople and presented to

148 FOOT OF CROSS FROM ST-BERTIN ABBEY. Gilt bronze, champlevé enamel. Height 31 cm. c. 1160–70. Museum, St-Omer. Believed to be smaller version of large cross made under Abbot Suger for St-Denis Abbey. Supported by four evangelists with their symbols behind them. On hemispherical base and square shaft above, enamels with Old Testament scenes—on reproduced photograph, Jacob blessing Ephraim and Menasseh (Genesis 48) and Eliah with widow of Sarepta (1 Kings 17:8–18). Bronze busts on capital, personifications of Elements (man with raised arm personifies Air). Mosan work of superb quality and technical skill in direct line of development from style of Liège font (105).

149 CHRIST IN MAJESTY. Central panel of altar frontal from Silos (see 145).

150 CHRIST IN MAJESTY in a mandorla between symbols of evangelists. Enamel book cover. Height 23.6 cm., width 13.6 cm. First half 12th century. Musée de Cluny, Paris. Claimed for both Limoges and Spain, this plaque obviously related to Silos enamels (149) in technique (e.g., bronze cast heads) and style (especially symbols of evangelists), but is earlier. Concentric folds less logical, more ornamental than those in Silos plaque.

151 TOMB PLAQUE OF GEOFFREY OF ANJOU (d. 1151). Champlevé enamel. Height 63 cm. Between 1151 and 1160. Museum, Le Mans. Originally in St-Julien, Le Mans. Deceased shown alive, sword in hand, standing under arcade against ornamental background, in ceremonial dress. Lion on conical cap or helmet and four more on shield. Though in different medium, closest stylistic connection with stone sculpture such as Virtues shown as warriors at Aulnay (91).

148 ▷
149 ▷
150 ▷

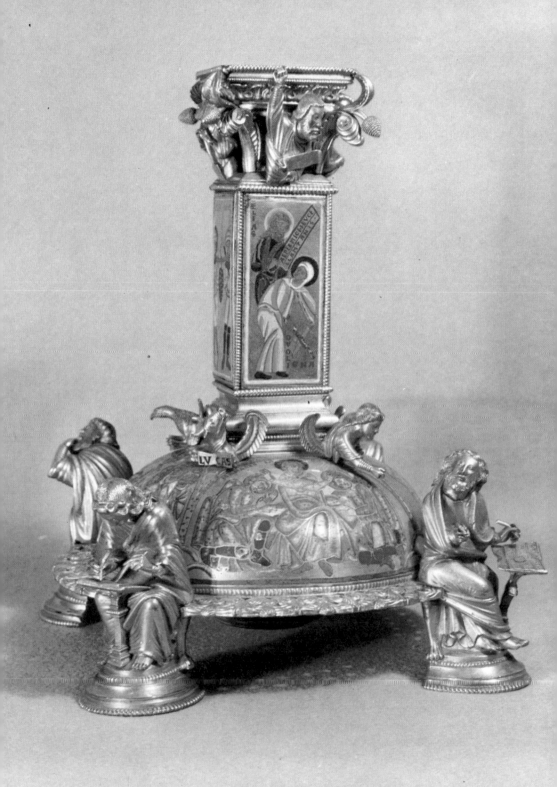

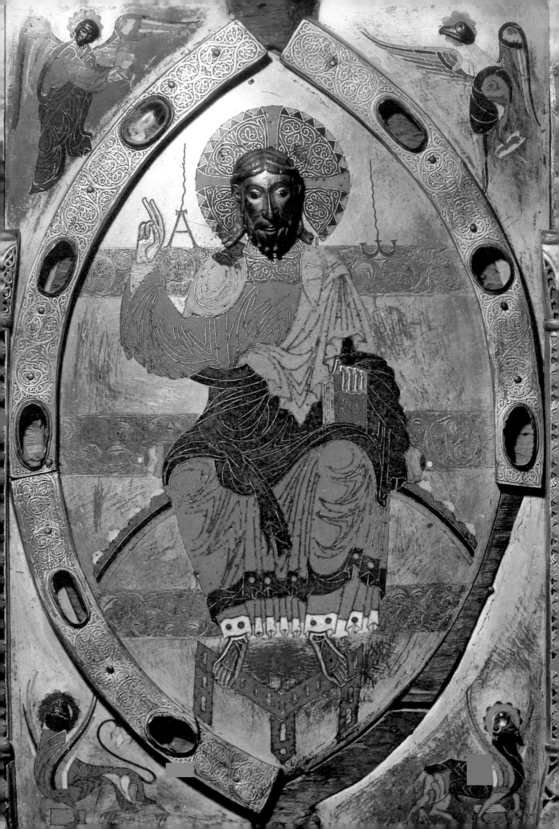

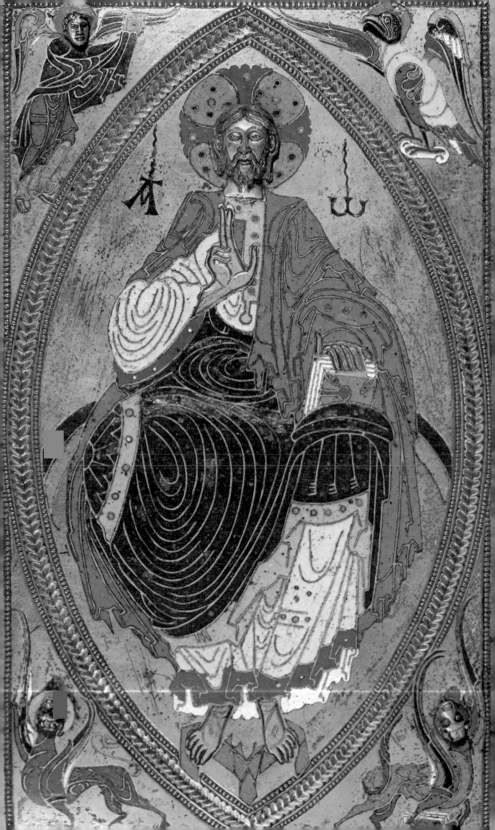

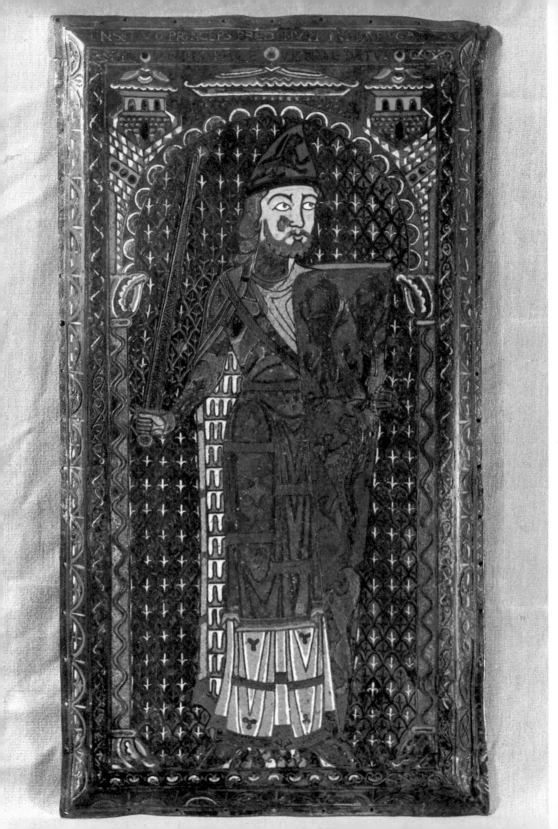

Italian churches (Amalfi, Monte Cassino, S. Paolo fuori le Mura [Rome], Monte Gargano). These were imitated by local craftsmen (Tomb of Bohemond, Canosa). In northern Italy, contacts with Germany were close and German craftsmen were at times called to work there, as was probably the case with the bronze doors for S. Zeno at Verona (*135*). But Italian craftsmen were perfectly capable of making bronze doors themselves, and in no other country does such a large number of bronze doors still survive as in Italy. In Troia Cathedral there are two doors, one dated 1119, the other 1127, the latter by Oderisius of Benevento. In the later 12th century, Barisanus of Trani made doors for Trani, Ravello (1179), and Monreale, and Bonannus of Pisa made two doors for Pisa Cathedral, of which one survives (*138*), and one for Monreale.

Cloisonné enamels were made in Italy under Byzantine influence, while the champlevé type was introduced from the north in the course of the 12th century. As in other countries, metal objects of various types and techniques were part of the essential furniture of every church, and many of these treasures are still preserved, some having been in continuous use from the time they were made eight hundred years ago.

◁ 151

152 SYMBOL OF ST. MARK. Detail of so-called Gloucester candlestick. Given to Gloucester Abbey by Abbot Peter. c.1110. Gilt bronze. Height of whole 58.4 cm. Victoria and Albert Museum, London. Based in shape and type of decoration on candlesticks of Bernward of Hildesheim, made a hundred years earlier. Whole object consists of little figures, animals, and monsters climbing in foliage or fighting. Religious subject, symbols of evangelists, on central knob only. Similarity of motifs to contemporary Canterbury manuscripts. Perhaps candlestick made there.

153 RELIQUARY HEAD. Socalled portrait of Frederick I Barbarossa. Gilt cast bronze, eyes niello. Height 32 cm. c.1160. Schlosskirche, Kappenberg. Striking head with stylized hair and beard, supported by three angels; at back was originally figure of Otto von Kappenberg (d.1171), but only inscription Otto remains. According to documentary evidence, it was given by Otto to Premonstratensian Abbey at Kappenberg as reliquary containing hair of St. John the Baptist. Document states it was made in likeness of emperor. Is not certain whether first made as Frederick's portrait (Otto was Frederick's godfather) and later used as reliquary. In any case, is early attempt at portraiture going beyond stereotyped forms of a ruler (e.g., *104*); follows examples of antique portrait busts and is contrast to symbolic representation of Henry the Lion (*108*).

154 DOORKNOCKER. Cast bronze. c.1130. Fixed to north door, Durham Cathedral. Lion's head was most frequent convention for doorknockers, but here monstrous head of devil with lion's mane used. Ring with animals' heads. Local work, indebted to motifs in local manuscript initials.

152 ▷

153

154 ▷

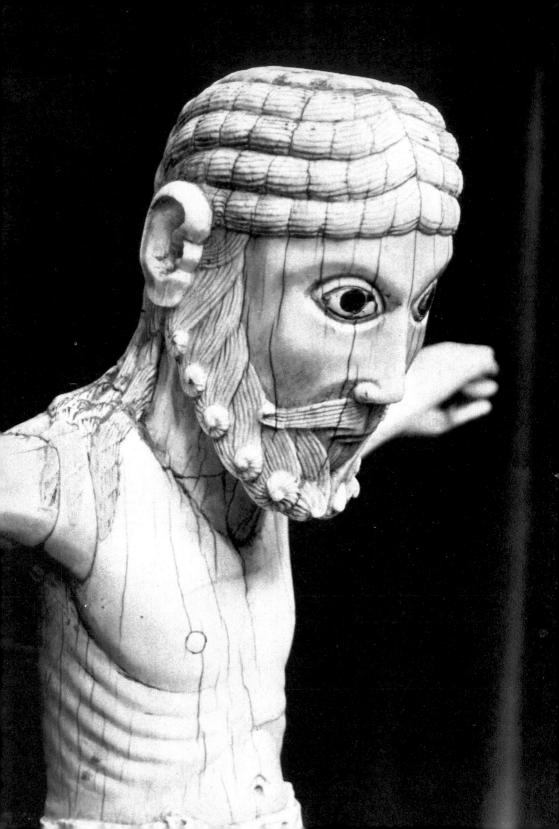

IVORIES

The importance of ivory carving cannot be overestimated. Between the fall of the Roman Empire and the 11th century, a period during which monumental sculpture was in decline, ivory sculpture was one of the few forms of artistic expression practiced in plastic form. The Carolingian period was particularly fertile in ivory carving, and the revival of sculpture under the Ottonian rulers was at first confined to ivories. In Byzantium also, ivory carving continued to develop and, because ivory objects were easily transported, it was through this medium that the West kept in touch with sculptural activities in the Greek East.

Ivory tusks came to Europe by trade routes from Africa and Asia, but because of the cost of this material, bone, walrus tooth, and whalebone were often used, especially in Germany and England. In this context, it is interesting to note that, in Book III, Chapter 93 ("Carving Ivory") of his manual, Theophilus mentions decorating bone with gold leaf, a practice which must have been widespread. The painting of selected details was also common, though few surviving examples preserve anything but the scantiest remains of the original polychromy.

The uses to which ivory carvings were put were varied. Some objects were complete in themselves—for instance, crucifixes (*155*), liturgical combs, chess pieces, and boxes of various sizes and shapes which served as reliquaries or were intended for secular use. Bishops' and abbots' croziers often ended with crooks in ivory. But ivory reliefs were often incorporated in a larger work in other materials, chiefly metals. Thus, book covers, altar frontals, and shrines were frequently adorned with ivories (*156, 157*). Many such reliefs became detached from the original object and their original use is now unknown (*158*).

Ivory carving was a highly specialized art but, because of the great demand for ivory objects, many workshops sprang up to meet the need. In Germany, the transition from the Ottonian to the Romanesque style was slow and its occurred imperceptibly during the second half of the 11th century. The so-called Würzburg group of plaques, dating from c. 1090, in spite of their debt to Ottonian and Byzantine models—one plaque uses a Greek inscription—are thoroughly Romanesque, and they were perhaps not without influence on Burgundian stone sculpture. In the 12th century, Cologne became an important center for ivory, walrus, and bone carving (*157*). Italian Romanesque ivories frequently show a strong dependence on Byzantine models. By far the most important surviving work is the late-11th-century *paliotto* at Salerno which, depending heavily on Early Christian iconography, shows, nevertheless, a certain link with the style of Ottonian ivories.

Also inspired by Ottonian prototypes were 11th-century ivories in Spain, though there, in contact with the native art, the style became very distinctive. Two crucifixes—one given by Ferdinand I to S. Isidoro at León in 1063 (now in Madrid), the other, a little later, from

◁ 155 CRUCIFIX. Ivory with enameled eyes. Height 33 cm. Late 11th century. From Carizzo Abbey. Museo Provincial, León. Triumphal representation of crucified and not of dead Christ (as, e.g., *102*). Ornamental treatment of hair and beard. As in older cult images, immobile posture, expressionless face, symbol rather than real being. Silos panels (*122*) represent similar style in stone sculpture.

Carizzo Abbey (now in León, *155*)—testify to the high standard of this branch of art in Spain. Objects of such fine workmanship must have been very influential in the rebirth of stone sculpture. This also applies to Spanish reliefs in ivory, such as the plaques with the apostles from the reliquary (now lost) of St. John the Baptist and St. Pelayo, made c. 1059 for the church of St. Pelayo, later renamed S. Isidoro, at León. The figures of the apostles are perhaps a little heavy and their feet are of almost grotesquely large size. They are compact, standing out in prominent relief from the neutral background. Though clearly derived from Ottonian models, they are nevertheless Romanesque in their ornamental use of folds and in their unity with the framing arcades. Another large group if ivory plaques survives from the shrine of St. Millán (St. Aemilius), made between 1053 and 1067 for the abbey of S. Millán de la Cogolla *(156)*, by artists whose signatures and portraits survive: *Engelram Magistro et Redolfo Filio*. These German names are invaluable evidence of the movement of artists and explain how artistic styles were transmitted over great distances. The enigmatic whalebone carving in the Victoria and Albert Museum in London (*158*) was probably made by an artist with a wide knowledge of artistic styles in many parts of Europe, including Spain, Germany, France, and England.

English early Romanesque ivories—or, more frequently, walrus and whalebone carvings—include some of the most intricate ever made, in their decorative use of motifs, as if literally following the advice of Theophilus when he wrote about bone carving: "All around, delicately portray small flowers or animals, or birds, or dragons linked together by their necks and tails." From the latter half of the 12th century, some outstanding works survive among which is the large walrus-tusk cross, tentatively attributed to Bury St. Edmunds Abbey (Metropolitan Museum of Art, New York).

156 St. MILLAN between St. Asellus (left) and St. Gerontius and St. Sophronius (right). Ivory plaque from shrine of St. Millán, S. Millán de la Cogolla. 1053–67. Shrine destroyed in 1809 with exception of some ivory plaques. According to inscription, made by Engelram and his son Redolfo (Rudolf), obviously German names. Not surprisingly, these ivories have stylistic connections with Ottonian art, as have other 11th-century works in Spain (*137*) and Roussillon (*72*).

157 ASCENSION. Walrus ivory plaque, height 21 cm. c. 1130. Victoria and Albert Museum, London. Christ with banner, in mandorla, ascends to heaven, from which emerges Hand of God and two angels. Virgin and apostles on either side and below Habakkuk with inscribed scroll. Border of stylized acanthus. One of group of ivories made in Cologne and known as *gestichelte Gruppe*, because of characteristic method of representing draperies by lines of dots. Soft, rounded forms similar to those in Mosan art but linear effect of draperies.

158 ADORATION OF MAGI. Whalebone plaque (from shrine?). Height 36.5 cm. c. 1130. Victoria and Albert Museum, London. Astonishing attention to every detail, carving of superb delicacy and virtuosity. Towering and sad, deeply moving figure of Virgin. Vigorous frieze of fighting animals at base. Has been ascribed to England, Normandy, northeastern France, Spain. Angularity of folds, modeling of feet and above all of hands are strikingly similar to those of effigy of Rudolf of Swabia (*104*), so German origin not impossible. Illustrates international character of Romanesque art.

156 ▷

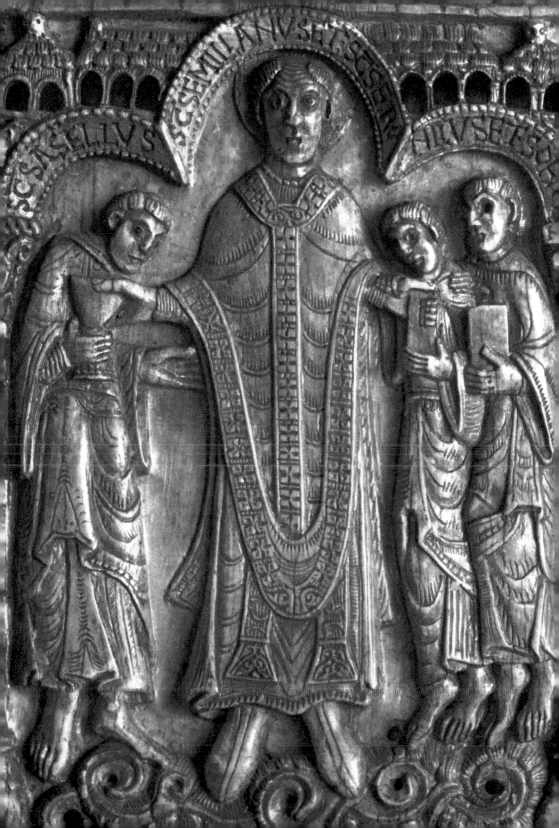

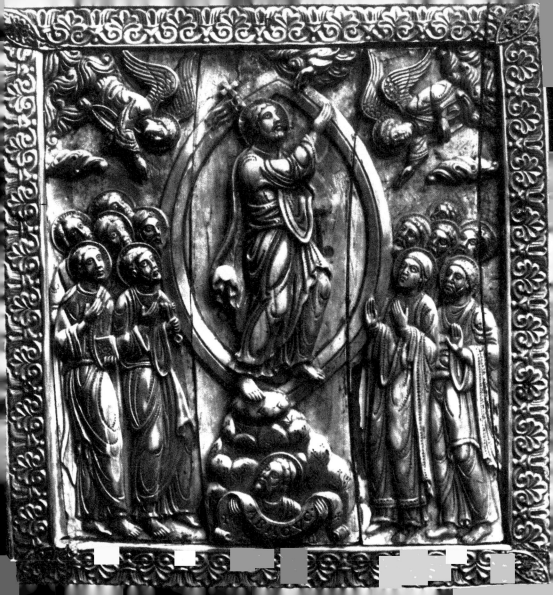

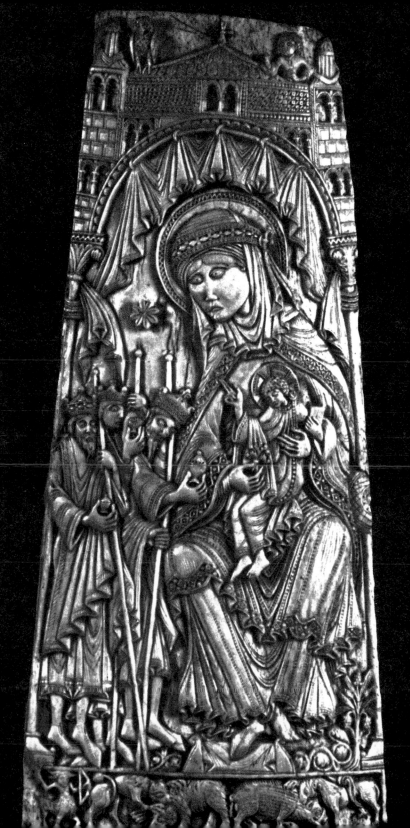

158

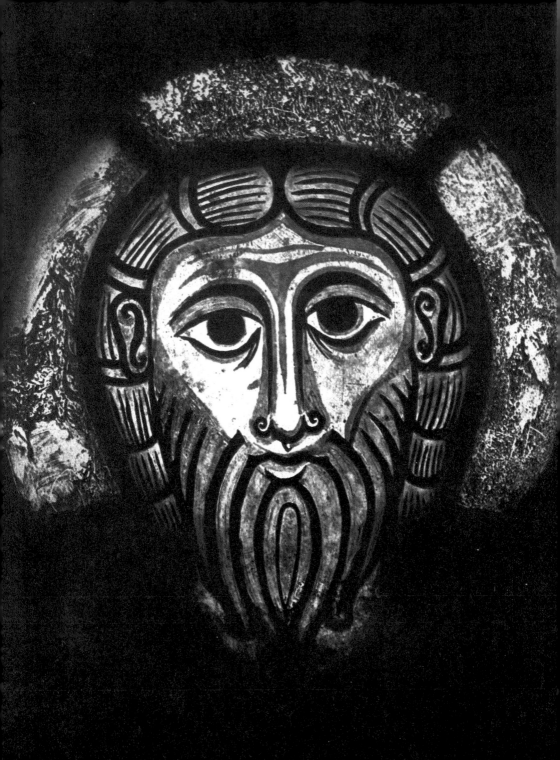

STAINED GLASS

The idea of using stained glass windows to augment the decoration of a church is very ancient and, in the West, goes back at least to Carolingian times. But the windows of early medieval buildings were small and colored glass diminished the amount of light transmitted. Thus the size of windows was increased progressively until, in the Gothic period, they practically replaced the walls. It would, of course, be absurd to claim that Gothic architecture was evolved in order to provide for the maximum use of stained glass but, undoubtedly, stained glass was a contributing factor in the development of Gothic architecture.

In Romanesque buildings, stained glass windows combined with wall paintings to provide the color decoration of a church. But glass had two advantages over painting: the translucent colors of glass were more vivid, more brilliant than the reflected colors of frescoes, and they were more durable, did not fade or absorb the soot from candle flames. The technique of making stained glass during the Romanesque period is described in detail by Theophilus. In brief, the panes of colored glass were cut to the required shapes, following the design prepared on a wooden board. Those pieces that required additional decoration or highlights—Theophilus mentions specifically the garments, faces, hands, feet, and nude figures as requiring highlights—were painted with additional enamel colors which, when fired, fused with the glass. The pieces were then assembled on the board and joined by strips of lead, which also played an important part in the general design, giving outlines to selected forms in the composition.

The discovery of a Carolingian head at Lorsch which was part of a large figure demonstrates that figural stained glass was already in use during the 9th century, and this is further confirmed by documents that mention figures painted on windows. The earliest Romanesque stained glass surviving, which dates from the second half of the 11th century, is unfortunately only a fragment, a head, probably of Christ, found at Wissembourg (Weissenburg) in Alsace (*159*). The emerald-colored nimbus, composed of three pieces, surrounds the head made of a single piece of greenish glass, on which the features are painted in black and the modeling is achieved by three shades of white. This is of particular interest, since it is precisely what Theophilus recommends in Book II, Chapter 20, entitled "Three Shades of Color for Highlights in the Glass." He writes that the brush strokes should be "thick in one place, light in another, and then still lighter and distinguished with such care that they give the appearance of three shades of color being applied." But in spite of this modeling by tones of differing value, the general appearance of the Wissembourg head is flat and linear. The features are ornamental in the extreme. The large eyes and the solemnity of expression

◁159 HEAD, PROBABLY OF CHRIST. Stained glass from Wissembourg (Weissenburg) in Alsace. Height 25 cm. Second half 11th century. Musée de l'Oeuvre Nôtre-Dame, Strasbourg. Ornamental treatment of features, especially ears and nostrils. Some hint of plasticity in use of three different tones of paint on face.

give this head a supernatural character. The windows of Augsburg Cathedral, although later (c. 1135), are still in this early Romanesque tradition of representing large figures in solemn, immobile, strictly frontal positions *(161)*.

The country which in Theophilus' days was famous for the "precious variety of windows" was France, and it is there that the largest number and the greatest variety of 12th-century stained glass is found. The windows made under Abbot Suger at St-Denis c. 1145 were, to use Suger's own words, "painted by the exquisite hands of many masters from different regions" (*De administratione*, XXXIV). The school of stained glass that developed in the Île-de-France as a result of this great undertaking was among the most important and influential in Europe, but its history belongs to the Gothic period. Of the original windows of Suger's building, some survive in a much restored state, though many original fragments, which were scattered after the French Revolution, exist to testify to the high artistic ability and great iconographic inventiveness of Suger's artists. These windows no longer employed large, frontal figures but consisted of a series of small medallions, each containing multi-figured scenes and enclosed by rich floral borders. Even the famous Tree of Jesse window (now much restored) was divided into six panels, each with a central figure and two flanking ones, one above the other.

160 BUILDING FLEET FOR DUKE WILLIAM OF NORMANDY. Detail of embroidery called Bayeux Tapestry. Height 53 cm. c. 1080. Town Hall, Bayeux. Narrative strip, total length 69 meters, relating events leading to and during invasion of England by Normans in 1066. Decorative borders of plants, animals, genre scenes, fables, etc. Probably commissioned by Bishop Odo of Bayeux for his cathedral. Lively figure style derived from English manuscript painting. Strong evidence for English workmanship, perhaps at Canterbury.

161 DANIEL AND DAVID. Stained glass. Height 230 cm. c. 1135. Augsburg Cathedral. Two of five surviving figures (Moses, Jonah, and Hosea not reproduced) comparatively little restored. They carry scrolls with texts from their respective prophecies. David represented as king, others have hats signifying they are Jews. Figures large, strictly frontal, hieratic. Monumental style, characteristic of early Romanesque glass.

162 CRUCIFIXION. Detail of stained glass in east window, Poitiers Cathedral. c. 1150. This is central of three scenes. Below is Crucifixion of St. Peter (patron saint of cathedral); above, Ascension. Two groups of figures above arms of cross witness Ascension. In contrast to early glass with monumental, frontal figures, later Romanesque glass, as illustrated here, stresses emotions through agitated movements.

163 DAVID. Fragment of stained glass. Size of whole fragment 74 × 21 cm. 1160–66. St. Patroklus Cathedral, Soest. David, his kingship symbolized by scepter, under trefoil canopy, holds scroll inscribed *Dicite I[n] Nacionib[us] Dominus Regn[at]* (1 Chronicles 16:31). Fragment from central window of apse, with scenes in medallions from Descent from Cross to Ascension, flanked by prophets. David, three-quarter view, on left side. Three windows of apse and wall paintings, dated 1166, formed single iconographic program. Stylistically, glass related to manuscript paintings of Helmarshausen school (e. g., Psalter of Henry the Lion).

160 ▷
161 ▷
162 ▷

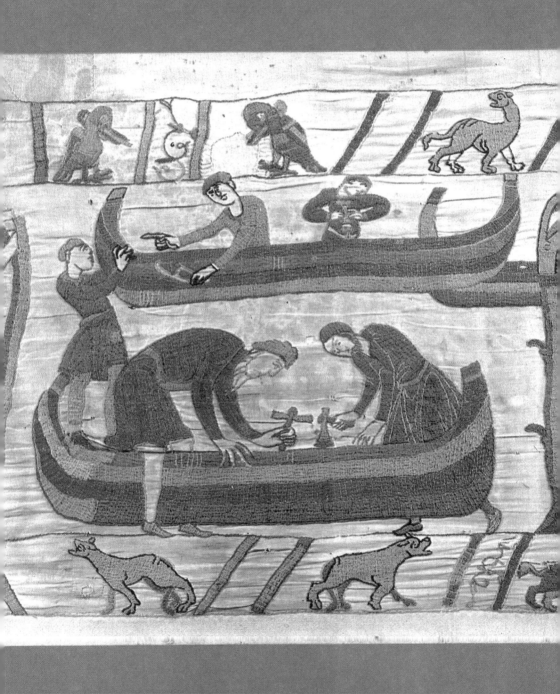

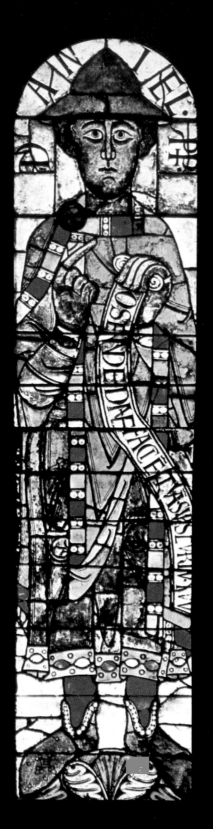
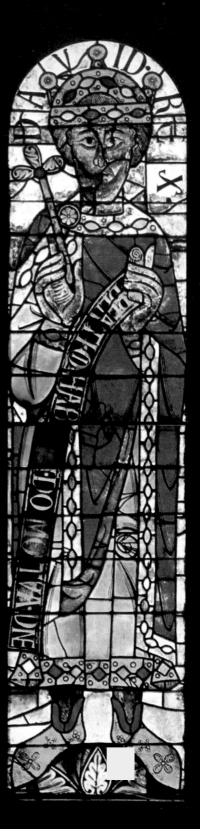

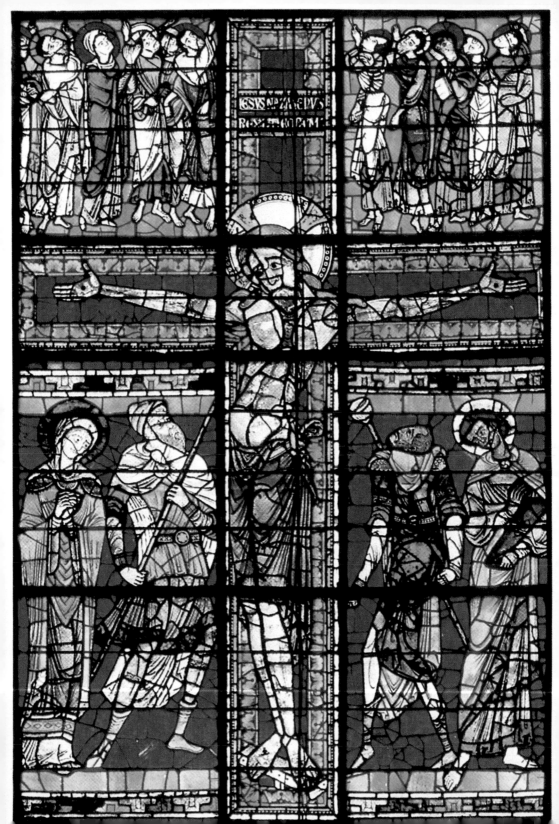

A little later than Suger's glass are the superb windows of the cathedral of Châlons-sur-Marne, the work of Mosan artists whose style is very close to the enamels attributed to Godefroid de Claire.

An important school of Romanesque stained glass existed in the western regions of France in the second and third quarters of the 12th century. Examples from this school include windows at Le Mans, Vendôme, Angers, and Poitiers (*162*). The elongated and agitated figures made in this school are akin in style to the sculpture and painting of the region. But here, too, the need for narrative scenes resulted in the use of smaller figures than in earlier glass. The compositions are crowded and lack the clarity of the early Romanesque style.

In the second half of the 12th century, the influence of the transitional art from either the Ile-de-France or the Meuse-Lower Rhineland region put an end to the Romanesque style in glass painting. It is most instructive to compare the Wissembourg head (*159*) of the 11th century with the late Romanesque work at Soest (*163*). The forms of the early head are so abstract that they give the impression of a supernatural apparition, but the head of David at Soest is conceived three-dimensionally, in three-quarter view, with light and shade. The supernatural became humanized and real. This new attitude marks a departure from the Romanesque style, toward the new humanism that characterized the transitional period.

◁ 163

WALL PAINTING

The deplorable habit of 19th-century restorers of stripping bare the walls of medieval churches to reveal their beautiful masonry not only destroyed many original wall paintings, some hidden under whitewash, but also falsified the appearance of the interiors. For except in rare cases, as in Tuscany, where marble inlay covered the walls, all Romanesque churches were plastered and painted. An earlier chapter mentioned that even the carved features of buildings were polychromed. The vast wall surfaces of Romanesque interiors, like those of Early Christian basilicas, were particularly suited to extensive painted decoration.

Mosaic was, of course, in every way a preferable technique to wall painting. Composed of *tesserae*, small cubes of colored glass and stones set in plaster, mosaics were much more durable. Moreover, their rough surface caught and reflected the light in such varied ways that even a neutral background looked "alive." But this technique was very expensive and rarely used and, as a result, few craftsmen were skilled in making mosaics—and probably none outside Italy. From the *Chronicle of Monte Cassino*, written before 1075 by Leo of Ostia, we learn that when Abbot Desiderius was rebuilding the monastic church, he hired mosaicists in Constantinople to lay the mosaics in the apse, over the entrances in the narthex end in the main façade, and other craftsmen for making pavements. We are also told that the practice of these arts had been dead in Italy for more than five hundred years and that Desiderius decided a great number of young monks in the monastery should be thoroughly initiated in these arts in order that this knowledge might not again be lost. Although this statement exaggerated the position, it nevertheless reflects the contrast between the poverty of this art in 11th-century Italy and its splendor in contemporary Byzantium. It was in direct imitation of the Greek imperial patronage of this art that the doges of Venice and the Norman kings of Sicily sponsored vast schemes of mosaic decoration. The popes drew on the local workshops of mosaicists when they renewed two Roman Churches, S. Clemente in 1128 (*164*) and S. Maria in Trastevere in 1140 (*167*). At the time of the political triumph of the papacy over the empire, the popes reverted to this "imperial" technique to add splendor to their newly gained authority. There was no lack of models in Rome in this technique, to mention only S. Constanza and S. Maria Maggiore, and it is not surprising that Romanesque mosaics are full of inspiration from such Early Christian decorative schemes. But the extensive use of gold in these mosaics was a conscious attempt to emulate the contemporary Byzantine practice, and in the figure style there is also evidence of a strong influence from that source. At the end of the 12th century and the beginning of the 13th, Venetian mosaicists were called to Rome to execute decorations in St. Peter's and in S. Paolo fuori le Mura, but these have perished. Mosaics were also used on exteriors of buildings at Monte Cassino and elsewhere (*46*), and a curious example of such decoration outside Italy, but no doubt executed by an Italian craftsman, existed at St-Denis Abbey, where it was applied on Abbot Suger's orders to a tympanum of the north portal.

The techniques used in wall paintings varied a great deal and not all were true frescoes. Even in one decorative scheme, different techniques were sometimes used, for example, when certain colors (such as lapis lazuli), which were not completely soluble, had to be

applied *a secco*. The final touches were often made in tempera. Over the ages, these various techniques responded in different ways to time and atmospheric conditions and, in the same wall painting, the deterioration of various colors can vary considerably. When looking at medieval wall paintings, one should bear in mind the probable deterioration in their condition and the changes that have occurred in the original pigments.

Few entirely painted interiors survive intact, but even from the fragmentary remains some conclusions can be drawn about the general disposition of the paintings. Naturally, the main apse, as the focal point of the church, was the place of honor, dedicated to Christ, usually Christ in Majesty (*175*), and only exceptionally to such representations as the Crucifixion (*164*). With the increasing importance of the Virgin Mary in 12th-century iconography, she was also at times given a place in the main apse, as in the celebrated mosaic at S. Maria in Trastevere (*167*), where she sits enthroned on the right side of Christ. The walls above the nave arcade and the vaulting, if there was any, were obviously suitable for a large number of representations, and these were usually drawn from the Old and New Testaments. The lateral apses were often assigned to the Virgin and the saints, particularly the saints to whom the church was dedicated. The Last Judgment or other apocalyptic scenes were usually on the western wall of the nave or the narthex. However, there was no rigid system to which all painted decoration adhered, certainly the variations were far greater than in the Greek church. Romanesque buildings displayed great differences in their forms—for example, the domed churches of western France or the two-transept churches in Germany—and, therefore, no single system of decoration could develop. Moreover, local

164 CHRIST ON CROSS. Detail of apse mosaic. c. 1128. S. Clemente, Rome. Against background of acanthus scrolls, dead Christ on cross, with twelve doves (for apostles) placed within arms of cross. Virgin Mary and St. John the Evangelist with gestures of grief stand on either side. Below cross, serpent, and four rivers of Eden with stags drinking their waters. Juxtaposition of Original Sin and Redemption. Both Early Christian and Byzantine elements in iconography and style.

165 ABBOT DESIDERIUS (d. 1087) with model of his church. Detail of apse wall painting. c. 1080. Sant'Angelo in Formis. Church founded by Desiderius, abbot of Monte Cassino, completed c. 1075. Apse frescoes probably first to be painted, in any case before 1087, when Desiderius died, for he is represented with square nimbus, symbolizing living person. Many Byzantine elements

in whole cycle, but treatment of head in geometric terms, wholly Romanesque.

166 LAST SUPPER. Detail of wall painting on north wall of nave. Late 11th century. Sant'Angelo in Formis. Best preserved complete cycle of Romanesque wall paintings. Christ in Majesty in main apse, biblical scenes on nave walls, Last Judgment on west wall, with further paintings in aisles and narthex. Some may date from 12th century. Two main elements form basis of this local school, Roman and Byzantine. Vivid colors as if painters tried competing with mosaics.

167 TRIUMPH OF VIRGIN. Apse mosaic. c. 1140. S. Maria in Trastevere, Rome. Church rebuilt and mosaic commissioned by Pope Innocent II, who is represented with model of church among figures flanking central group: enthroned Christ, his arm on shoulder of his mother. Above, hand of God

holds crown. One of earliest scenes of Triumph of Virgin, not yet actual coronation. Many survivals of Early Christian art (e.g., lambs symbolizing apostles), but sumptuous style in keeping with confident and triumphant papacy of 12th century.

168 ADAM NAMING ANIMALS. Wall painting in S. Pietro Abbey near Ferentillo. Second half 12th century. One of series of biblical scenes in nave strongly influenced by contemporary painting in Rome (wall paintings, mosaics, and "Atlas" bibles). Nude Adam in landscape of garden of Eden, four rivers flowing under his feet. Attempt at naturalism in human figures and some animals, but rivers and plants still symbolic.

169 TWO HORSEMEN IN COMBAT. Wall painting in crypt, Aquileia Cathedral. c. 1200. Below biblical scenes, imitation of hangings painted in red with monochrome trees, birds, and secular scenes such as one illustrated here. Horsemen are sketches presumably intended as Christian knight pursuing infidel. This wall painting imitates hangings such as must have often decorated churches and of which Bayeux Tapestry (160) is early example.

170 ARCHANGEL MICHAEL AND HIS ANGELS FIGHTING DRAGON. Detail of wall painting. c. 1100. S. Pietro al Monte, Civate. Extensive fresco cycle in narthex, nave, and crypt survives, showing strong Byzantine influence in facial types, drapery style, and color scheme, while iconography shows blending of Ottonian and Byzantine elements. Scenes are based on Apocalypse; St. Michael and dragon illustrate Revelation 12, showing "woman clothed with the sun and the moon" giving birth to son who is threatened by dragon with seven heads and ten horns. *Michael, et Angeli ejus proeliabantur cum dracone* (Michael and his angels fought against the dragon). This fight against dragon depicted in forms that follow text closely and fulfill superb decorative function.

171 VIRGIN MARY. Detail of apse wall painting. 1123. S. Clemente, Tahull, now Museo de Arte de Cataluña, Barcelona. Rightly most celebrated of Catalan paintings. Below

Christ in Majesty, apostles, and Virgin placed under arcades. She holds chalice with rays of light, usually believed to be Holy Grail, but perhaps symbolic of Christ, since on book held by Christ in Majesty are words *Ego Sum Lux Mundi* (I am the light of the world). Flat, linear style and pure brilliant colors derived from Mozarabic sources but expressiveness of exaggerated, geometric forms due to genius of painter.

172 WALL PAINTING OF PANTEÓN DE LOS REYES, S. Isidoro, León. c. 1160. This mausoleum of kings of León, built in 11th century and celebrated for early capitals (67), received painted decoration during reign of Ferdinand II (1157–88). Sumptuous paintings on six bays survive, blending New Testament scenes with rich ornament, used to stress structural features such as arches. Principal subject Christ in Majesty with symbols of evangelists, shown as angels with heads of their symbols (e.g., with eagle's head for St. John).

173 ARCHANGEL MICHAEL AND HIS ANGELS FIGHTING DRAGON. Detail of wall painting in porch, St-Savin-sur-Gartempe. c. 1100. Most extensive cycle of Romanesque wall paintings surviving in France: Apocalyptic scenes in porch, Passion in tribune of porch, biblical subjects in nave (13), lives of Sts. Savinus and Cyprian in crypt. Many artists at work but all paintings roughly contemporary, using similar colors, with yellows and ocher much in evidence. Dynamic style based on Carolingian manuscripts. St. Michael and his angels shown as horsemen, unlike Italian composition of same subject at Civate (170).

174 SIX APOSTLES. Detail of altar frontal from Urgel, now Museo de Arte de Cataluña, Barcelona. Early 12th century. Divided into three parts, Christ in Majesty in center, St. Peter and five apostles on left, St. Paul and remaining apostles (here illustrated) on right. Painted altar frontals were substitutes for those in precious metals, hence imitation of gold background. Decorative pyramid grouping of figures, alternation of colors for haloes, simplification of drapery designs.

164 ▷

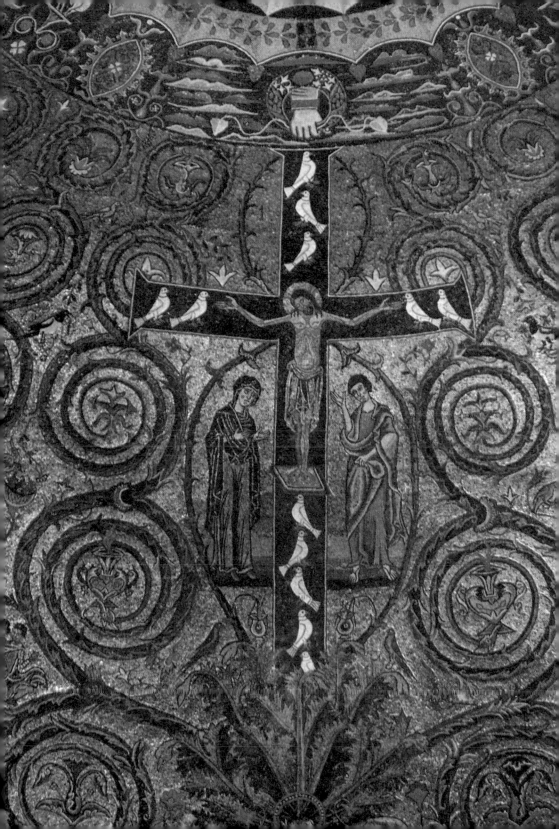

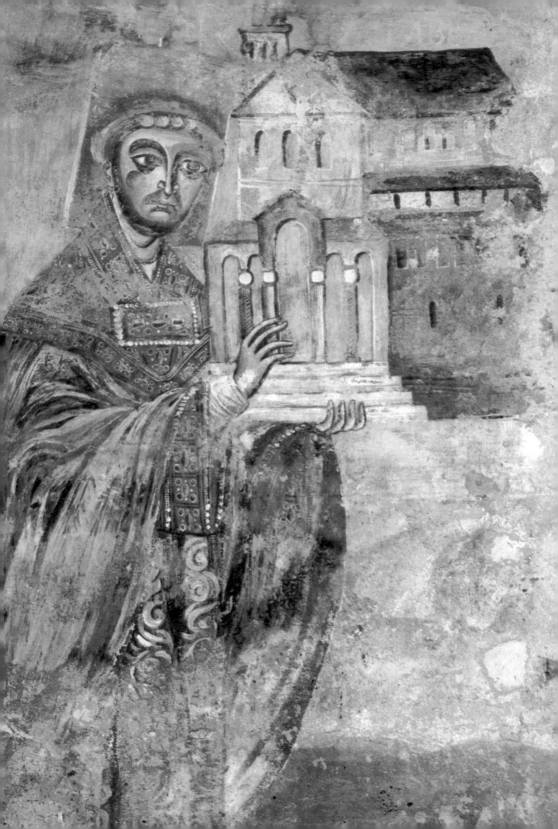

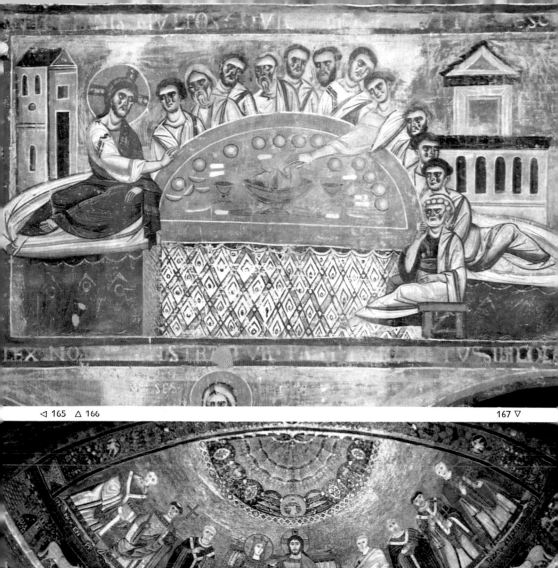

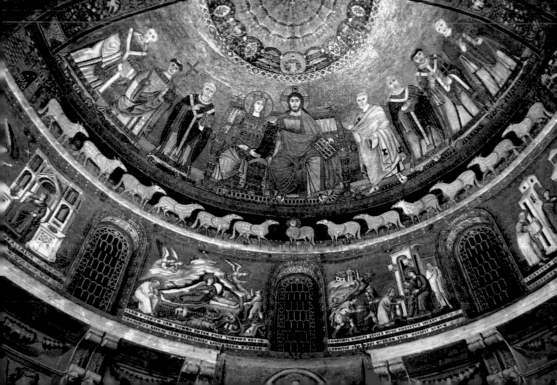

STVS NOMIIIPRV · · · VREX MANFATSICVTFERIN

△ 168 ▽ 169 170 ▷

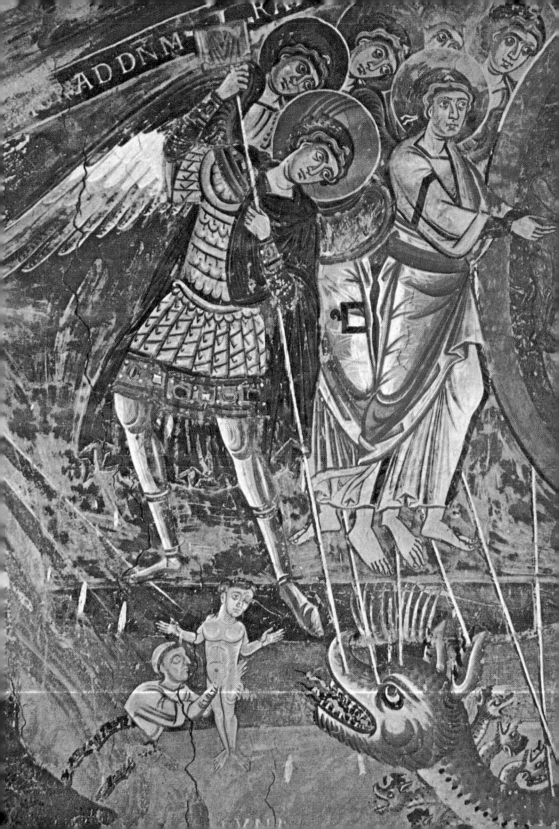

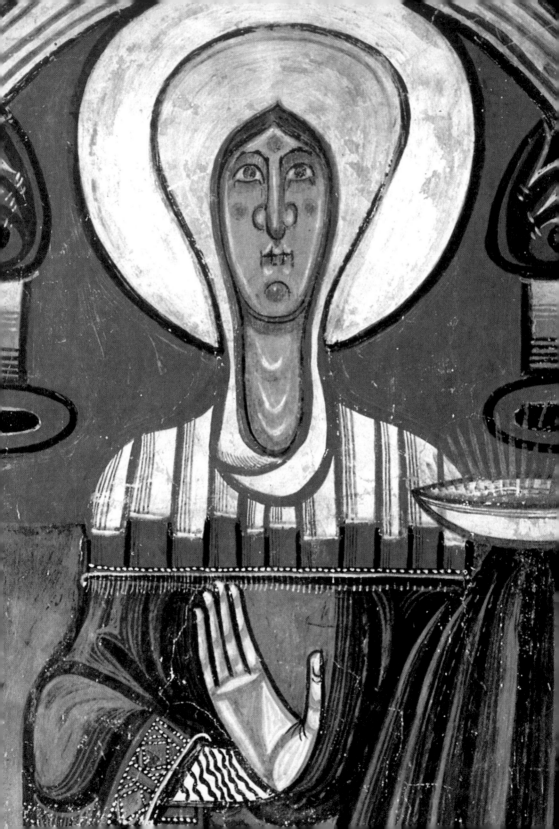

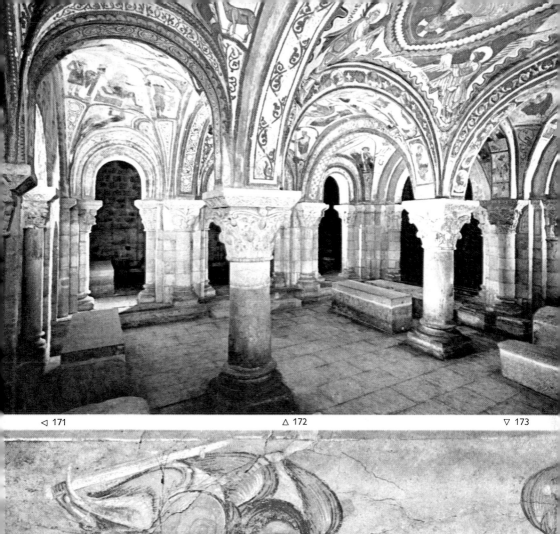

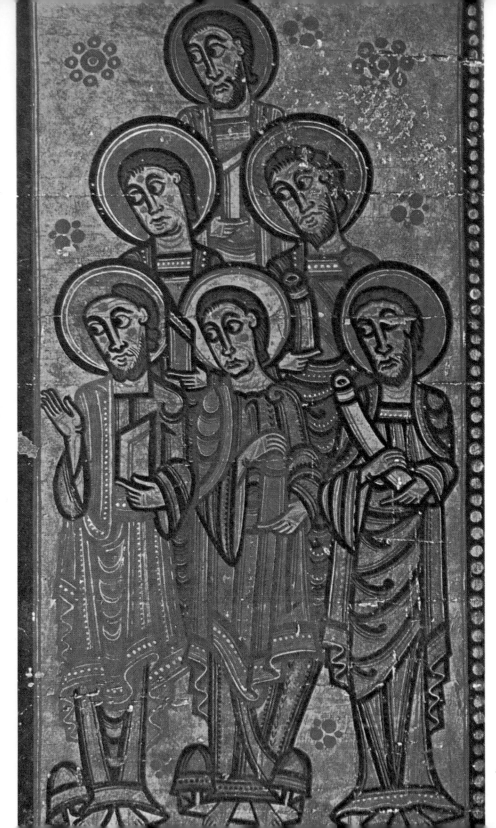

174

traditions and historical conditions always had some influence, with the result that wall painting in Romanesque Europe shows considerable differences in iconographic program and style.

The effect of cultural traditions and historical connections is seen particularly clearly in Italy. There, Venice and the regions along the Adriatic coast, as well as the Norman South, were in close touch with Byzantine art. The northern regions developed a style that combined Byzantine elements with those of Ottonian painting. Central Italy, with Rome, was less open to external fashions, and local traditions were a constant source of inspiration, though even there the impact of Byzantine art was felt. The total loss of the decoration of the abbey of Monte Cassino, carried out under Desiderius, deprives us of the key monument which, because of the prestige of this abbey as the founder house of Benedictine monasticism, must have been particularly influential in Europe. It is often said that this loss is partially compensated for by the survival of the painted decoration of the abbey of Sant' Angelo in Formis, near Capua, a dependency of Monte Cassino, built by Desiderius (founded 1058, finished 1073 or 1075), although whether or not these wall paintings reflect the lost decoration of Monte Cassino can only be a matter for conjecture. Some scholars believe that, while the wall paintings in the apses and on the side walls of the nave date from the 11th century, those in the western part are from the 12th or even the 13th century. But it is difficult to believe that the work dragged on for so long. Admittedly, there are stylistic differences between certain parts of the scheme but these can well be explained by the fact that different painters, with somewhat different training and style, were working simultaneously. What is overwhelmingly evident in these wall paintings is their profound debt to the Byzantine style and iconography without, however, being a slavish imitation. The painters were not Greeks but Italians, who had a knowledge not only of Byzantine art (possibly at Monte Cassino) but also of the painting traditions of Rome. The figure of Abbot Desiderius (*165*), as the donor with the model of the church, is placed in the main apse, along with the angels, below the enthroned Christ. The prominent place given to him is in keeping with Roman rather than Greek custom. Desiderius is represented with a square nimbus—which symbolizes a living person—and this gives a valuable clue for dating this apse painting, since Desiderius died in 1087. The artist had no Byzantine model for this representation and it is most revealing to see how he resorted to depicting the head of the abbot by conventional, linear means. Only through his bushy eyebrows and mustache does his head differ from those of the angels. What is remarkable, however, is the way the folds of his rich vestments are treated with masterly illusionism, going back to some very early, probably late classical sources, which must have been available in Rome. When compared with the still surviving façade of the church, the model of the building held by Desiderius is an accurate but simplified rendering of its architectural features. This is a rare example of an artist observing the forms, such as they are, and not using a schematic building copied from a pattern book. But for the biblical scenes (*166*) he, or his collaborators, reverted to conventional, long-established types of compositions, at times following Byzantine formulas very faithfully, occasionally simplifying them in the spirit of geometric patterns, so characteristic of Romanesque art. The colors are rich; especially striking are the blue backgrounds and the blue, red, and

ocher for the dresses. The faces, with patches of red on the cheeks, are somewhat stereotyped, but the figures carry conviction through their dignified and emphatic gestures.

The earliest Romanesque wall paintings in Rome and its neighborhood include the famous frescoes in the lower church of S. Clemente and at Castel Sant'Elia, and these were soon followed by the mosaics in the main apses of S. Clemente and S. Maria in Trastevere, to which reference has already been made. The general trend in the stylistic evolution of Roman painting during this period was away from the lively and elegant narrative of the early cycles, toward a more hieratic and sumptuous style, especially in the apse mosaic S. Maria in Trastevere. The majestic figure of Christ dominates the composition by its size and by virtue of being in the center. His arm on his mother's shoulder expresses an unusual tenderness, which is an exception to the usual solemn representations in Romanesque art. As the verses from the Song of Songs (*Canticum Canticorum*) are included in the composition, it is clear that this scene has a double meaning: It is not only Christ and his mother who are represented here, but also Christ and his church, for according to Christian interpretations of the Song of Songs—St. Bernard alone left 86 homilies on the subject—Solomon and his beloved are Christ and the church. Pope Innocent II (1130–43), who commissioned the mosaic, is represented with the model of the church among the saints flanking the throne. To contemporaries, this mosaic must have been easily understood as a political statement by the papacy in its campaign for supremacy over secular rulers. From this composition, therefore, it was to be understood that Christ and the church enthroned together are supreme, with St. Peter, next to the throne, as the first head of the church and the current pope, his successor because of his office, standing on an equal footing among the saints.

The large number of wall paintings surviving from the late Romanesque period in Rome and its neighborhood and extending to Umbria (*168*) continued to develop the monumental qualities, the plasticity of the figures, and the interest in realistic detail already present in the earlier period. This style was unaffected by the revolutionary changes toward Gothic art that were taking place in the transalpine regions. Although it drew spasmodic inspiration from Byzantine art, it remained faithful to Romanesque traditions throughout the 13th century.

Even in the regions traditionally open to Byzantine influences, late Romanesque painters at times showed an interest in realistic effects, as in the wall paintings in Aquileia Cathedral (*169*) which imitate embroidered hangings. The painter quite successfully depicted the way in which the material sags under its own weight between the rings on which it hangs.

The north Italian provinces were particularly affected by Ottonian art and, in fact, it would be more correct to say that north Italy was one of the provinces of the empire which contributed considerably to the development of Ottonian art, especially in painting and ivory carving. The wall paintings at Galliano in Lombardy (c. 1007) are among the most important surviving Ottonian monuments in that medium. During the Romanesque period, Ottonian influences were still effective—an example of this being the apocalyptic cycle of wall paintings in S. Severo at Bardolino near Verona—but in the most outstanding Romanesque paintings in Lombardy at S. Pietro al Monte, c. 1100, on the mountain above Civate, Byzantine influences are predominant (*170*). This is seen in the facial types and the

drapery style, as well as in the iconography. The date of the Civate paintings is not firmly established, but this important monument seems to belong to that large group of works —wall paintings, manuscript illuminations, and works in metal—of a late 11th- and early 12th-century date, on which the Byzantine style has a marked influence, perhaps due to renewed contact with Constantinople through the First Crusade.

In Spain, which is particularly rich in paintings surviving from the 12th century—both wall paintings and painted altar frontals (174)—the persistent influence of Mozarabic book illuminations (e. g., 199) produced works in which a flat, geometric design dominates (200). At times, as in the cycle at S. Clemente at Tahull (171), the emphatic exaggeration of the features comes dangerously close to caricature. Yet, this work is superby expressive. Gradually, Spanish wall painting became tempered by contacts with France and Italy (172) and, by the end of the 12th century, shows an overwhelming influence from Byzantium—for example, wall paintings at Sigena, for which an English authorship has been convincingly claimed.

A lively school of wall painting that existed in western France is best represented by the extensive cycle at St-Savin-sur-Gartempe (173). The work of several painters of unequal talent, they have, nevertheless, a fairly uniform style, with lively, vigorous movement, and elegant, slender forms. Compared with contemporary wall paintings in the Cluniac chapel at Berzé-la-Ville—near Cluny and probably painted by the master who was responsible for the decoration of the apse painting, now lost, of Cluny III—St-Savin is quite unaffected by Byzantine art. Berzé-la-Ville (175), however, is a supreme example of a style strongly under Byzantine influence—that is to say, hieratic and deeply spiritual. The Romanesque artist did not copy his models slavishly. The damp-fold drapery became, under his brush, an intricate system of patterns that was to influence the sculptors of the Burgundian school (85 and 86). In some respects, the painter of the Berzé-la-Ville cycle made the same, though less extreme use of Byzantine models as his contemporary metalworker in Saxony, Roger of Helmarshausen (143).

The influence of Byzantium on Romanesque painting took different forms at different times and places, but it was almost universal, though seldom direct. We have seen its impact on Italy. North of the Alps, some Byzantine elements were transmitted by Ottonian intermediaries into early Romanesque painting (178). Berzé-la-Ville is an example, the best that survives, of a wave of Byzantine influences which were reinterpreted by Romanesque painters in a predominantly linear way, with the help of vivid, pure colors. The St. Paul painting at Canterbury (179) was an English version of this style. Then, there appeared a succession of works in which Byzantine models (from Italy, especially Sicily) were emulated for their expressive qualities and for their plasticity in the treatment of figures. To these works belongs the cycle in Nonnberg, Salzburg (177), at Montmorillon (176), and at Winchester (180). With such paintings, the Romanesque style was on the wane. The fluid, plastic forms which depend less on line than on highlights and shades, in which abstraction is replaced by naturalism, are no longer truly Romanesque. When the Gothic style in painting came into being in the 13th century, it replaced not the Romanesque but that transitional, Byzantine-influenced painting, which had gained momentum late in the 12th century.

175 CHRÌST IN MAJESTY BETWEEN APOSTLES. Detail of apse wall painting. Berzé-la-Ville Priory. Early 12th century. Favorite place of Abbot St. Hugh of Cluny. Frescoes probably executed by painter from Cluny before Hugh's death in 1109. Strong Italo-Byzantine elements, rich colors on dark blue ground with white for highlights. Majestic, supernatural Christ exercised deep influence on Burgundian sculpture (*85* and *86*).

176 ELDERS OF APOCALYPSE. Detail of wall painting in crypt, Nôtre-Dame, Montmorillon. c.1200. Last phase of Romanesque style, before advent of Gothic forms, was strongly and universally influenced by Byzantine art. Here forms are fluid, exaggerated, and expressive. This last stage in development is often described as Romanesque Baroque.

177 ST. FLORIAN. Detail of wall painting in nun's choir, Stiftskirche Nonnberg, Salzburg. Height 138 cm. c.1150. One of series of half-figures of saints painted in niches, strongly influenced by Byzantine art, via Italy. Modeling of figure achieved convincingly by few quick strokes of brush. Soft contours.

178 CHRIST PREACHING IN SYNAGOGUE AT NAZARETH. Detail of wall painting in west choir, Lambach Abbey. End 11th century. Church dedicated 1089. Extensive remains of original frescoes, including rare scene of Christ between Jews, on which occasion he said, "No prophet is accepted in his own country" (Luke 4:16–30). Stylistic sources Ottonian and Lombard, with some Byzantine elements transmitted by both.

179 ST. PAUL THROWS VIPER ON FIRE. Wall painting in St. Anselm's Chapel, Canterbury Cathedral. Height 175 cm. c.1140. Only one scene, but well preserved, survives from what must have been extensive cycle. Chapel was ready for dedication of choir in 1130 but painting is somewhat later, closely related in style to Bury Bible (*196*). Byzantine damp-fold used extensively for modeling and decorative device. Compare early use of damp-fold by Roger of Helmarshausen (*143*).

180 DESCENT FROM CROSS AND DEPOSITION. Wall painting on east wall, Chapel of Holy Sepulchre, Winchester Cathedral. c.1180. Recently discovered after safely removing 13th-century wall painting of same subjects. Transitional style, profoundly influenced by Byzantine art from Sicily. Painter of these frescoes must have known or even collaborated in illuminating Winchester Bible, one of foremost works in transitional style.

175 ▷

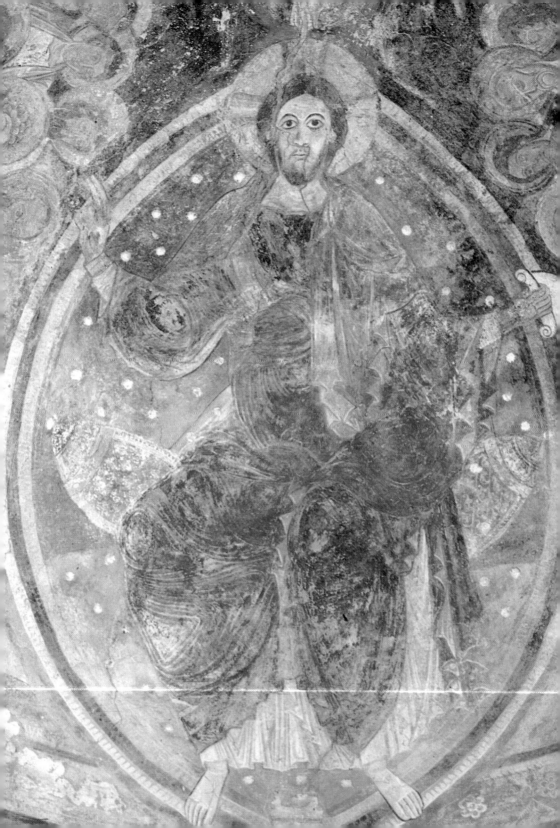

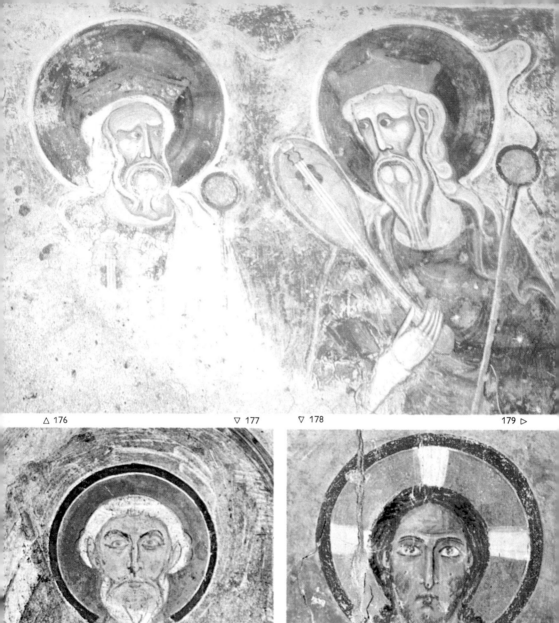

△ 176 ▽ 177 ▽ 178 179 ▷

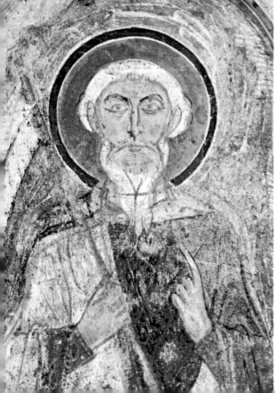

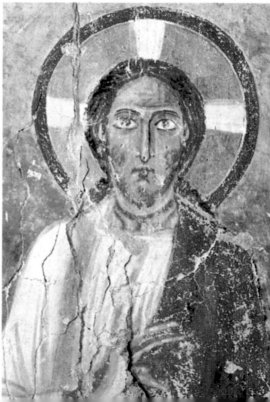

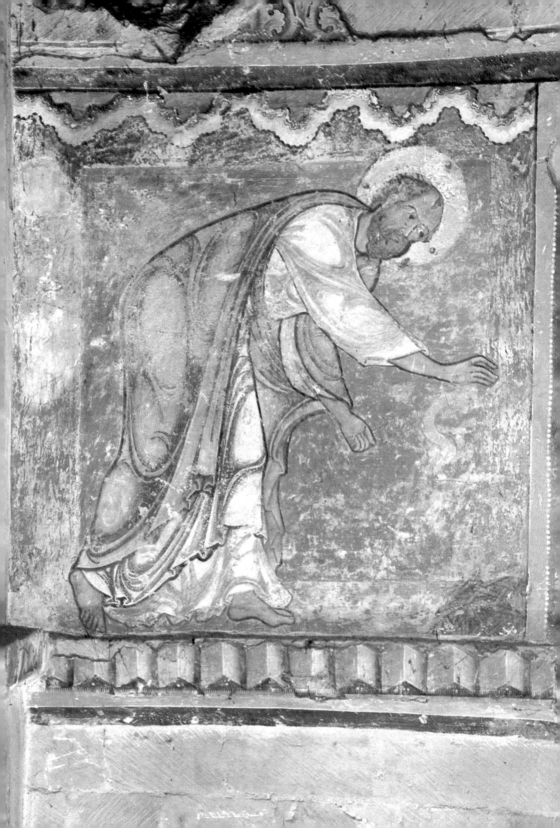

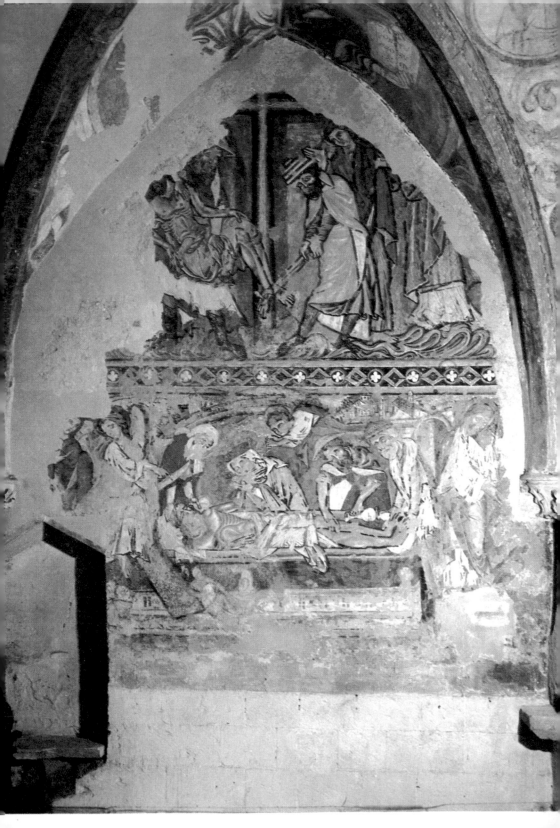

BOOK ILLUMINATION

No church services could be conducted without books such as the missal, the anti-phonary, the lectionary, the gradual, and the troper, not to mention the bible or parts of it such as the psalter, the gospels, and the epistles. In monastic communities, there were, in addition, numerous glosses and commentaries on the scriptures, the writings of the church fathers, the lives of the saints, and books on philosophy, literature, grammar, and science. Not all these books were illuminated, but much time and expense were devoted to making books look sumptuous, if only by decorating the initial letters of the opening chapters. This was not the invention of Romanesque painters, for Merovingian books were already so decorated. But Romanesque initials (*183*) are often figural and narrative. In this, they can be compared to Romanesque capitals on which narrative scenes began to appear from the 11th century onward. There is a further analogy between Romanesque initials and carved capitals, for, as on capitals, there appeared on initials a variety of strange, monstrous beings, fighting, devouring, and pursuing each other. Such initials have no connection with the accompanying text and are there simply for the enjoyment of the reader.

In the 11th and 12th centuries, monks were encouraged to copy and decorate books, and we even know the names of many monastic scribes and painters. But there were also secular, professional men who specialized in this branch of art, combining it at times, it seems, with work in other techniques (see note to *196*). Quite clearly, many such secular artists traveled from place to place, even from country to country, seeking commissions. However, it is probably safe to assume that, during the Romanesque period, much artistic production in book illumination emanated from monastic scriptoria. Indeed, in some cases, it is possible to study the stylistic developments in an individual scriptorium because a large number of surviving books can be localized with certainty. The style prevailing in one or several scriptoria at times deserves the description of a school, as is the case in such centers as Canterbury, St-Omer, Salzburg, Cologne, Rome, or Cîteaux, to mention only a few. On the other hand, where one would expect the existence of a flourishing school, as at Cluny for instance, the almost total destruction of its library leaves the matter uncertain. Without doubt, however, the output of illuminated books during the Romanesque period was enormous and, in spite of fires, vandalism, wear and tear, the dissolution of monasteries, and the dispersal or destruction of their libraries, there is still a wealth of surviving material, much of which still awaits study and publication. It is, nevertheless, safe to assume that all the most important books are known and that certain general conclusions about their style are permissible.

Romanesque illumination evolved naturally and gradually out of older styles, and, at times, it is difficult to say, on purely stylistic grounds, whether a given book is Ottonian, Anglo-Saxon, Mozarabic—in other words, pre-Romanesque—or already Romanesque. The criteria for such judgments are stylistic and therefore depend on subjective opinions. Otto-nian book illuminations in the early stages, in the 10th century, still bore the strong imprint of Carolingian art and often even of antique models. These extraordinarily gifted Ottonian artists had an understanding of late antique forms, draperies, and the illusion of space. They

◁ 180

181 Christ in Majesty between Symbols of Evangelists and Four Prophets. Evangeliary from St. Maria ad Gradus. Cologne, fol. 1 verso. c. 1030. Erzbischöfliches Priesterseminar, Cologne, Hs. 1a. 21.2 × 14.4 cm. Example of late Ottonian painting in which flat, linear treatment of folds of Christ's garments announces early Romanesque style. Heads of prophets have traces of illusionism which dominated earlier Ottonian painting.

182 Tree of Jesse. Vyšehrad Gospels. 1080–85. National and University Library, Prague, MS XXIV A. 13, fol. 4 verso. 34 × 41.5 cm. Earliest known representation of Tree of Jesse, so popular in Romanesque art (see also *190*). Based on prophecy of Isaiah (11:1), *Et egredietur virga de radice Jesse* (And there shall come forth a rod out of the stem of Jesse), it developed into genealogical tree of Christ from royal house of Jesse, David, and Solomon. Bohemian miniature related in style to Regensburg school of painting (and still containing Ottonian features, see *181*) shows Isaiah and Jesse, branch growing out of his body. Seven doves represent Seven Gifts of the Holy Ghost.

183 St. Ildefonsus in Prayer below Christ. St. Ildefonsus, *De Virginitate Sanctae Mariae*. Late 11th century. Biblioteca Palatina, Parma, MS 1650, fol. 5 recto. Illuminated at Cluny, perhaps by German painter trained in traditions of Ottonian art (purple page, gold letters). At end of this book two illuminations by different artist using similar style to that of wall paintings at Berzé-la-Ville (*175*).

184 Christ in Majesty between Symbols of Evangelists. Bible from Stavelot Abbey. 1097. British Museum, London, MS Add. 28107, fol. 136 recto. 44 × 27 cm. Mosan work by Goderannus and his workshop in which soft, curving draperies made early appearance. Roundness of body is suggested quite convincingly. This is one of earliest Mosan works of art in which these elements, influenced by Byzantine art, are present. They were further developed in Liège font (*105*).

185 Last Supper and Transfiguration. Bible from Floreffe Abbey. c. 1155. British Museum, London, MS Add. 17738, fol. 4 recto. 48.3 × 33.7 cm. Fully developed Mosan style with compact figures whose three-dimensional volume is implied by linear means. This stage in development of Mosan painting paralleled by enamels attributed to Godefroid de Claire, numerous works in metal (*141*) and ivory.

186 Lily. *Liber Floridus*. c. 1120. University Library, Ghent, MS 92, fol. 230 recto. Written and illuminated by Lambert, canon of St-Omer. Allegorical book of flowers contains representations of plants fairly correct in general design, but without any desire for accuracy of detail. Interest in allegory rather than in nature was Lambert's motive in writing this book.

187 Pentecost. Antiphonary. From St. Peter's Church, Salzburg. Late 12th century. Stiftsbibliothek, Salzburg, Cod. a. XII, fol. 7 recto. 43 × 31.5 cm. Manuscript of Salzburg school. Facial types and drapery strongly influenced by Italo-Byzantine models. Apostles, with St. Peter in center, Dove of Holy Spirit above them with torches radiating downward toward apostles, illustrating Acts of the Apostles 2:3, *Et apparuerunt illis dispertitae linguae tamquam ignis, seditque supra singulos eorum* (And there appeared unto them cloven tongues like as of fire, and it sat upon each of them). Framing arcading indicates that event is taking place indoors.

188 Summer Landscape. *Carmina Burana*. Early 13th century. Staatsbibliothek, Munich, Clm. 4660, fol. 64 verso. 18 × 12 cm. This famous anthology of lyrics, probably written and illuminated in Benediktbeuren Abbey in Upper Bavaria, contains one of earliest medieval landscape paintings, illustrating poem praising summer. But like landscape in Ferentillo wall painting (*168*), it is not based on study of nature but is composed of conventional forms of plants and animals, treated in flat, ornamental manner.

181 ▷

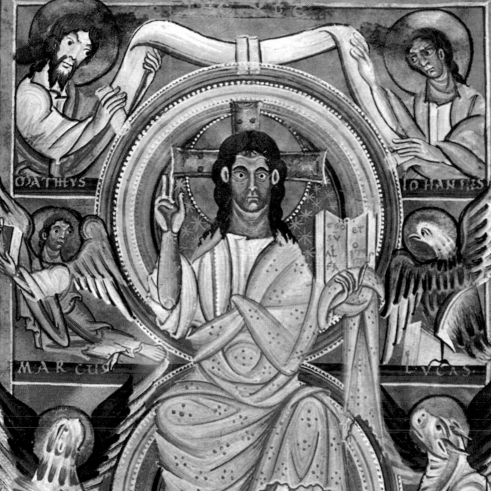

CLAVSA REX PORTA PENETRAT QVE RESPICIT ORTVM·

VIRGVLA DE IESSE PCE DIT SPLENDIDA FLORE·

EGREDIETVR VIRGA

DE RADICE IESSE ET ELIIS IN ASCENDET

ET REQVIESCET SVP

EV SPS DNI

IN NOMINE DNI INCIPIT
OPUSCULUM PREFATIO
NIS IN QUA EXPRIMIT
HUMILIS DEVOTIO
ATQ. PIA CONFESSIO
SEQUIT.

LUMEN VERU

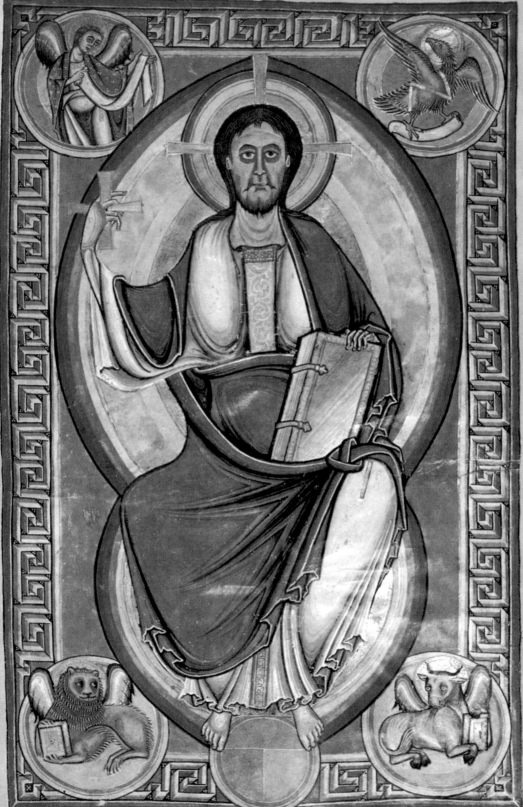

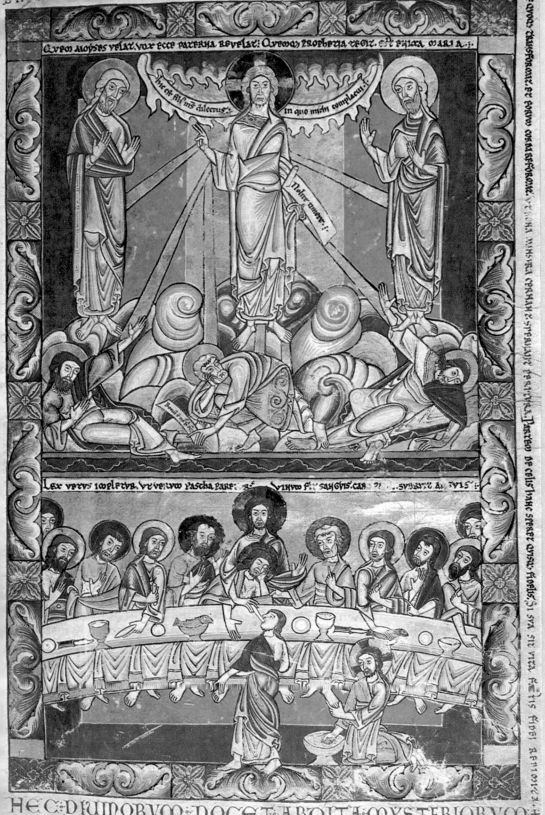

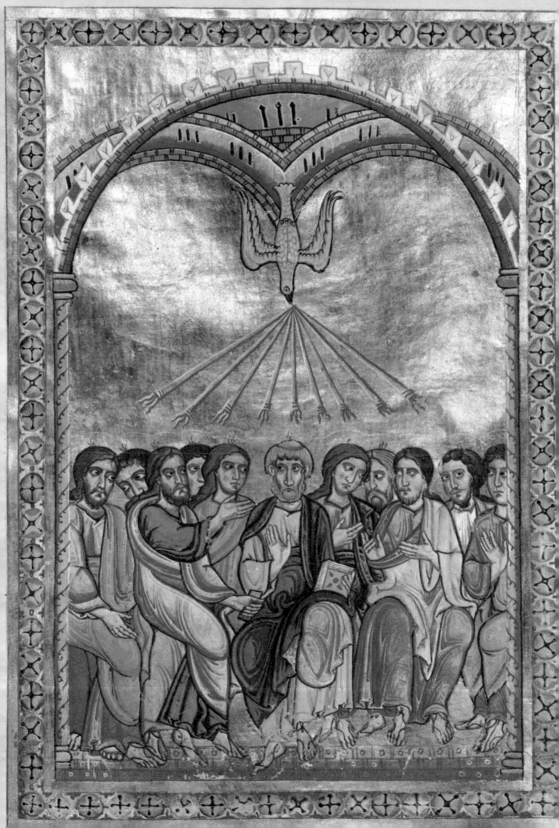

also had contact with contemporary Byzantine art and were absorbing some of its forms. But later Ottonian painting evolved away from illusionism toward more abstract forms (*181*) that led directly into the early Romanesque style. From the middle of the 11th century onward, German illuminations are decidedly Romanesque. The prestige of German painting at that time must have been very great. Of the few surviving manuscripts from the great library at Cluny, the late 11th-century lectionary has initials that are Rhenish and miniatures of a distinctly Byzantinizing character, which presuppose models similar to those that formed the style of Roger of Helmarshausen (*143*). A similar Byzantine character is found in the Cluniac wall paintings at Berzé-la-Ville (*175*). Another Cluny manuscript, a copy of the Ildefonsus *De Virginitate* of c. 1100 (*183*), must, in fact, have been painted by a German artist, perhaps from Regensburg. The school of Bohemian painting, which came into being in Prague in the last quarter of the 11th century, was also inspired from Regensburg. The lavishly illuminated books from that school, of which a few survive (*182*), are notable not only for their forceful if somewhat heavy style but also for their highly original iconography (e. g., the earliest known Tree of Jesse).

It is usual to link the conquest of England by the Normans in 1066 with the introduction of Romanesque art into England. This is an exaggeration for, by the middle of the 11th century, English painters were already moving toward the Romanesque style without any help from Normandy. The Norman Conquest certainly accelerated the process, however. The striking page with Christ Crucified (*189*), added c. 1070 to an English psalter by a Norman painter, is thoroughly Romanesque, with firm outlines, solid masses, and ornamental symmetry. The foliage that frames the page is based on the pre-Conquest acanthus borders found in manuscripts of the so-called Winchester school. But there it was a riotous, unruly foliage that took no account of the frames, while here it is kept well under control. The figure of Christ on the Cross, pathetic in its expression of death, the loincloth arranged in artificial, angular folds, is not an illustration of the biblical event. It is a timeless cult image, a symbol of the idea the Redemption through Christ's death. The formal similarity of this moving image to the bronze figure at Werden (*102*), with which it is nearly contemporary, suggests a common source—namely, the late Ottonian-early Romanesque illuminations of Cologne.

The impact of Ottonian painting is also detectable in the Sacramentary of St-Étienne at Limoges (c. 1100) (*191*), a manuscript that was influential in the formation of a 12th-century school of painting, stained glass, and enamels in the region.

It has been noted that artists of German origin worked in Spain in the 11th century and that Ottonian art played an important role in the development of metalwork and ivory carving there. In book painting, the Mozarabic style, which expressed itself most vividly in the illustrations of the commentary on the Apocalypse by Beatus of Liebana—copied numerous times in the course of the 10th and 11th centuries (*199*) and later—became the basis on to which forms from outside Spain were superimposed. The superb *Liber Testamentorum Regium* at Oviedo, written in Mozarabic script as late as 1126–29, is decorated with seven miniatures representing Spanish rulers, in which the vivid, almost brutal colors of

◁ 188 Mozarabic painting are somewhat toned down and the figure style, although reminiscent

189 CHRIST ON CROSS WITH SYMBOLS OF EVANGELISTS. Psalter. c.1070. British Museum, London, MS Arundel 60, fol. 52 verso. 30.5 × 19 cm. This miniature, probably painted by a Norman, was added to an English psalter from Winchester written and illuminated c.1060. It represents similar development to that found in Werden crucifix (*102*). Expressiveness of dead body achieved through reduction of forms to hard, angular, geometric shapes. Decorative effect of symmetrical trees and rich border. This border is Romanesque version of acanthus borders found in Anglo-Saxon books of so-called Winchester School.

190 MADONNA AND CHILD. St. Jerome, *Explanatio in Isaiam*, from Cîteaux Abbey. c.1130. Bibliothèque Municipale, Dijon, MS 129, fol. 4 verso. 38 × 12 cm. This is part of simplified Tree of Jesse (compare *182*), Jesse reclining at bottom of page. Above, large Virgin holding Child not in austere manner as in most Romanesque representations, but as tender mother, caressing her child. This iconographic type is of Byzantine inspiration, as is style of draperies. On Virgin's nimbus is Dove of Holy Spirit, and two flying angels hold crown and church.

191 ASCENSION. Sacramentary from St-Étienne, Limoges. Early 12th century. Bibliothèque Nationale, Paris, MS Lat. 9438, fol. 84 verso. 270 × 167 mm.
Vigorous drawing in black outline, heavy colors, extensive use of gold. Dramatic gestures and expressions. Decorative *clavi*, gold rectangles on garments. Ottonian influences on iconography and style. Later development of this style found in stained glass (*162*) and in Limoges enamels.

192 ST. GREGORY THE GREAT. Letters of St. Gregory. From St. Martin's Abbey, Tournai. c.1150. Bibliothèque Nationale, Paris, MS Lat. 2288, fol. 1 recto. 36 × 25 cm. Pope Gregory with crozier and book, enthroned, inspired by Dove of Holy Spirit (flying above), six medallions with busts of Gregory's correspondents. Sumptuous frontispiece, heavy colors include gold. Flat design with great decorative effect.

193 LIGHTING THE PASCHAL CANDLE. Exulted Roll. Width 28 cm. c.1060. Biblioteca Vaticana, Rome, Vat. lat. 3784. Written and painted at Monte Cassino early during abbacy of Desiderius (1058–87). Like many Exulted Rolls, one of illuminations represents ceremony of blessing and lighting paschal candle on Saturday before Easter. Initials in this Roll characteristically Monte Cassino work, composed of interlacing bands and animals. Illuminations lost some pigments. Colors pastel-shaded, with some gold. Another Monte Cassino Exulted Roll is in British Museum, London (MS Add. 30337).

194 FOURTH AND FIFTH DAYS OF CREATION. Bible, so-called Perugia Bible. c.1150. Augusta Library, Perugia, MS L. 59, fol. 2 recto. 54 × 35.7 cm.
A giant bible of Umbro-Roman school. Page divided into two scenes framed by borders of interlacing motives. Above, God seated on globe creates Sun, Moon, and Stars. Below, practically identical figure of youthful, beardless God, creating Fish and Birds. Green underpaint, left exposed for shadows. Smooth modeling, arbitrary folds.

195 RETURN OF THE MAGI. Psalter from St. Albans Abbey. 1120–30. Library of St. Godehard, Hildesheim. Page 27. 28 × 18 cm. Biblical picture cycle prefacing psalter was Anglo-Saxon tradition. This psalter related to several manuscripts illuminated at St. Albans and Bury St. Edmunds abbeys. Stylistic sources Ottonian and Italo-Byzantine. Forms well defined and modeled by linear folds and white highlights. Neutral background of colored fields with schematic trees suggesting landscape.

196 MOSES EXPOUNDING LAW OF UNCLEAN BEASTS. Bible, so-called Bury Bible. From Bury St. Edmunds Abbey. 1130–40. Corpus Christi College, Cambridge, MS 2, fol. 94 recto (lower half). Approx. 26 × 35 cm. Illuminated by Magister Hugo, a secular artist who also cast bronze doors and bells and carved figures in wood for Bury St. Edmunds Abbey. Lavishly painted, in strikingly vivid colors. Strong Italo-Byzantine influence, which had profound effect on English painting (see *179, 180*).

189 ▷

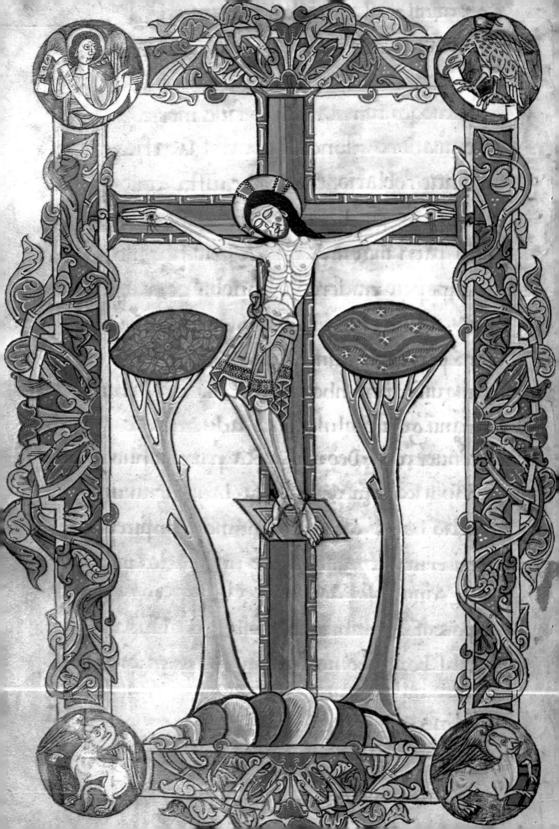

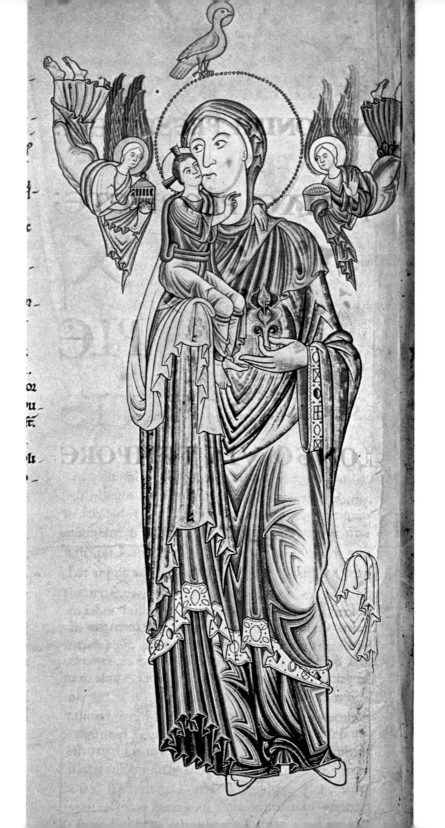

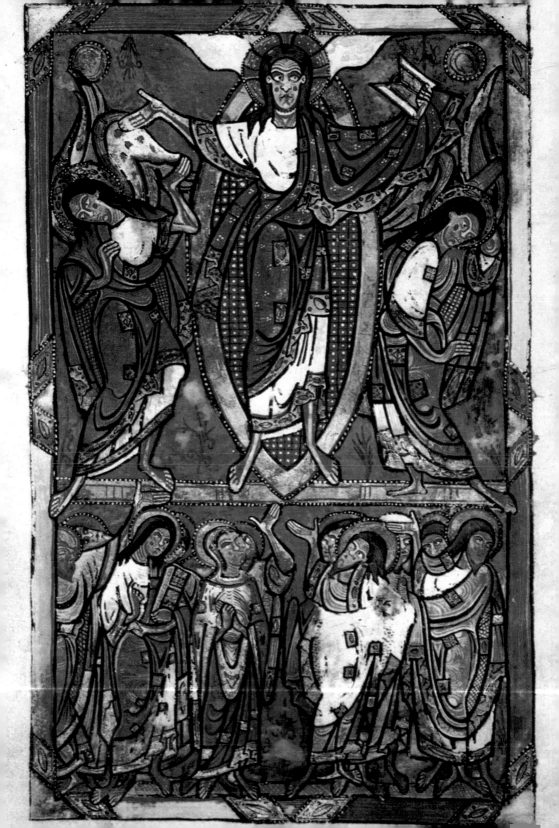

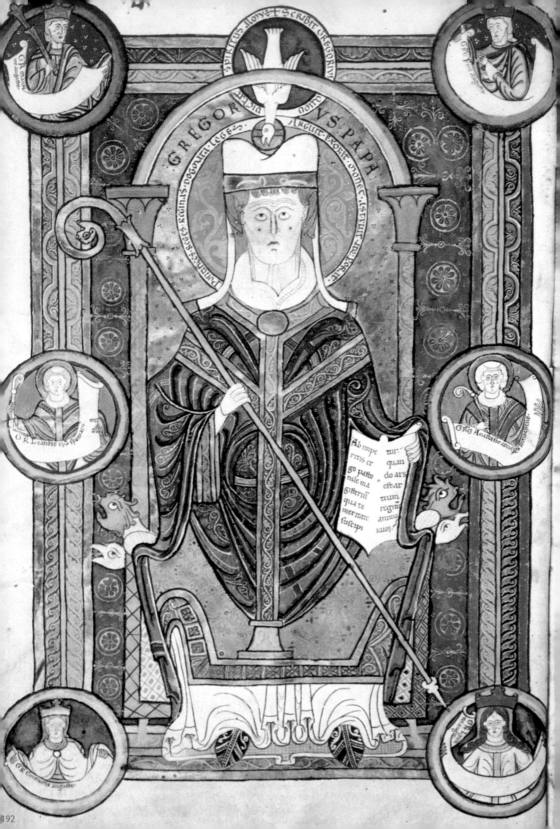

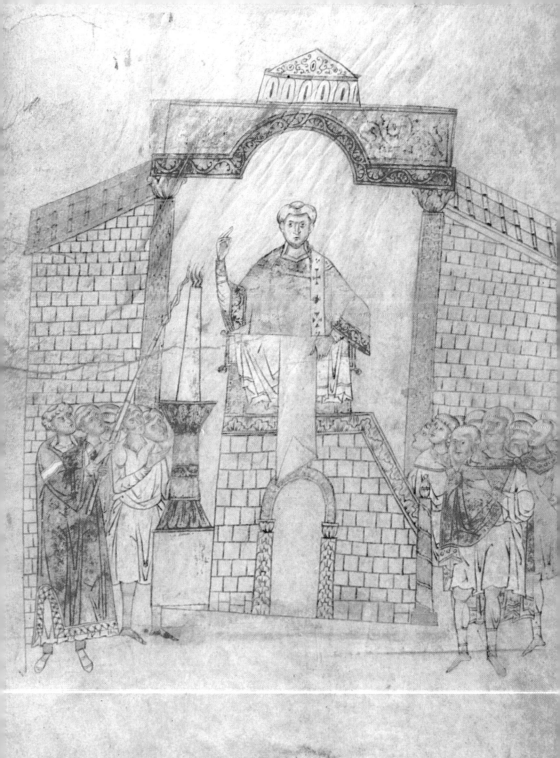

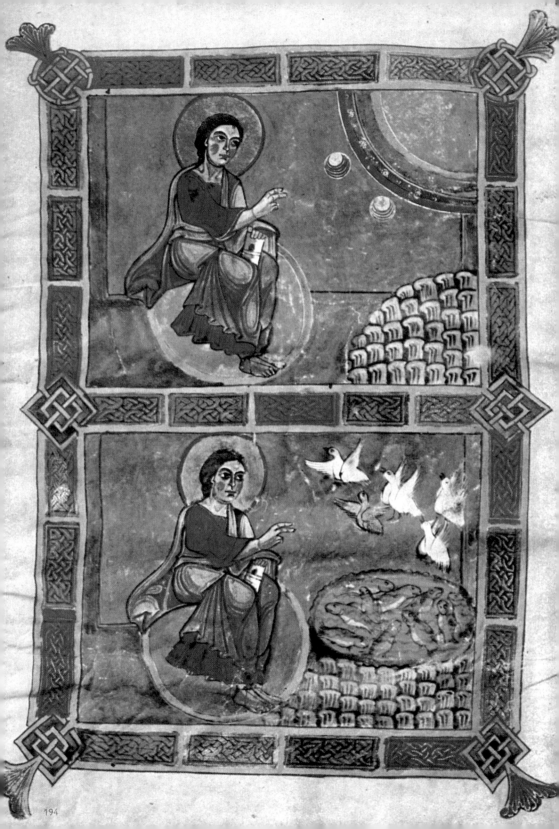

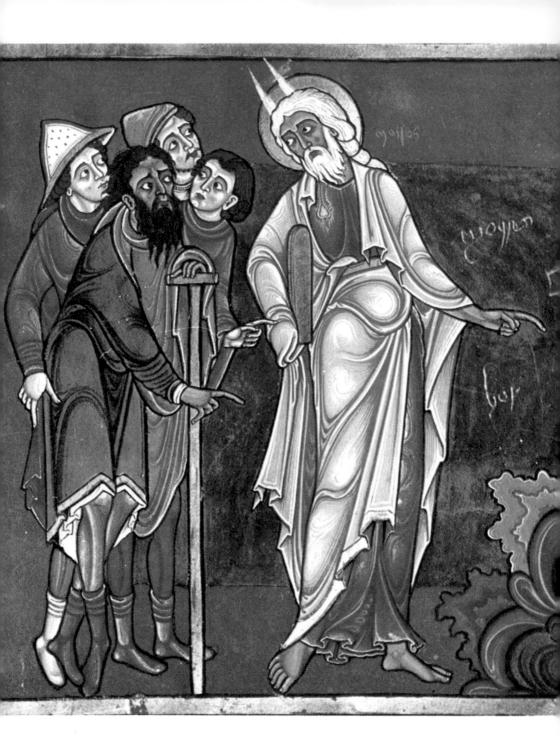

of Mozarabic art, is akin to early Romanesque painting in Cologne (e. g., the Abdinghof Evangelistary, c. 1070–80).

Ottonian painting also made a strong impact on Italian book illumination, and it has been demonstrated that, for instance, the initials in Italian books—and not only those from northern Italy but also from central Italy and even, to a lesser extent, from Monte Cassino— were derivatives of the great Ottonian centers of book illumination.

Important though it was in the formation of Romanesque painting, Ottonian art was not the only source from which it developed. The vigorous Anglo-Norman book illuminations, which flourished in the late 11th and early 12th centuries and which consisted chiefly of painted initials, developed independently of Ottonian art, and the influence of this type of illumination was such that its echoes are found in the earliest Cistercian manuscripts illuminated at Cîteaux during the abbacy of the Englishman Stephen Harding (1109–33).

One of the most difficult questions concerning Romanesque illumination is the exact source of the Byzantine influence, which played such a decisive part in its development. In some cases, this influence was probably direct from Byzantium, either through the travel of artists or through Greek objects reaching the West. Influences from Byzantium were at times second-hand, from Italy, as was certainly the case in the second half of the 12th century, when the Byzantine mosaics in Sicily became an important source of inspiration for wall painting and book illumination north of the Alps. But Italy was open to Byzantine influences much earlier, as, for instance, when Greek mosaicists came to Monte Cassino. Moreover, Byzantine art was not static and, on the contrary, it was undergoing considerable stylistic changes during the 11th and 12th centuries, and thus Byzantine influences, depending on their date, could vary quite substantially. Also, the interpretation of Greek or Greek-influenced models by Romanesque artists varied a great deal. While the painter of the Cluny Lectionary (183) and that of the Berzé-la-Ville frescoes (175), emphasized the decorative qualities of folds which, like a delicate net, cover the whole massive figure of Christ, the near contemporary Goderannus, who painted the majestic Christ in Majesty in the Stavelot Bible in 1097 (184) used only a small number of folds and used them principally to suggest the volume, the structure, and the position of the body underneath. The two works, so different in scale, technique, and even iconography, are nevertheless related in their common source. But it is not surprising that the Berzé painting is in the line of development that led to the decorative style of Autun and Vézelay, while the successors of the Stavelot Bible artist were Reiner of Huy (105) and other great artists of the Meuse region. The Floreffe Bible (185) is a representative of the fully developed Mosan style initiated in painting by Goderannus.

Among the French schools of book illumination that blossomed in the 12th century, that which shows a particularly clear Byzantine inspiration is the second school at Cîteaux, which emerged during the second quarter of the century and is represented by a number of works made for Cîteaux and Dijon. Unlike the initials of the first school, the illuminations became deeply religious and noble in their restrained gestures and solemn expressions (190). Though of Byzantine inspiration, the folds of the garments, attempting to define the bodies they cover, are principally decorative, with metallic, angular hems.

In Italy, Byzantine elements are found underlying much of the early Romanesque painting. Southern Italy was particularly receptive in this respect. It was here that a special type of illumination was evolved, the so-called Exulted Rolls. These are long parchment rolls, with the text of the "Paschal Praise" (*laus paschalis*) starting with the word "exultet," which was sung by the deacon at the blessing of the paschal candle on the Saturday before Easter. The text is illustrated by a series of pictures, placed upside-down in relation to the text, so that they could be seen by the congregation as they were being unrolled, while the text is seen by the deacon standing in the pulpit. The surviving Exulted Rolls range from very fine examples, strongly Byzantine in style, to the rather crude products of provincial workshops. Many include representations of the ceremony of blessing and lighting the candle and chanting in front of the unrolled scroll (*193*).

197 ILLUSTRATIONS OF THE BOOK OF NUMBERS. Bible, so-called Lambeth Bible. From Canterbury, probably St. Augustine's Abbey. c.1150. Lambeth Palace Library, London, MS 3, fol. 66 verso. 52 × 34 cm. A giant bible, second volume of which is in Maidstone Museum, MS P. 5. Subjects in top register from right: Moses receives commandments on Mount Sinai (Numbers 1:1). Moses appoints Levites guardians of tabernacle (Numbers 1:50); Moses counts tribes of Israel (Numbers 1:2). Middle register: Duties of Levites (Numbers 3 and 4). Bottom register: Sin offerings (Numbers 6 and 7) and, on left, duties of Merarites (Numbers 4:30–32). Damp-fold which was used in Bury Bible (*196*) as means of modeling here became decorative device. Canterbury painter delighted in crowded scenes animated by strong emotions expressed by jagged garments, covered by tubular patterns of folds.

198 MOUTH OF HELL. Psalter, so-called Winchester Psalter. c.1150. British Museum, London, MS Cotton Nero C.IV. fol. 39 recto. 32.5 × 23 cm. Text in Latin and Norman French. Written and illuminated at Winchester. Prefaced by 38 pages of Old and New Testament scenes. Mouth of Hell, favorite subject in English art, here shown as two monstrous heads in profile, joined by nostrils, enclosing damned tortured by devils. St. Michael, outside frame of picture,

locks doors hinged on teeth of devils' heads. St. Michael's dress with damp-folds (compare *196* and *197*). Expressiveness at times borders on caricature. Two illuminations in this book direct copies of Byzantine works, probably from Sicily.

199 FLOOD. Commentary on Apocalypse by Beatus of Liebana. Illuminated by Stephanus Garsia between 1028 and 1072 for St-Sever Abbey in Gascony. Bibliothèque Nationale, Paris, MS Lat. 8878, fol. 85 recto. 36.5 × 28 cm. During 11th century, Gascony was under Spanish domination. This is one of several copies of Beatus. Illuminations are based on Mozarabic prototypes. Brilliant, pure colors; figures two-dimensional; clear, simplified contours and expressive gestures and features. The highly original style and iconography of this work had a profound influence on Romanesque art.

200 STONING OF ST. STEPHEN. Detail of wall painting from S. Joan de Boi. Late 11th century. Museo de Arte de Cataluña, Barcelona. White, round stones showered on saint who, bleeding and on his knees, turns submissively to God, symbolized by hand with ray of light. Deep religious faith depicted by simple, almost symbolic forms. Colors also simple: red, blue, black, and yellow, clearly defined by contours. Sleeves of two different colors used for contrast with total indifference to reality.

197 ▷

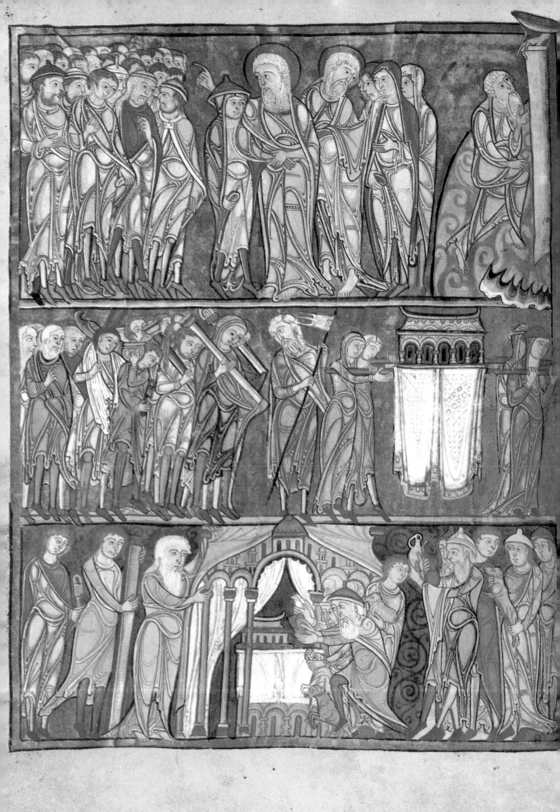

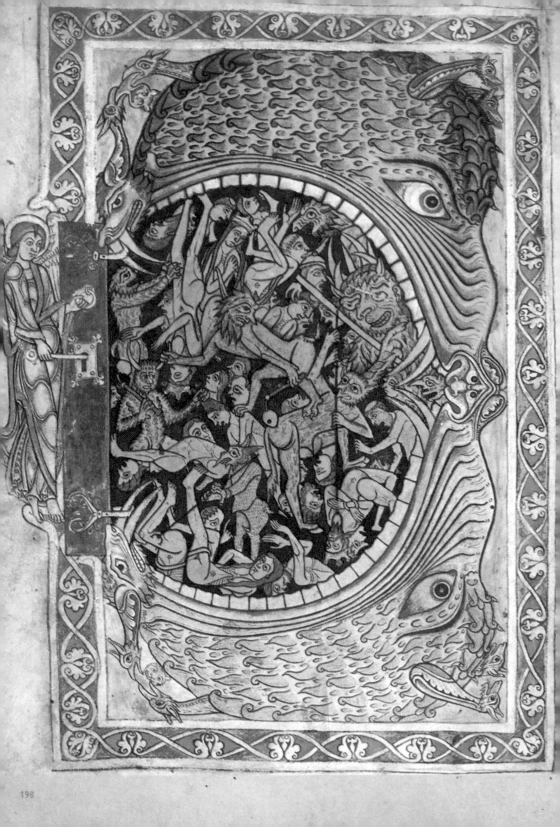

Another type of manuscript in great vogue during the Romanesque period in Italy was the "Atlas" bible (*bibbia atlanticha*), produced in Umbro-Roman centers. The popularity of these bibles is shown by the wide distribution of examples, not only in Italy but as far away as Spain (the Avila Bible, now in Madrid). These giant books are illuminated with initials and whole-page pictures, divided into two or more registers (*194*). Their sources are at least in part Carolingian, but in style they resemble contemporary Roman wall paintings. Norman Sicily developed a lively school of illumination in which Byzantine elements were dominant. The same was also true of manuscripts produced in the Crusading Kingdom.

In England, from 1066 until c. 1120, the predominant form of book decoration was the initial. But from the third decade of the 12th century onward, full-page narrative pictures became the fashion, and English scriptoria produced some of the most spectacular books of the Romanesque period. The St. Albans Psalter, now in Hildesheim (*195*), and the *Life and Miracles of St. Edmund* (now in New York), two works executed by the same artist, are the first of a long list of books in which religious narrative of great originality makes its appearance for the first time since the conquest of England by the Normans. The painter of these two books drew on old English sources, but he was also deeply indebted to Ottonian and Italo-Byzantine art. The somewhat later Bible of Bury St. Edmunds, illuminated by Magister Hugo (*196*), is a masterpiece that combines some elements of the St. Albans illuminations with Byzantine damp-fold draperies. The resulting style strikingly balances decorative and monumental qualities. The slender, elegant figures have a clarity of form that is further enhanced by vivid yet subtle colors set against blue and green backgrounds.

This manuscript must have made a profound impression on contemporary art in England, for its impact can be seen not only in book painting but also in wall painting (*179*) and even in sculpture. But the immediate successors to the Bury Bible were manuscripts in which the English taste for expressive, turbulent forms and decorative details suppressed the calm monumentality of Byzantine origin, which is so striking a feature of the Bury Bible. In the Lambeth Bible, a Canterbury work (*197*), the damp-fold was no longer used simply as a means of showing the shape of the human body but was now employed as an eccentric decorative device and as a means of giving an impression of energy and agitation to the figures. To a lesser extent, this is also a feature of the Winchester Psalter (*198*) and several other manuscripts from different scriptoria, some even from northern England.

This trend in English painting was one of the factors that influenced the development of book illumination in northeastern France and Flanders. There, in a number of monastic scriptoria, decorative tendencies comparable to those in English painting can be observed in many striking works (e.g., *192*). English illuminations exhibit these decorative, truly Romanesque tendencies in their most extreme form, but they can be seen embodied in paintings in all parts of Europe. Many German and French illuminations of the 12th century display a similar love of ornamentation. Even in botanical works, the decorative effect was dominant (*186*), and this interest in the decorative aspect of a picture, resulted in the representation of a landscape in the form of a flat composition like a carpet (*188*).

Much stress has already been put on the fertilizing effect of Byzantium on Romanesque painting. Wave after wave of Byzantine influences reached the West, but Western painters

invariably modified the forms, which were essentially plastic and monumental, in the spirit of two-dimensional, almost abstract designs, charged with an intense, expressive power. The Mosan school and some Italian scriptoria stood apart from this general trend. But in the course of the second half of the 12th century, again under the influence of Byzantine models, chiefly from Sicily, there was a gradual transformation of the prevailing styles. This can be clearly seen in the celebrated Winchester Bible (c. 1180), in which the earliest miniatures are still purely Romanesque, not far removed from the style of the Lambeth Bible and the Winchester Psalter. But the work was continued by a group of painters (c. 1170) who were obviously familiar with Sicilian mosaics and who initiated in England a trend away from Romanesque conventions toward three-dimensional monumental forms, which Byzantium had inherited from classical art. Similar transformations were taking place everywhere. In France, the most famous late example of the style is the Souvigny Bible at Moulins. In Germany, the clearest illustration of this "transition" away from Romanesque may be seen in the works of the Salzburg school (187). As in the field of sculpture and metalwork, so it was that painting entered an exploratory phase, which finally resulted in a complete break with the past. Romanesque art fulfilled the aesthetic and religious needs of the men of the 11th and 12th centuries. The classicizing trend of the late 12th century was only an interlude. It was not to lead directly to the Renaissance. The medieval spirit had not yet spent itself and the Gothic style lay ahead.

BIBLIOGRAPHY

GENERAL

Aubert, M. *L'Art roman en France*. Paris: Flammarion, 1961.

Beckwith, J. *Early Medieval Art: Carolingian, Ottonian, Romanesque*. London: Thames and Hudson; New York: Praeger, 1964.

Bertaux, E. *L'Art dans l'Italie méridionale*. Paris: Fontemoing, 1904.

Boase, T. S. R. *English Art, 1100–1216*. Oxford: Clarendon Press; New York: Oxford University Press, 1953.

Bonet, B. *The Romanesque Movement in Spain*. Barcelona: Ediciones Poligrafa, 1967.

Busch, H. *Germania romanica*. 2d ed. Vienna: Schroll, 1967.

— *Romanesque Europe*. London: Batsford; New York: Macmillan, 1960.

Collon-Gevaert, S., Lejeune, J., and Stiennon, J. *Art roman dans la vallée de la Meuse aux XIe et XIIe siècles*. Brussels: Arcade, 1962.

Decker, H. *Italia romanica*. Vienna: Schroll, 1962.

Decker, H. *Romanesque Art in Italy*. London: Thame sand Hudson, 1958; New York: Abrams, 1959.

Durliat, M. *L'Art roman en Espagne*. Paris: Braun, 1962.

Evans, J. *Cluniac Art of the Romanesque Period*. Cambridge: Cambridge University Press, 1950.

Evans, J. (ed.). *The Flowering of the Middle Ages*. London: Thames and Hudson; New York: McGraw-Hill, 1969.

Fillitz, H. *Das Mittelalter I*. Berlin: Propyläen, 1969. (Propyläen Kunstgeschichte.)

Focillon, H. *Art of the West in the Middle Ages*. 2 vols. London: Phaidon, 1963.

Frankl, P. *The Gothic: Literary Sources and Interpretations Through Eight Centuries*. Princeton, N.J.: Princeton University Press, 1960.

Gantner, J. *Romanesque Art in France*. London: Thames and Hudson, 1956.

—, and Roubier, J. *Gallia romanica*. Vienna: Schroll, 1966.

Haskins, C. H. *The Renaissance of the Twelfth Century.* New York: World Publishing Co., 1957.

Kidson, P. *The Medieval World.* New York: McGraw-Hill, 1967.

Kubach, H. E. and Bloch, P. *Früh- und Hochromanik.* 1964.

Künstler, G. (ed.). *Romanesque Art in Europe.* Greenwich, Conn.: New York Graphic Society, 1968.

Mâle, E. *Religious Art in France, XII Century.* New York: Harper and Row, 1958.

Metropolitan Museum of Art, New York. *The Year 1200.* A centennial exhibition at the Metropolitan Museum of Art, February-May 1970. 2 vols. Greenwich, Conn.: The New York Graphic Society, 1970.

Oakeshott, W. *Classical Inspiration in Medieval Art.* London: Chapman and Hall, 1959.

Palol, P. de, and Hirmer, M. *Kunst des frühen Mittelalters vom Westgotenreich bis zum Ende der Romanik.* 1965.

Panofsky, E. *Abbot Suger on the Abbey Church of Saint-Denis.* Princeton, N.J.: Princeton University Press, 1946.

— *Renaissance and Renascences in Western Art.* Stockholm: Almqvist and Wiksell, 1960.

Stoll, R. *Architecture and Sculpture in Early Britain: Celtic, Saxon, Norman.* London: Thames and Hudson; New York: Viking, 1967.

Swarzenski, H. *Monuments of Romanesque Art: The Art of Church Treasures in Northwestern Europe.* 2d ed. London: Faber and Faber; Chicago: University of Chicago Press, 1967.

Theophilus. *The Various Arts.* Edited by C. R. Dodwell. London: Nelson, 1961.

Tuulse, Armin. *Scandinavia romanica.* Vienna: Schroll, 1968.

ARCHITECTURE

Aubert, M. *L'Architecture cistercienne en France.* 2 vols. Paris: Editions d'Art et d'Histoire, 1943.

Boase, T. S. R. *Castles and Churches of the Crusading Kingdom.* London and New York: Oxford University Press, 1967.

Clapham, A. W. *English Romanesque Architecture.* 2 vols. New York: Oxford University Press, 1934.

— *Romanesque Architecture in Western Europe.* Oxford: Clarendon Press; New York: Oxford University Press, 1936.

Conant, K. J. *Carolingian and Romanesque Architecture, 800 to 1200.* 2d ed. Harmondsworth and Baltimore, Md.: Penguin Books, 1966.

Dehio, G. and Bezold, G. von. *Die kirchliche Baukunst des Abendlandes.* 7 vols. Stuttgart: Bergsträsser, 1887–1903.

Evans, J. *The Romanesque Architecture of the Order of Cluny.* Cambridge: Cambridge University Press, 1938.

Frankl, P. *Die frühmittelalterliche und romanische Baukunst.* Potsdam: Akademische Verlagsgesellschaft Athenaion, 1926.

Gall, E. *Dome und Klosterkirchen am Rhein.* Munich: Hirmer, 1956.

Hahn, H. *Die frühe Kirchenbaukunst der Zisterzienser.* Berlin: Gebrüder Mann, 1957.

Lasteyrie, R. de. *L'Architecture religieuse en France à l'époque romane.* 2d ed. Paris: Picard, 1929.

Puig y Cadafalch, J. *La Géographie et les origines du premier art roman.* Paris: Laurens, 1935.

— *Le premier art roman.* Paris: Laurens, 1928.

Ricci, C. *Romanesque Architecture in Italy.* London: Heinemann, 1925.

Taylor, W. (comp.). *A Bibliography on Romanesque Architecture.* Charlottesville, Va.: American Association of Architectural Bibliographers, 1960–61.

Tuulse, A. *Castles of the Western World.* London: Thames and Hudson, 1958.

Whitehill, W. M. *Spanish Romanesque Architecture of the Eleventh Century.* London: Oxford University Press, 1968.

SCULPTURE

Aubert, M. *La Sculpture française au moyen âge.* Paris: Flammarion, 1946.

Beenken, H. *Romanische Skulptur in Deutschland.* Leipzig: Klinkhardt & Biermann, 1924.

Blindheim, M. *Norwegian Romanesque Decorative Sculpture, 1090–1210.* London: Tiranti; New York: Transatlantic Arts, 1966.

Crichton, G. H. *Romanesque Sculpture in Italy*. *London:* Routledge and Kegan Paul, 1954.

Deschamps, P. *French Sculpture of the Romanesque Period, Eleventh and Twelfth Centuries*. Florence: Pantheon, 1930.

Focillon, H. *L'Art des sculpteurs romans; recherches sur l'histoire des formes*. Paris: Presses Universitaires de France, 1964.

Francovich, G. *Benedetto Antelami*. Milan: Electa, 1952.

— "La corrente comasca nella scultura romanica europea." *Rivista del Reale Istituto di Archeologia e Storia dell'Arte*. Anno 5 (1935–36), pp. 267 ff., and Anno 6 (1937–38), pp. 47 ff.

Gaillard, G. *Les Débuts de la sculpture romane espagnole*. Paris: Hartmann, 1938.

— *La Sculpture romane espagnole*. Paris: Hartmann, 1946.

Grodecki, L. *La Sculpture du XIe siècle en France*. Paris: Baillière, 1958. (L'information d'histoire de l'art, III.)

Jullian, R. *L'Eveil de la sculpture italienne: La Sculpture romane dans l'Italie du Nord*. Paris: Van Oest, 1945.

Panofsky, E. *Die deutsche Plastik des 11. bis 13. Jh*. New York: Kraus, 1969. Reprint.

Porter, A. K. *Romanesque Sculpture of the Pilgrimage Roads*. 3 vols. New York: Hacker Art Books, 1966. Reprint.

— *Spanish Romanesque Sculpture*. 2 vols. Florence: Pantheon, 1928.

Salvini, R. *Wiligelmo e le origini della scultura romanica*. Milan: Martello, 1957.

Sauerlander, W. *Die Skulptur des Mittelalters*. 1959.

Saxl, F. *English Sculptures of the Twelfth Century*. Edited by H. Swarzenski. London: Faber and Faber, 1954.

Steingräber, E. *Deutsche Plastik der Frühzeit*. 1955.

Stone, L. *Sculpture in Britain in the Middle Ages*. Harmondsworth and Baltimore, Md.: Penguin Books, 1955.

Zarnecki, G. *English Romanesque Sculpture, 1066–1140*. London: Tiranti; New York, Transatlantic Arts, 1951.

— *Later English Romanesque Sculpture, 1140 to 1210*. London: Tiranti; New York, Transatlantic Arts, 1953.

METALWORK

Braun, J. *Meisterwerke der deutschen Goldschmiedekunst der vorgotischen Zeit*. 2 vols. Munich: Riehn & Reuch, 1922.

Chamot, M. *Medieval English Enamels*. London: Benn, 1930.

Falke, O. von, and Frauberger, H. *Deutsche Schmelzarbeiten des Mittelalters*. Frankfurt am Main: Baer, 1904.

Gauthier, M-M. *Emaux limousins champlevés des XIIe, XIIIe, XIVe siècles*. Paris: LePrat, 1950.

Hildburgh, W. L. *Medieval Spanish Enamels and their Relation to the Origin and Development of Copper Champlevé Enamels of the 12th and 13th Centuries*. Oxford: Oxford University Press, 1936.

Nørlund, P. *Gyldne Altre*. Copenhagen, 1926. English summary.

IVORY

Goldschmidt, A. *Die Elfenbeinskulpturen aus der Zeit der karolingischen und sächsischen Kaiser*. 4 vols. Berlin: Cassirer, 1914–26.

GLASS

Aubert, M. *Le Vitrail français*. Paris: Editions Deux Mondes, 1953.

Grodecki, L. *The Stained Glass of French Churches*. London: Drummond, 1948.

Wenzel, H. *Meisterwerke der Glasmalerei*. Berlin: Deutscher Verein für Kunstwissenschaft, 1951.

PAINTING

Ancona, P. d'. *La Miniature italienne du Xe au XVIe siècle*. Paris & Brussels: G. van Oest, 1925.

Anthony, E. W. *Romanesque Frescoes*. Princeton, N.J.: Princeton University Press, 1951.

Boeckler, A. *Deutsche Buchmalerei vorgotischer Zeit*. Königstein im Taunus: Langewiesche, 1952.

Demus, O. *The Mosaics of Norman Sicily*. London: Routledge and Kegan Paul, 1950.

— *Romanische Wandmalerei*. Munich, 1968.

Deschamps, P. and Thibout, M. *La Peinture murale en France au début de l'époque gothique*. Paris: Centre nationale de la recherche scientifique, 1963.

Dodwell, C. R. *The Canterbury School of Illumination*. Cambridge: Cambridge University Press, 1954.

Dominguez Bordona, J. *Spanish Illumination*. Florence: Pantheon; New York: Harcourt, Brace, 1930.

Garrison, E. B. *Italian Romanesque Panel Painting*. Florence: Olschki, 1949.

— *Studies in the History of Medieval Italian Painting*. 3 vols. Florence: L'Impronta, 1953.

Grabar, A., and Nordenfalk, C. *Romanesque Painting from the 11th to the 13th Century*. Geneva: Skira, 1958.

Pacht, O., Wormald, F., and Dodwell, C. R. *The St. Albans Psalter*. London, 1960.

Porcher, J. *L'Enluminure française*. Paris, 1959.

Rickert, M. *Painting in Britain: The Middle Ages*. Harmondsworth and Baltimore, Md.: Penguin Books, 1954.

Salmi, M. *Italian Miniatures*. New York: Abrams, 1956.

Swarzenski, G. *Die Salzburger Malerei*. 2 vols. Leipzig: Hiersemann, 1908–13.

INDEX

Descriptions of the illustrations are listed in italics

196